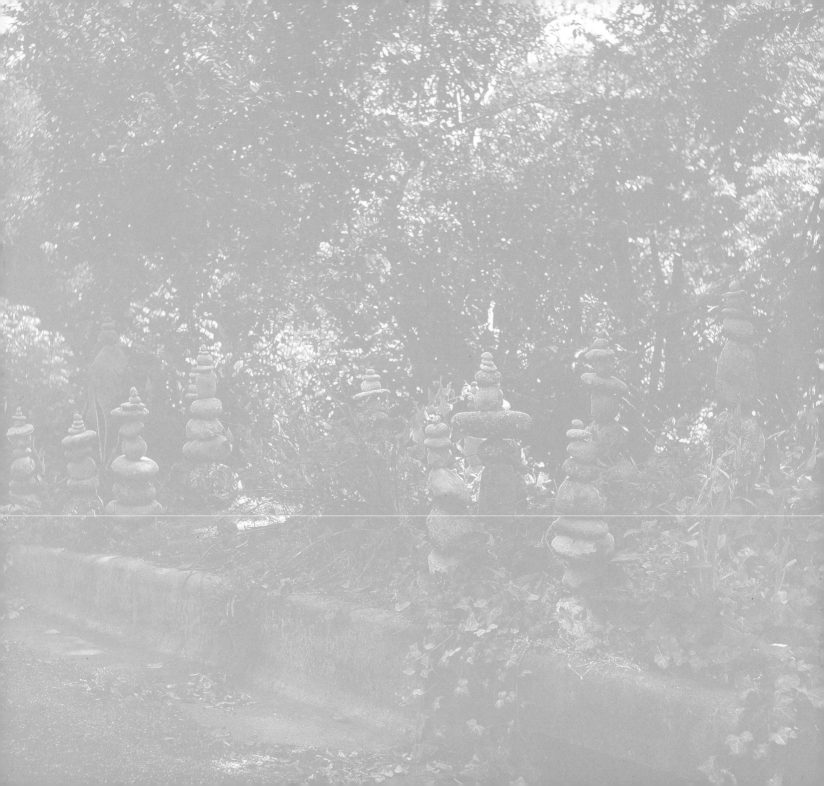

# Yard Art and Handmade Places

## EXTRAORDINARY EXPRESSIONS OF HOME

Jill Nokes, *with* Pat Jasper

*Foreword by* Betty Sue Flowers

*Principal photography by* Krista Whitson

UNIVERSITY OF TEXAS PRESS  AUSTIN

Printed in China
First edition, 2007
*All rights reserved*

Requests for permission to reproduce material
from this work should be sent to:
    *Permissions*
    University of Texas Press
    P.O. Box 7819
    Austin, TX 78713-7819
    www.utexas.edu/utpress/about/bpermission.html

The paper used in this book meets the minimum
requirements of ANSI NISO Z39.48-1992 (R1997)
(Permanence of Paper).

Book and jacket design by Lisa Tremaine

*Library of Congress Cataloging-in-Publication Data*

Nokes, Jill, 1951–
  Yard art and handmade places : extraordinary expressions of
home / Jill Nokes, with Pat Jasper ; foreword by Betty Sue
Flowers ; Krista Whitson, principal photographer. — 1st ed.
    p. cm.
  Includes index.
  ISBN 978-0-292-71679-7 (cloth : alk. paper)
  1. Garden ornaments and furniture—Texas. 2. Decorative
arts—Texas. 3. Gardens—Texas—Design. I. Jasper, Pat. II.
Title.
  SB473.5.N65 2007
  712'.609764—dc22                          2007011574

*Dedicated to my dear Jack, with love and gratitude*

# CONTENTS

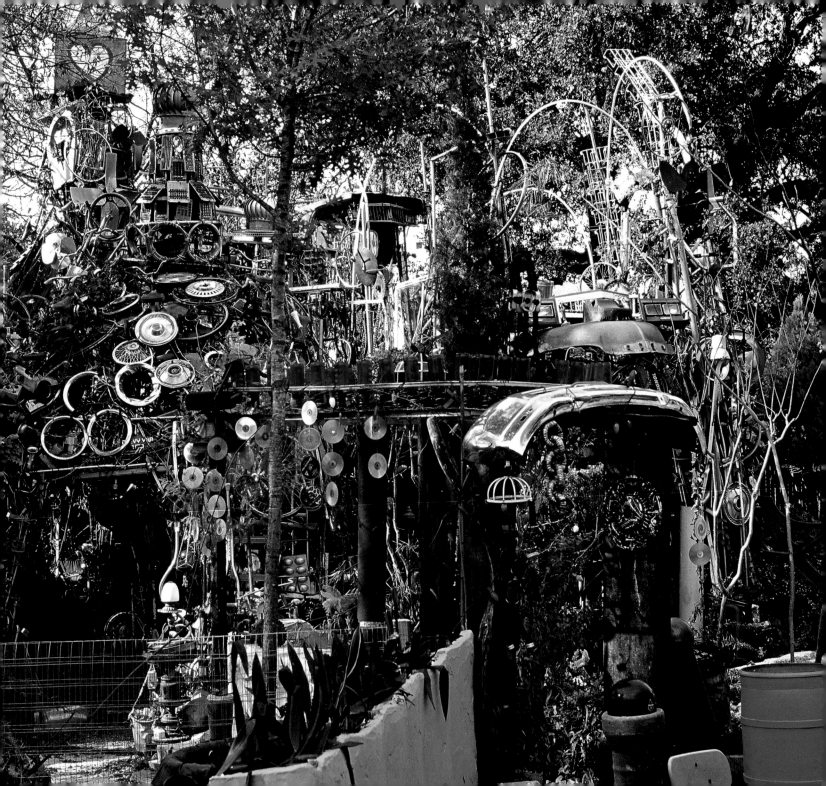

*Betty Sue Flowers*

YOU MIGHT EXPECT a book about yard art to be mainly descriptive in the way catalogs and travel guides are, but the journey we take in *Yard Art and Handmade Places* leads us into deep centers of the human heart, where to create a garden is to bestow a specific blessing. While Jill Nokes is informative about ecoregions and delightful in her descriptions ("butterscotch-colored flowers"), her true subject is the people she meets and the stories they tell about their yard art projects.

Only a master listener could have elicited these stories, none of them obvious from looking at the gardens themselves. There is Sam, whose yard of birdhouses, featured on TV, reunited him with a long-lost love. There is Vince, who built a "Cathedral of Junk"—a series of arched domes made of scrap metal trusses into which are woven car bumpers, kitchen utensils, bicycle parts, CDs, hubcaps, and other "metallic flotsam and jetsam from our consumer culture." Like many of the other "gardeners" Nokes profiles, Vince has become a kind of curator of his own creation, finding that he has to post a schedule in the local weekly paper to control visitation. Nokes tells his story with dignity and respect, from his dumpster diving days to his musings about the reactions of his visitors—"A lot of Depression-era people come by, and they relate to the recycling point of view, and also I've had people cry, because they're overwhelmed by something in it."

Like Vince and his Cathedral of Junk, almost all of the yard artists are people of very modest means who have created extraordinary expressions of themselves and their private visions of an idealized landscape. Some of these visions give their creators an intense sense of meaning in their lives and perhaps even saved the life of Cleveland, "the Flower Man," whose vision in the hospital led him away from a descent into alcoholism: "I had this pretty vision: it was going around

like a whirlwind, picking up stuff, taking it up high and making it look pretty, and this vision was showing so many people just looking out at space, you know, just wanting to know, What is that?"

So many of the stories reflect a spiritual dimension of experience that the cumulative effect is to convince us that the most primal act of individual creation must be to make a garden. One of the gardeners, Jesús, celebrates the twenty-foot-high rock waterfall he built in his front yard with a *corrido* that suggests a closeness between the original Gardener and the human one: "Las piedras que he puesto, solo Jehová Dios las hizo, hace mucho tiempo antes el paraíso" (The rocks that I have put here, only Jehova God made them, long ago before he made paradise).

The effect of these stories is to make us wonder and admire, and we appreciate Nokes as well as her gardeners, for she has written a book that is as much an exploration of the human spirit as it is a uniquely engaging garden tour.

ALLEN LACY SAID it all for me when he wrote, "To write is to be indebted." Anyone who writes a book about people and the places they live is especially obliged to lean heavily on outside assistance. During the years of thinking and working on this project, I was always aware of my dependency on the extensive web of friends, family, and strangers who supported this effort in so many ways.

I must begin with an expression of gratitude to the people and their families who agreed to appear in this book. I was continuously amazed when, over and over, folks would welcome me, a complete stranger, into their homes and lives, and by how generous they would be in sharing their story. Today a sense of connection to others so often suffers from media-driven feelings of mistrust and fear, yet I discovered that it is still possible to recognize and enjoy our common humanity. If I convey no other message than this, I will consider this book to be successful.

This project also taught me that places are fragile. Three of the yards in this book (chapters 12, 13, and 25) were damaged by Hurricane Rita after these interviews were recorded. As if that weren't enough, Charlie Stagg's original studio (Chapter 13) burned to the ground in July 2006. A long windbreak of trees planted in 1948 (Chapter 19) burned in the spring of 2006 during some of the worst wildfires ever seen in the Panhandle. So many places come and go before we even know they exist. Perhaps we meant to slow down and take a closer look, but somehow we never got around to it.

The next round of appreciation goes out to Pat Jasper, who began this book with me as co-author. I had encouraged her to sign on with me because I'd hoped that her experience in folklore, combined with mine in horticulture, would yield some fresh insights on this broad subject

of vernacular yards and gardens. Her companionship on long road trips and experience in field-work contributed so much to shaping the initial ideas and interpretations about what we were see-ing. She was also a whole lot of fun! Pat is much in demand as a curator, producer, and consultant, and eventually those other commitments pulled her away from writing this book. But it's safe to say had she not been willing to join me in the beginning of this wild ride, this book probably would never have gotten off the ground. So I thank you, Pat, for all the energy you put into this project, and for your friendship.

Next in line to thank are all the scouts, those folks who took me around their community, who asked around and sought out things to show me, who fed and housed me, and who, in many cases, dropped everything to accommodate my visit. There is no way I could have covered so much ground or understood even a fraction of what was on view, had it not been for their guid-ance. Thank all of you for good conversation and for helping me sort out my ideas. This group (and I hope against hope that I haven't forgotten anyone) includes Wynn Anderson, John Begnaud, Chris Best, Lynn Castle, Bobby Crabb, Walt and Isabel Davis, Gary Dunnam, Paula Edwards, Debbie Elliott, Beth and Larry Francell, Holly Hanson, Binnie and David Hoffman, Hoppy Hopkins, Lisa Jost, Carol Kitchen, Don Lambert, Sheridan Lorenz, Robert Oliver, Linda Owen, Paula Owens, Bob and Mary Anne Pickens, Bobby Peiser, Project Row House folks (especially Antoine Bryant and Debra Grotfeldt), Morgan Price, Ruben and Marcie Reyes, Howard Taylor, Susanne Theis, Carol Wagner, Bruce and Julie Webb, Miriam Young, Cliff Vanderpool, and Wilfred Weinheimer. Thank you so much for sharing your knowledge about your home towns.

A special group of people were valuable in guiding the ideas and format of this book. They suggested books to read that I was not aware of, they encouraged me to broaden the thematic scope, and most of all, they were patient listeners. Thank you, Kevin Anderson, Eugene and Caroline George, Betsy Barlow Rogers, and Lon and Dede Taylor.

Special and affectionate appreciation goes to my friend Will Pickens, whose thoughtful reading

of the first two chapters at a crucial time helped me put this book on a better footing. Your contribution, Will, is above and beyond the call of duty, and I will always be grateful.

Eternal gratitude also goes to my childhood friend Lisa Rogers, who edited and formatted the manuscript before I turned it in. At the end of writing, replacement troops are always needed, but having someone who knew me so well made these last tedious tasks a joy.

I want also to acknowledge Krista Whitson's generous participation in this project. Without underwriting or grants, the photo documentation of these places became a significant investment, but one she accepted in her typical classy, organized way. Her photographer's and architect's eye had so much to do with how these stories were presented. Thank you again, Krista.

Thanks to Barney Lipscomb and the Botanical Research Institute of Texas for giving us permission to use their map of Texas. Special appreciation goes to photographers Griff Smith and Janna and John Fulbright, whose contributions to this book were so important. As we came down to our last dime and with our time running out, you both helped out more than you know.

At the end of this project, I was given a special gift: Betty Sue Flowers agreed to write the foreword. Not only did she contribute her wonderful interpretation, she also took the time to make valuable editorial comments on the text. Thank you, Betty Sue, for taking the time out from your demanding responsibilities to help me.

Finally, thanks to my fabulous in-laws, George and Virginia Nokes, whose support in all things has meant the world to me. And thanks to my dear husband, Jack, who stood by me through the dry, lonely writing phase and who gave me wise counsel when I was stuck or discouraged. You are my life's companion, and I could not have done this without you.

YARD ART AND HANDMADE PLACES

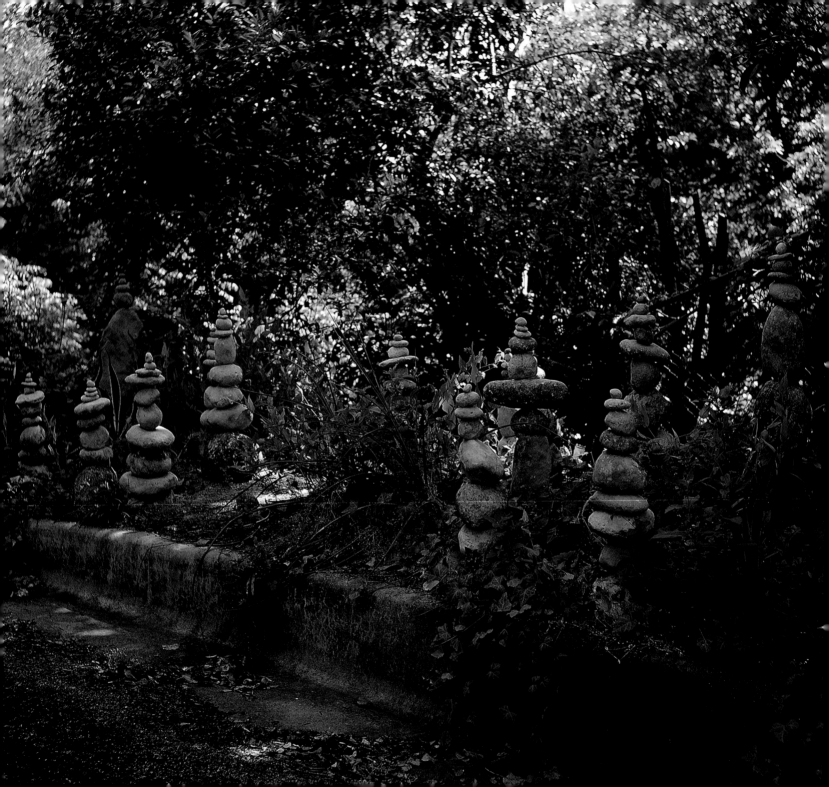

# Places Full of Memory and Meaning

As you may guess from the title of my last book, *How to Grow Native Plants of Texas and the Southwest*, the focus for much of my career has been the study of woody plants indigenous to the region I have been most familiar with all my life. In this book I take a look at the ways ordinary people organize and shape the space around their house to express identity and belonging. As a horticulturist, I obviously have had experience with garden-making, but there are many other reasons I have been drawn to this subject. I hope to contribute a new perspective on the ways residential property can be transformed into extraordinary places of memory and meaning.

## REAL PLACES

My family was a typical product of the prosperity that followed World War II. The G.I. Bill raised my father above his parents' educational level, and with his diploma in hand, he eagerly left his hometown in the Rust Belt region near Buffalo, New York, and headed to El Paso to make a new life for himself and my young mother. Throughout my Texas childhood we seldom visited our great aunts and grandparents back East, but I held on to faint memories of the way their attics and basements smelled when I secretly explored them, and of the funny stories they told of eccentric New England uncles and cousins. My family stayed in El Paso less than ten years before becoming corporate migrants, moving so often that I lost track of how many schools I had attended. We lived in a series of anonymous new neighborhoods where everyone was just like us, but after a while we quit trying very hard to make friends because we knew we'd just be moving again soon. I used to envy kids with big families and grandparents who lived in the country, or those with a religious or ethnic heritage that made them feel part of a group. Carrying my lunch tray into yet another school cafeteria where no face was familiar, I never felt like I belonged anywhere.

## LEARNING WHERE TO LOOK

In graduate school, as the rest of the nation was preoccupied by the Watergate hearings, I was spending time in the piney woods of east Texas with my special new friend, Oza Hall. Oza had retired from the Texas Forest Service, so he had time to show me around remnant virgin hardwood bottoms, stands of long-leaf pines, and other places in Newton County that had been his home for nearly seventy years. In fact, he had hardly left the county in his whole life, but he could find his way around those woods in the pitch dark with his hunting hounds.

One day, Oza took me deep in the woods to the homestead of an ancient African American man, or so he seemed to me then. The man's house was a plain dogtrot log cabin with a chimney made from clay, mud, and Spanish moss, surrounded by a swept dirt yard

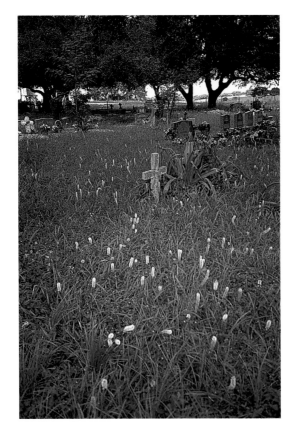

Green lilies (*Schoenocaulon tex-anum*) and crinum lilies (*Crinum* x spp.) bloom in an Elgin cemetery. (Photo J. Nokes)

framed by an old tumble-down split-rail fence. In one corner of the lot, a raw-boned mule monotonously trudged round and round in a circle, grinding sugar-cane in a crude mill. A fire was lit nearby to boil the strong-smelling sugar water, slowly converting it into thick, dark syrup. The man showed us how he made an elixir for coughs from the inner bark of the chokecherry tree, and how wild ginseng root tied in a small pouch worn around the neck could soothe a deep chest cold. In the back of the lot was the privy; on the other side, a smokehouse and an area for wash pots

stood ready. I felt like I had just stepped onto the pages of the recently published *Foxfire Book* of folklore. I remember being enchanted with the whole scene, yet aware that there was so much I didn't understand, including the old-school style of speech the man used. But the memory of that place and the old man's natural wisdom, simplicity, and self-sufficiency stayed with me for years.

During that same time, I also tagged along with my mentors Benny Simpson and Lynn Lowrey as they searched deserts and woodlands for outstanding native plants to introduce into cultivation. Later, after my first book was published, I found myself visiting cities and small towns either as a consultant or to deliver programs to garden clubs and plant societies on how to use some of those same plants in landscape design. While on those pleasant sojourns, my gracious hosts often wanted to show me the meticulously restored historic home and garden of an important local personage, or the formal demonstration gardens at the courthouse or visitors' center. Though those kinds of places offer interesting ways to learn part of a community's story, I found myself eager to explore instead the older neighborhoods, *barrios*, and cemeteries because that's where the forgotten heirloom plants and overlooked remnant stands of native species can sometimes still be found. It's also in these personal and experimental places that people are likely to be doing their own yard work, and might have something different to offer.

Thirty years later, as I began the field research for this book, I drove more than two thousand miles on one trip to deep east Texas with various friends who had grown up there, looking for old-time traditional gardens, or at least yards that had some of the features and patterns that the old man had once shown me and Oza. I was looking for people who had the same ability to

fashion things from what was at hand, who remembered how to make medicine from a few plants, who cherished something learned from their ancestors, and who were holding on to the old ways. But I never found anyone who came close.

Are these places disappearing? Surely many of the old traditional ways are gone, as the old-timers themselves have passed away and rural areas continue to empty out. But I did learn that in many ways entirely new things or variations on those older expressions have taken their place. We just need to look for them. Perhaps I have been fascinated by real places with stories because I never understood how important they were until I was old enough to share them with a family of my own. Maybe my own background was so bland that I am eager to romanticize and idealize something that seems different or unique. All I know for sure is that looking for and meeting people who have a clear sense of where they came from, and a desire to share part of it with me, has enriched my life and made me want to learn more.

## THE VERNACULAR REALM

*Vernacular* is one of those useful adjectives with meanings generous enough to apply to subjects as different as language, architecture, landscape, and customs. Formally, the word *vernacular* is used to describe something that is native or originating in the place where it is used or found. Linguistically, it means something expressed or written in the native language of a place, or more commonly, it indicates plain, everyday, ordinary language. *Language*, *place*, *native:* these are the words that link my work with plants to the study of gardens as expressions of home and identity. In hindsight, they are also the signposts that have marked the search for meaning in my own life.

## HOME AND GARDEN

Most research in the history of landscape design has focused on formal, elite gardens to document their size, location, inventory, and the philosophical intent of the architect, owner, or designer. The stunning grandeur of these sites frequently eclipses any questions about those nameless individuals whose hard work and on-the-ground innovation actually built them. In contrast, the study of vernacular landscapes is often removed from horticulture and garden design and is devoted instead to analyzing how an individual's connection to a larger ethnic or cultural group is expressed through recognized patterns, practices, and vocabulary. Initially I was inclined to assign the creative efforts of individuals I encountered into categories of ethnicity, race, or folk-art products of unschooled naïveté. But as growing urbanization, media saturation, and the restless mobility of the general population contribute to the dilution of

Indian blanket wildflowers surround an old homestead in Pontotoc. (Photo J. Nokes)

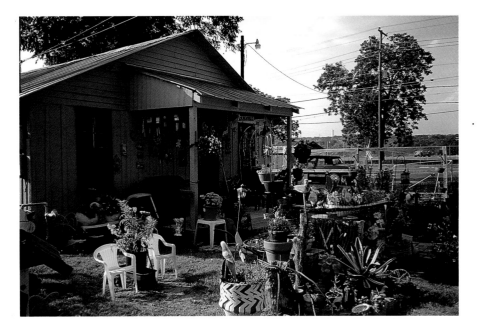

Traditional Mexican American yard in New Braunfels displays a lively arrangement of containers and decorative objects.
(Photo J. Nokes)

forms a location, a given space, into a place, a repository of meaning."[2]

As you will see from the stories that follow, the yards and gardens included here present many layers of meaning, and sometimes homeowners with little else in common employ the same vocabulary to describe their achievements, thus suggesting common themes that transcend other differences. Yet what they all share is their strong identification with the particular spot where they live, and their determination to use their property to express publicly a very personal vision of what it means to live and belong there. In this context, the idea of home is described as being more than just real estate and property values. Instead, it is seen as something mythic, something remembered and yearned for. At their best, these places become an important contribution by an individual and family to a life-affirming order.

pure expression, I discovered that trying to create a rigid catalog of these experiences of space was limiting and incomplete. Gradually, through listening over and over to the interviews with the garden makers themselves, I began to realize that what makes these places worth looking at is something more than ethnic or cultural branding. It begins with "the most monumental aspect of material culture—the use of space."[1] By looking at the ways people use their yard or garden to create particularly exuberant statements about themselves, their history or background, and even religious beliefs, I learned that the larger meaning binding all these places together is what they have to say about the relationship of the owner to his or her homeland. As Robin Doughty asserts, "Settlement is the process of dwelling, of experiencing a sense of belonging in a physical and cultural setting. Human industry trans-

### THE GARDEN AS A GESTURE OF HOSPITALITY
In the introduction to the publication series *Placenotes*, Kevin Keim, director of the Charles W. Moore Center for the Study of Place, remarks, "As we all sense that *everywhere* looks more and more like *nowhere*, we seek out places that make us feel as though we were *somewhere*." For several decades, we have seen increased attention given to place-making and sense of place as important indicators of cultural and social vitality. Yet in the familiarly tragic way humans have of valuing something just as it slips out of reach, today we are also witnessing the rapid replacement of our indigenous landscape by relentless sprawl-spawned monoculture and homogeneous development. As Neal Peirce explains, "Since 1970, a third of all new housing units have been built with rules (usually made by the developer) the homeowner is obliged to join if he wants to live there."[3]

Paint colors, plant selections, and size of lawn are just a few of the things that must be approved by the association before the owner is allowed to modify his property. But security, orderliness, and predictability are benefits that come with a price: more generic landscapes, less understanding and tolerance of outsiders, and a diminished sense of community and long-term attachment.[4] In contrast, the homeowners in this book remind us that the garden can be a powerful gesture of hospitality and sociability. The unexpected and playful outrageousness of many of these yards is often a source of pride and delight to the neighborhood rather than a despised aberration from the norm because they provide a kind of "intermediate zone where individuals, families, neighbors, and strangers can interact."[5]

## HOME AS LIFE TERRITORY

The scale of some of the projects in this study actually exceeds the typical definition of yard and garden (see Chapters 18, 19, and 20). Nonetheless, they still relate to the house from which they are viewed and enjoyed, so I do include them as examples of the way the personal property around a home can be a vivid demonstration of place-making. Through the experience of being inside these modified spaces, they can offer an understanding, aided by all the senses, of what it means to live and work in a certain area. Architect and urban planner Timothy Beatly expands the definition of home: "Our home is our life territory, the communities, landscapes, and bioregions that we occupy and depend on for our emotional existence."[6] Beatly and others view the private home within a larger context of natural and human ecological systems where property values, social relationships, and cultural norms either encourage or deter the individual from feeling deeply connected to a particular place.

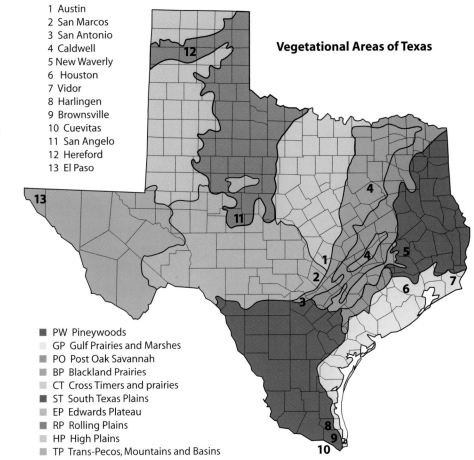

1 Austin
2 San Marcos
3 San Antonio
4 Caldwell
5 New Waverly
6 Houston
7 Vidor
8 Harlingen
9 Brownsville
10 Cuevitas
11 San Angelo
12 Hereford
13 El Paso

**Vegetational Areas of Texas**

■ PW  Pineywoods
□ GP  Gulf Prairies and Marshes
■ PO  Post Oak Savannah
■ BP  Blackland Prairies
□ CT  Cross Timers and prairies
■ ST  South Texas Plains
■ EP  Edwards Plateau
■ RP  Rolling Plains
□ HP  High Plains
■ TP  Trans-Pecos, Mountains and Basins

Texas, with ten vegetational areas or ecoregions as diverse as subtropical beaches, the Chihuahuan desert, pine forests, and vast treeless plains, offers many different contexts in which to consider whether a particular regional response or practice develops in reaction to local weather, soils, cultural affiliations, or history. Some of these gardens exist in climates so harsh and ex-

The vegetational zones of Texas. The numbers indicate locations of garden sites visited in this book. (Map courtesy of Botanical Research Institute of Texas)

Broken brick, glass, and fossils beautify an old barn in Dripping Springs. (Photo J. Nokes)

symbol of endurance, of permanence, a steadfast declaration of "I was here, I did this. This is where I call home."

Texas offers much to the study of vernacular gardens because its ecological, historical, and cultural diversity make what we find here relevant to garden-making throughout the United States. Its enormous urban populations and rural enclaves provide ample variety for comparisons to other cities and regions. Steady immigration into former Anglo-dominated communities is also initiating change in some of the same ways seen elsewhere. Generalizations can be tricky and misleading, but a survey of a big state like Texas casts a net wide enough to make the mix interesting.

## LEAVING YOUR MARK

There was a time in America when almost all people participated in the act of building. Whether it was building a cabin or corral, barn or root cellar, expressing one's life through building and shaping space was common. Even plain utilitarian structures often bore the imprint of their maker, perhaps in the form of something as simple as initials carved on a beam or a special stone laboriously positioned as a fireplace mantel. Today building technology is so complex that "it has become the exclusive domain of professionals."[7] Note, however, that about one-third of the people included here designed or built their homes themselves. The yard and garden remain as one of the few common realms where people with ordinary means and skills can shape space with their own hands to create a personal expression that is visible to all.

In this book, I use the terms *yard* and *garden* interchangeably, though for most people, a garden is more often considered the specific area designated for intensive planting, like a vegetable or flower garden. *Yard* is

treme that it's hard for outsiders to appreciate how challenging it is to make a garden there, or even to spend time outdoors. It may be unreasonably difficult to enjoy, but when it's all you have, you make the best of it. I found that some of these efforts to "make the best of it" resulted in superlative celebrations of home and region. As we know from the stories of pioneer settlers who struggled to carve out a homestead from the wilderness, some of the gardens profiled here reflect an attachment to place that is amplified by the difficulty required to achieve it. In other instances, as we shall see, the struggles preceding the embellishment and decoration of property were not so much environmental as personal or societal (see Chapter 5). As the embodiment of overcoming some private adversity or a daunting ecological challenge, like getting trees established on a dry windy plain (see Chapter 20), the garden becomes a

often used to describe the area with the lawn as a setting for the house, usually including some foundation planting and perhaps some space set aside for leisure and work activities. As we become more and more removed from rural settings, the yard is usually understood to be one's property that is maintained to varying degrees according to the standards of the neighborhood, but without the special attention or display that signals that the owner is a dedicated hobbyist or gardener. To many people, *garden* implies either an elite or grand landscape or an elaborate horticultural display, requiring expertise and resources. Thinking about it in this way, almost everyone has a yard, but fewer people will claim to have a garden.

*Garden* will always be the preferred term for an intensively cultivated space, but to me it can also apply to someone's concrete patio decorated with planters made from recycled materials filled with plastic flowers. Yards and gardens are outdoor spaces near the house that have been shaped, organized, and modified for habitation and display. What all of these very different gardens presented here have in common is that they are *occupied* space. Instead of serving only as vacant settings for their homes, these yards are used and lived in. Because of the inseparable connection to vernacular architecture, fencing, walls, fountains, and other built forms are included here as part of the yard.

## I WONDER AS I WANDER: METHODS AND CRITERIA

Familiarity with the state was essential to the search for special yards and gardens. My goal was to look in most of Texas's ten bioregions to learn if each had built landscapes that were as distinct as the indigenous soils, climate, and plant communities surrounding them. Looking at major urban areas with their own histories

and demographics was also important, but breaking a large city into comprehensible zones that could be surveyed in a reasonably thorough manner was often very difficult. Random cruising of neighborhoods actually turned up some interesting sites, but in almost every area, I was lucky to have local people as scouts to suggest where to look and who to talk to. This was the only way to check my impressions about a town's character against the experience of someone who truly lived there.

One unexpected difficulty in the search process was to provide my scouts with enough information about what I was looking for without being so explicit that they might eliminate something of interest because they assumed it wouldn't apply. Over the years as I described this project to others, they often surmised that I was searching only for wacky yard art or outrageous odd-ball environments. I had to learn ways to suggest the general intention of my searching, while still allowing for some open-endedness that would leave room for discovery. My initial request for local help often revealed how people understood and viewed their own community. It was not unusual for people, even in smaller cities, to admit they were unfamiliar with huge sections of their town, or for them to be surprised at what we found there by merely driving up and down the streets. Sometimes a simple question about a natural feature, such as "What is your definition of a bayou? How does it differ from watershed or creek?" would temporarily stump my local guides, as they had never thought about anything so familiar and so much a part of their landscape. A bayou is just a bayou!

Even when these explorations did not turn up something suitable for this project, just the act of looking and asking questions from an outsider's ignorant standpoint was always worthwhile. Driving through small

north-central Texas towns, I saw empty Victorian brick opera houses and train depots, markers of the community's brief moment of glory and prosperity when cotton was king. I could imagine a scene when the town's people gathered to celebrate with bands and barbecue, tossing their hats in the air when the ribbon was cut or the first train arrived. Down in rice-growing counties, small Czech-Tex towns bypassed by the highway today seemed forlorn and nearly empty, yet the neighborhood streets still possessed a melancholy dignity provided by matched rows of huge live oaks whose branches reached across like cathedral arches to cast an eternal shady canopy. Someone who was optimistic about the town's future must have planted them seventy-five years ago. Searching for current, active sites with one eye on the past helped me understand how landscapes often reflect many layers of cultural and natural history. As Elizabeth Barlow Rogers explains, "Because landscapes have a temporal dimension, altering with time, they can be read as palimpsests, documents in which nature's own powerful dynamic and the changing intentions of human beings over the years inscribe a historical record."[8]

To begin the search, my criteria for the yards I might include in this book were simple: the gardens had to be made by the owner and the family themselves. They would not be designs copied from magazines, or built and maintained by a landscape company. They must be active, meaning the owners must be present and still working in their garden. Many of these places, like most gardens, are inherently ephemeral, and without the animating presence of their creators, they soon change or disappear altogether. This rule eliminated a few very worthy and interesting remnant sites that have been maintained to one degree or another by other people. At the other end of the spectrum, I tended to stay away

from brand-new subdivisions, having understood, as Robin Doughty states, "the passage of time is necessary for the experience of place."[9] Without history, gardens and yards serve as decoration, not vehicles for stories.

There were occasions when I did look for something specific, like long-established windbreaks in the Panhandle (Chapters 19 and 20) or palm collectors in the Rio Grande Valley (Chapter 9). The trail to these people was surprisingly easy, thanks to plant societies, county agents, and local history museums. With only the vaguest notion of why these places might be worth looking at, I was amazed over and over to discover that the reality of these sites was more profound and interesting than anything that had initially existed in my imagination.

Encounters with the garden makers included here usually led to photo documentation and lengthy audio-taped interviews conducted over several visits. Often my questions would prompt the place makers to reflect about their garden in a fresh way and cause them to question some of their motivations, the way you do when someone asks you about something that to you is just an ordinary part of everyday life. One of the greatest privileges of this project was to enter the gates of a garden with the companionable owners and to be a witness as they told me their story and savored their achievement.

I will not claim to be objective about my selections. As Rita Dove writes, "Subjectivity is what makes life interesting and turns human history into a kaleidoscope of wills meeting accidents."[10] This is not a rejection of methodical approaches that provide empirical data. My goal here was not to map or quantify groups of people or settlements but instead to look for individual expressions that might help explain the role of "imagination and perception in understanding human attachment to

land."[11] At the end of this journey, I hope to encourage people to take the time to look at familiar and ordinary places in their own community.[12]

## THE COMMUNITY OF STORIES

Although as a landscape designer I had experienced the automatic intimacy that comes from working with clients inside their personal property, I was unprepared for the degree of openness I encountered with these garden makers and the power their narratives held for me as they explained how their yards came to be. I found that the garden itself is a story with "human hopes and desires part of the landscape."[13] Despite widely differing backgrounds, history, and social status, often a moment occurred in these narratives when a certain piece of that individual's experience could be universally recognized, thus dissolving the differences that keep us separated. In these accounts, we learn of loss or celebration, the memorializing of a life's work, a desire to offer something positive to the community, and the determination to leave a handmade legacy for all to see. Although respect for the people who trusted me with their stories prevents me from revealing all that I was told, it is also true that many of these narratives included hard disappointments and failures, precisely because they are about life and family. So, rather than regarding these stories as idiosyncratic sentimental accounts, or tales told by simple folk, know that by what is said or left unsaid you can be sure that these also include themes common to most families, such as the bitterness left behind after a father deserts the family, the worry when a child falls ill, or the uncertainty about a future that seems to have no place for you. Bankruptcy, unfulfilled potential, and misguided choices are here as well. Some of these gardens were made in spite of these travails, while others offered a way of transforming hurt and failure into a promise of something better. It is my hope that by reading the stories provided by these owners, we will discover that the objects on display are less interesting than the connection we feel to others when we are inside the yard itself. When we view these places only as curiosities or oddities, or focus our attention mainly on the assembly of material objects, we risk distancing ourselves from the makers, and reducing their achievement to an exotic or even fetishized installation. When this dominates the discussion, we miss the opportunity to view the garden, as "a place for mundane tasks, spiritual refreshment, and the expression of ideals, beliefs, and aesthetic values."[14] Here I have tried my best to let the voices of the garden makers stand front and center, telling it in their own words.

## A PIECE OF EARTH AND A GENEROUS HEART[15]

The search for larger meanings in small personal landscapes offers many sweet truths as well as worthwhile detours. How much can a visitor assume to know about a life partially revealed through a garden? I discovered that it's not as important to extract lofty interpretations or pronouncements about someone's one and only precious life as shown through a garden as it is simply to enjoy the privilege of entering inside the gate to be that person's companion for the time being. Such encounters, with spirits generous enough to share their life with strangers, offer a rich reward. These places are all around us, if we would take the time to look. J. B. Jackson, who spent his life looking at vernacular landscapes, puts it best:

> *Successful places are embedded in the everyday world around us and easily accessible, but at the same time are distinct from that world. A visit . . . is a small but significant event. We are refreshed and elated each time*

*we are there. I cannot really define such localities any*
*more precisely. The experience varies in intensity; it can*
*be private and solitary, or convivial and social. What*
*moves us is our change of mood, the brief but vivid*
*event. And what automatically ensues . . . is a sense of*
*fellowship with those who share the experience, and the*
*instinctive desire to return, to establish a custom of re-*
*peated ritual.*[16]

# The Repertoire of the Garden

The gardens profiled in this book are as different as the individuals who made them, yet a more intimate acquaintance with them reveals many things they have in common. Once you begin to recognize some of the characteristics that mark especially creative yards and gardens, you become aware of how many of those features are repeated again and again in different places. These might include similar activities or practices, certain popular decorative objects, or aesthetic preferences. Others may be more intangible qualities that link the intent of one owner to another, even though the end result may look very different. In this chapter we will take a look at some of the materials and practices that are part of the repertoire of vernacular landscapes.

## CURB APPEAL

If there is one quality that is shared by all the gardens in this book, it is that they are *occupied* spaces. Most front yards in America are empty foregrounds of lawn that mainly serve as a setting for the house or as a buffer from one's neighbors. Because America has always had relatively abundant real estate, we typically don't consider this emptiness wasteful. We don't miss using the front yard for growing lots of different plants, or as a place for regular recreation and social interaction. The front door has become a vacant symbol, deferring instead to the garage as the main everyday entry. Transitional spaces like front porches, sidewalks, and breezeways are often absent or unused, perhaps because

they can't compete with the allure of indoor climate-controlled virtual entertainment. But the yards that draw our attention here are active, living spaces in which decoration, work, cooking, and recreation all have their place and are used regularly. In several instances, yard displays began when indoor collections ran out of room and overflowed outside. Marian Reyes (Chapter 24) explains:

*I wanted to move from the inside out. I wanted to bring outside what I had inside. This house is a lot smaller than the other one we had, so I was not able to display all the things I had, so that's how I began.*

Another owner, Ira Poole, adds,

*What I have inside my house, I take to the outside. What I have on the outside, I bring it on the inside [in the form of landscape murals]. If you want to see it as math, I got sets within sets.*

Even first-time visits to some of the gardens shown here included tours of special exhibits in the home, such as Marian's shell collection, Cleveland Turner's living-room floor covered with play-pretties rescued from the trash, or Mary Saldaña's 850 miniature oil lamps lining her parlor walls. Indoor shrines or prayer rooms also often have their outdoor counterparts.

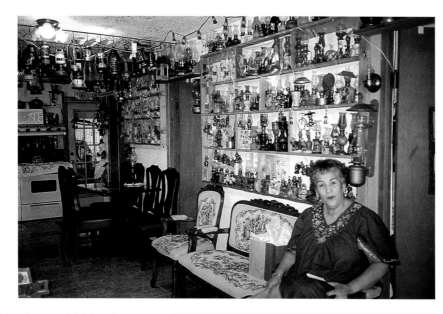

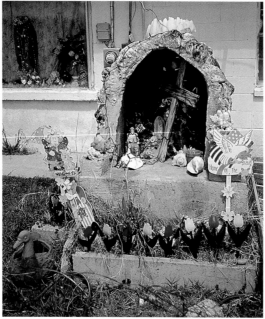

(*above*) Mary Saldaña's collection of miniature oil lamps lines the walls of her house.

(*right*) Shrines grace a house in Marathon, both indoors and outdoors. (Photos J. Nokes)

## PROCESS NOT PRODUCT

It's obvious that vivid display is important to most of the gardeners discussed here, but it was seldom separate from or valued more than the satisfaction derived from just plain working in the garden. As Craig Hoyal explains, "You get peace of mind, and, I don't know, my mind will go blank sometimes whenever I'm working . . . . It's just a good thing" (Chapter 12). Some of the activities that the garden makers consider as important and enjoyable as the finished product include the ongoing act of arranging and rearranging objects (Chapter 21), putting in long hours on the property after a full day at work (Chapter 11), scouring flea markets or garage sales for new objects to showcase (Chapter 7), swapping specimens at a plant society meeting, or gathering strange-shaped rocks in the country (Chapter 4). Although durable materials like concrete, stone, and ironwork were often used to define and organize distinctive yards, the contents are seldom permanently fixed. Thus working is viewed not as a burden or obligation but as an essential part of creativity that provides its own satisfaction. Through the intense level of activity in these yards, the owners demonstrate a truth well known to all gardeners: that gardens are not static veneers or arrangements; they are dynamic systems where change is both a delight and a challenge.

## SCENERY FOR THE STORY

Nostalgia for simpler times represented by folksy arts and crafts objects has become a popular style in home and garden decoration, and an argument could be made that some of the yards shown here are simply more rustic or humble versions of a trend found in numerous magazines and lush design books. Exuberant invention and compulsive collection can be found in both sophisticated displays of expensive items as well as yards that

showcase garage-sale treasures. Obsessive collecting can provide a comforting strategy for coping with a threatening and changing world. Romanticizing the past by gathering things that are either handmade or won't be manufactured again gives us a way to remove ourselves, at least in our imaginations, from the rough pace of history that seems to be spinning out of control. When we acquire a complete set of something after much determined searching, some of that feeling of control returns. In our private moments, we console ourselves with the thought that even though the world may be going to hell in a handbasket, at least we have our collection of Fiesta Ware or antique oilcans.

What sets these gardens apart from nostalgia-driven style or stage-set displays of antique replicas is that they are all self-referential. They are not copies or derivative of anything but the message and meaning assigned by the owner. For example, the metate in Mr. Villalón's yard (Chapter 8) belonged to his grandmother. Placing it outdoors by the table made from an irrigation wellhead presents an informal homage to family history and an opportunity to talk about old times with visitors as they sit outside. In Cleveland Turner's yard (Chapter 14), most of the profusion of objects is both the found booty and raw material of a virtuoso folk artist. Yet some items, like old flatirons, farm tools, canned figs (eons past their expiration date), and plants, are intentionally included to memorialize his mother's yard in Mississippi. Cotton plants, candy yams, Seven Sisters rose, and cockscomb are important pieces of a tale that is epic and personal at the same time. If you don't know Turner's story, they are just delightful components in his wild display.

In these yards, the garden is a portal through which we are invited to enter into the story of a person's life. Some of these gardens are not necessarily visually im-

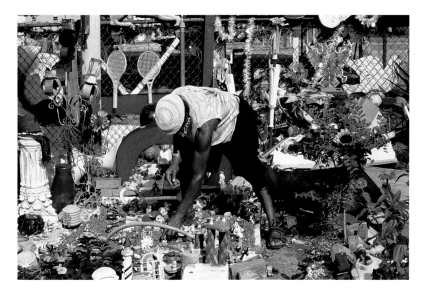

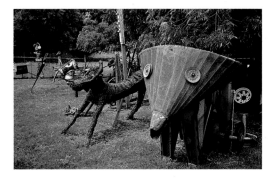

(*above*) Cleveland Turner draws deep satisfaction from constantly rearranging his yard display in Houston.

(*left*) A fruit stand in south Texas offers a variety of tire planters for sale.

(*bottom*) Waxahachie folk artist David Strickland creates fantastic creatures from old farm equipment and auto parts. (Photos J. Nokes)

pressive, certainly not to the standards of a glossy magazine spread. Their real power is revealed once the tale is told. Gardens included here have a special beauty because they are outward and visible signs of complex personal narratives, while at the same time they represent certain truths about human experience that all can recognize. Many of these garden makers are practiced storytellers and performers, while others are satisfied to let their work speak for itself. By accepting the invitation to enter these gardens, we have the opportunity to take away the meanings that seem to us most true. Sharing the stories is part of a greater hospitality represented by the occupied space—accessible to neighbor and stranger alike.

### SOMETHING SET IN MOTION

Although a few gardens presented here were begun with a master plan or vision in mind (Chapters 20 and 25), most makers admitted that they began their big creative adventure on a small scale without a grand purpose or intent. "I thought it would look good," was the basic reply of most. Initially, the mere act of building a garden provided its own satisfaction, but gradually, many projects gathered momentum as the maker's skills and confidence grew, which in turn attracted more attention from neighbors and others. Organizing the space around the house often became an interactive enterprise in which neighbors contributed objects or efforts to perpetuate the display (Chapters 4, 13, and 15). This unprogrammed collaboration suggests that these special places express something for the community, even if that something is not verbally articulated or the same for everyone. The reciprocal nature of these creative gestures almost always inspired and energized more creativity by the owners, a few of whom began to

view themselves confidently as bona fide artists (Chapters 14 and 21). Charlie Stagg and Joe Smith already had connections and training in the world of fine art, so their identity as artists was supported in a different way. Eventually, these creative environments generated so much momentum and scale that many of these makers became well-known local celebrities, the proud denizens of their own extraordinary domain (Chapters 14, 16, and 22).

### ON EARTH AS IT IS IN HEAVEN

A traditional Islamic saying describes a garden as "a comfortable place to meet with God in an earthly setting. A garden is where rocks, leaves, water, and plants all have a sacred role to play."[1] The idea of the earthly garden, cocreated with God as a foretaste of heavenly paradise, is a familiar theme in landscape history, and so it is no surprise that many of these homeowners assigned religious meaning to their gardens. Some even described spiritual experiences they had while working in the garden (Chapter 15). Many of the garden makers, though they had little else in common, used the same religious language to describe their garden. Declarations of "Welcome to my Garden of Eden" or "This is my sanctuary" were repeated in garden after garden. Others used words like *blessing*, *redemption*, and *sacred* to describe both the space and the action that takes place on their property. Some gardens were intentionally dedicated as a holy work (Chapter 25). Some evolved into refuges from the travails of the everyday world (Chapter 24). Still others were intended to serve as beacons of hope in marginalized neighborhoods (Chapters 5 and 14). Whether or not they were planned this way from the beginning, most gardeners felt that their achievement in some way reflected a higher purpose.

## ALL MANNER OF EARTHLY PARADISE

The homegrown version of an idealized landscape often reaches its highest form in gardens built by hobbyists and plant collectors (Chapter 10). Here a vision of nature perfected is expressed, often to a spectacular degree, through the owner's expertise and connoisseurship. In these gardens we do not see an accurate restoration of a natural ecosystem but rather an alternative version of Creation, as if God had decided to specialize in certain species, and planted all the bromeliads or hostas in one fabulous location.

Idealized landscapes come in other forms, too. Many Mexican American yards are recognizable by the use of bright colors, flowering plants, and a profusion of both new and recycled decorative objects. Neighbors often share a preference for fencing, walls, and borders to mark the limits and boundaries of their property. Sometimes these edges and layers set up a procession of discovery from the public zone on the curb to the private recess of the front door and porch (Chapters 7 and 14). Fences also provide a walkway along the front in neighborhoods lacking concrete sidewalks. Eric Ramos writes, "In an area where sidewalks are economically unfeasible, boundaries provide a guide which allows individuals to organize plants and other decorative objects and show off their hard work."[2] Rather than privacy fences installed to keep people out, these are used more as a framework and backdrop for arranging and presenting the display, and for keeping pets close by. Pat Jasper and Kay Turner further explain:

> Mexican American yard decoration is a patterned presentation that promotes an ideal of abundance and riches which is not tied to economic status. The Mexican American yard evokes a pastoral scene through the use

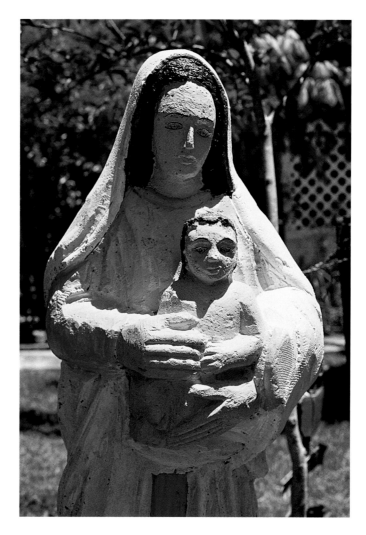

of conventional animal images and the cultivation of brightly colored plants.[3]

As an admiring passerby, I observed that hospitality and generosity were often inseparable from this kind of

The Blessed Mother welcomes visitors to the Reyes garden.

yard, which celebrates the possibility of prosperity. Even though the house itself may be modest, the owner is letting you know through her ornate and colorful garden that she has enough money to spend on nonessentials, and more than that, she is delighted to share it with you. (For more discussion of the qualities of Mexican American gardens, see Chapter 7.)

### THE WILD WILD WEST

The frontier spirit is still vividly present in the western half of Texas. Wide-open spaces and plenty of highway frontage have inspired more people than you might guess to set up elaborate tableaux of false-fronted western towns that include playhouse-sized saloons, chapels, jails, and homesteads. Torch-art cutouts of steers being roped or bucking broncos are also widely used, especially as decorations on ranch entries. Miniature windmills, seesaw-scale pump jacks, and life-sized statues of deer, buffalo, and other varmints are used to populate the scene. Even on smaller city lots, the western-theme flowerbed is common. These special displays are often given a place of honor apart from the ordinary static foundation planting. Many include the same components: a bleached cow skull, rusted plow or other exhausted farm equipment, sometimes transformed into metal art creatures, old horseshoes, cactus, and rocks and gravel. Specially gathered rocks and fossils often serve as a border or as sculptural elements. Pride in one's pioneer ancestry is important in many parts of rural Texas (Chapter 19), and these familiar displays of family artifacts, ranching or farming symbols, and animals celebrate an important part of a family's identity and position in local history. Miniature romanticized landscape displays by individuals often correspond to the idealized version of history found in their local history museums. Both display random or donated items

in a stage-set way, designed to bolster local myth and legend. The stories of one family are thus bound to others by honoring cherished old objects familiar to all.

### VISIONARY ENVIRONMENTS

The rich and controversial subject of Outsider and Visionary art has been well explored in publications and other forums that I will not attempt to report here. It was almost inevitable that some of the places encountered during the fieldwork for this book would fall into this broad category. In fact, many times my scouts and guides in different communities assumed that I was looking *only* for those over-the-top extravagant environments. What are these places, exactly, and what do they mean? I found Beardsley's definition most helpful: "Part architecture, part sculpture, part landscape, visionary environments seem insistently and purposefully to defy the usual categories of art practice."[4] In these yards, the "rich use of coarse and common materials"[5] reaches a level of colloquial ferocity unmatched elsewhere. Although inseparable from a personal chronicle, they are so exaggerated and exotic that description and interpretation by others can be elusive or misleading. They are fun, impressive, confounding, and even disturbing.

Although the four visionary environments in this book have little in common visually, they all incorporate a message about home and belonging. Charlie Stagg returned to Vidor to care for his aging parents and used the family's former hog pen to build his "sculpture you can live in" (Chapter 13). Cleveland Turner's exuberant yard in Houston's Third Ward celebrates his new life of sobriety in an urban setting and at the same time memorializes his Mississippi roots (Chapter 14). Vince Hannemann's Cathedral of Junk, first built as a private retreat, became a tourist attraction that celebrates Austin's idiosyncratic rebel personality

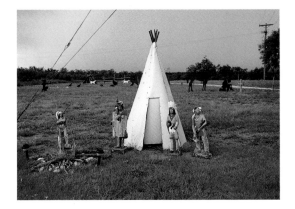

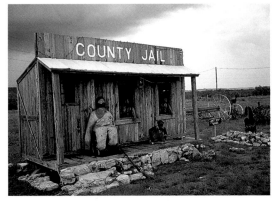

(*top left*) Miniature Indians wait outside their tepee along Highway 87 just south of Sterling City. (Photo J. Nokes)

(*top right*) A county jail is a familiar feature in an elaborate roadside frontier town scene. (Photo J. Nokes)

(*bottom left*) Traditional torch-art silhouettes decorate a ranch entrance. (Photo Pat Jasper)

(*bottom right*) A wheelbarrow from the old mine at Shafter serves as planter in Presidio. (Photo J. Nokes)

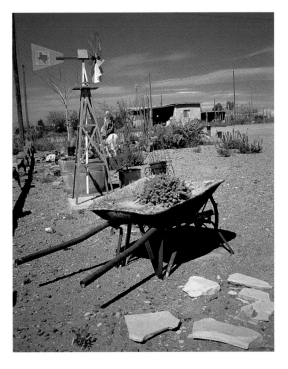

(Chapter 15). Mr. Loya lovingly and patiently built his magnificent concrete sculpture in homage to his adopted hometown of El Paso (Chapter 16). All of these places offer much to a discussion about intuitive expression, use of materials, and the artist's place in society, but the focus here is on the owner's story of living and working someplace, even if it's a different kind of world fully understood by him alone.

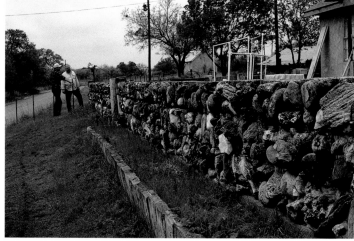

(*left*) In a harsh desert climate, a colorful wall adds to the landscape in El Paso.

Fossils, petrified wood, and other interesting rocks are part of an unusual wall in Mason County. (Photos J. Nokes)

## ENCLOSURE

Gates, walls, and fences are often the most durable garden features in a climate marked by extremes of heat, frost, and drought. Thanks to abundant geologic and human resources, Texas has an astounding variety of fences and rockwork to admire. I found that some of the best examples are in west Texas, where men who had apprenticed as stone masons in CCC camps, building state park buildings and monuments as part of the WPA projects, continued to use those same skills when they returned to their hometowns. Mexican ranch hands were often kept busy building walls, entries, and patios

### MR. CADENA'S WALL

Zoning laws that enforce a predictable conformity in the neighborhoods of many large cities do not apply to Mr. Cadena's part of town in San Angelo. As in other smaller cities in Texas, the connection to the open countryside is never very far away. Many streets simply end in a cultivated field or open pasture that is fenced with barbed wire and entered through a galvanized ranch gate. In the middle of a block of neat suburban houses, horses may be found grazing in a paddock behind the back patio. In the early morning, you can hear the wake-up call of chickens, the bleating of goats or sheep, and the tangy smell of trash and two-by-four scraps burning in a metal barrel.

Located at the end of one of these streets, Mr. Cadena's property is large and flat, occupying enough space for at least four more homes and yards. Pecan trees, hackberries, and Arizona ashes dot the bristly Bermuda grass in front of his mobile home and concrete patio. Behind the house is a larger corral with sheep, nanny goats, and kids.

There is little in the way of ornamental plants or a cultivated garden. Instead, Mr. Cadena has dedicated his attention and creativity to the stone and iron fence that encloses the front of his property.

Painted iron pickets made from rebar are encased in a stone and concrete structure. Double-stacked wagon wheels frame the main driveway entrance, and the whole entry is spanned with a rock-encrusted triple archway. Ceramic *bultos* (plaster-of-paris sculptures) of owls and eagles adorn the crest of each arch. Finials made from painted bowling balls rhythmically punctuate nearly the whole length of the wall. The mortar joints and the concrete base of another wall section have been repeatedly repainted, providing a changing color scheme that pleases Mr. Cadena.

The second entry leading to the corral also has a wagon wheel in the gate, but this time Mr. Cadena has added extra metal so that it looks like a giant spider web. This gate has a different decorative element: curving concrete forms embedded with cobblestones form the shape of a double-headed *borrego* or ram. The size, the construction, and the color all make this fence distinctive. But the most interesting part of the fence is found in the details: each small stone was especially collected by Mr. Cadena during his lifelong travels as a migrant worker.

The fence took Mr. Cadena more than thirteen years to build. He traveled as far as Minnesota to pick asparagus, sugar beets, and corn before returning to the Concho Valley to pick cotton. Along with the cotton sack, he always carried another sack to hold any special rounded stones that might catch his eye.

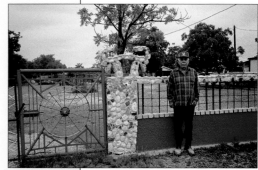

Most of the eight children in the family also worked in the fields and were recruited to gather stones, to mix the *mezcla* (mortar), and to paint when the wall was being built. Mr. Cadena knows the origin of each stone in his wall, including the ones from California and Canada sent by grandchildren.

The Cadena family came from a very remote *ranchito* in Coahuila. They were allowed to homestead on no-man's land (traditional native Mexican Indian lands), but they never legally owned the property. The older children remember gathering and sorting river gravel to mix with lime and sand to make a concrete floor. "You make your own lime, you make your own rope out of *sotol* and horsehair, you forge your own wagon wheels or fix new spokes with an axe or machete," recalls one of the sons. One of these wagon wheels is now on display in the wall, painted and framing the entrance.

The rock wall and welded fence keep Mr. Cadena's ever-growing flock of sheep from roaming the neighborhood, but they also enclose his own testimony of a life of hard work: pride of property, demonstration of different skills, and memories of the hot open fields where each stone was found.

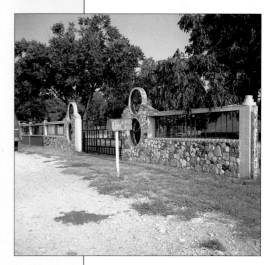

(*top*) Mr. Cadena has defined his home space with his custom-made gate and wall in San Angelo. (Photo J. Nokes)

Stones gathered from a life's work in the field are used in the wall.

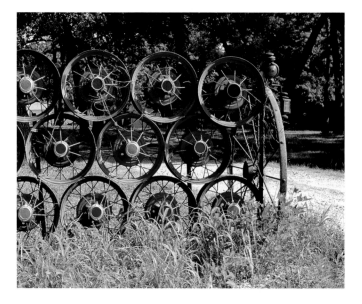

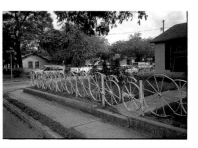

(*above*) Threshing wheels from an old combine create a fence near Boerne.

(*far right*) Wheel rims and reflectors mark an entry near Navasota.

(*right*) White wagon wheels form a fence in San Antonio. (Photos J. Nokes)

during slower work periods between harvest and sheep shearing. The availability of skilled yet inexpensive labor, plenty of rocks to work with, and a tradition of stonework continue to provide interesting walls and fences to this day. In some walls, even the stones come with stories.

Old wagon wheels and wheel rims are frequently used as accents in pipe fences, gates, and even furniture. Most elaborate metal fences seemed to be done by welders in their spare time, who had both the skill and the inspiration to transform scrap materials such as cultivator wheels or old moldboard plow parts into impressive enclosures or entries. Although the fence or wall was often the only decorative feature on a lot, because of the variety found everywhere, a whole book could be written on this element of vernacular architecture alone.

### WASH POTS AND WINDMILLS

Just as learning a new word heightens your awarenesss of it in every other paragraph you come across, when you begin to recognize certain decorative objects or materials, they suddenly seem to show up every time you turn around. We're not talking about obvious things like plastic pink flamingos or other overused consumer products. Instead, who would have guessed that miniature windmills (both old handmade ones and newer aluminum ones bought at the feed store) would outnumber the typical concrete birdbath? I had never thought about using a windmill as a sort of cowboy obelisk in my garden, but they are everywhere, both in western-theme gardens and in east Texas woodlands. The same goes for wash pots. In my limited and sanitized suburban experience, those old cast-iron vessels

looked like small cauldrons, but a friend corrected me: "That ain't no cauldron! That's a yard pot!" The wash pot was one of the most common utensils found in rural Texas before World War II.[6] It was used for everything from making soap, boiling laundry, and scalding hogs to mixing mash and frying chicharrónes. Too valuable (and also too heavy!) to throw out, many of them enjoy prominent placement in the yard as planters. These family heirlooms often serve as markers in an effort to recover remembered landscapes where important activities that involved the whole family used to take place.

Some recurrent objects reflect important regional and ethnic variations. The *nicho* or *capilla* (yard shrine) is a good example. Cynthia Vidaurri defines these as:

> *Religious folk art forms that consist of an icon—usually housed in some type of enclosure—that is placed outdoors on private property. Nichos are generally built as the result of a* promesa *(promise) made to a favorite saint [or aspect of the Blessed Mother or Jesus]. Petitions may be made for some form of intervention during a life crisis, such as debilitating illness, or having a son involved in dangerous military service. The petitioner promises to dedicate a shrine to that saint if the petition is granted. Believers take the completion of the* manda *(vow) as a serious, binding obligation. Another motivation behind the building of a* nicho *is simply to declare one's religiosity. It announces to passers-by that "this is a Catholic home" or "this home has received a miracle."*[7]

In some parts of Texas, yard shrines are also called *grutas* (grottoes), because their form is a miniature version of the larger naturalistic tableaux and pilgrimage sites found at parish churches. No matter what they are called or made from, most yard shrines are given a place of honor in the front yard. Made from concrete or

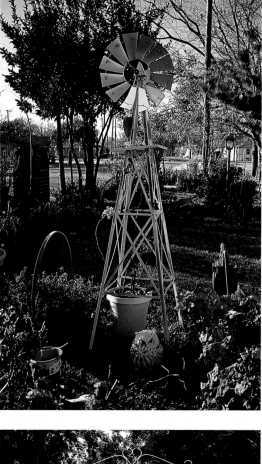

A windmill provides a focal point in a Luling garden.

(*bottom*) The old family wash pot is preserved as a planter in Denton. (Photos J. Nokes)

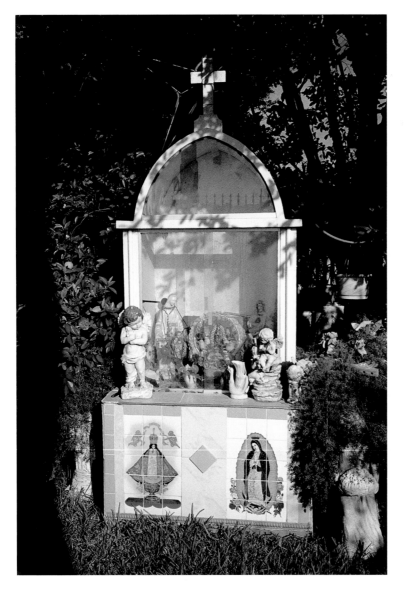

A *nicho* honors Our Lady of San Juan in a front yard in Edinburg. (Photo J. Nokes)

wood, hollowed-out stumps, or rustic rockwork, they have a recessed form that protects the principal image of a saint, Mary, or Jesus Christ. Vases filled with artificial flowers rest at the feet of the statue. Photographs, baby toys, ex-votos, scapulars, and religious prayer cards are also often added. *Nichos* are frequently set inside their own flowerbed bordered with painted or special rocks. They face the street, and some even invite devotional visits from outsiders. In yards otherwise neglected or unadorned, the *nicho* will still be lovingly tended.

### THIS 'N' THAT AND CHICKEN FAT

There is really no end to the variety of materials and objects found in vernacular gardens, but true originality always begins and ends with the way space is perceived and organized into living places. Handmade yard art has a special appeal, but many of the gardens in this book use familiar things in unexpected ways, and that's what makes them interesting. Some even see a direct kinship to fine art. Colleen Sheehy explains:

> *Like mixed media and assemblage sculpture, yard displays present familiar consumer objects, not originally meant for the yard, in new ways and in new configurations. Out of their original context, dime store dolls, toilets, etc., set in designed compositions may appear humorous or surreal. Yet these displays reveal a poetic use of objects.*[8]

The delight we experience in seeing a yard that has been decorated to the hilt, either for a holiday or as an everyday celebration of someone's space and territory, can give us a better understanding of both built and natural surroundings because we have allowed ourselves to stop, get out of the car, and become engaged.

We interact, react, remember, and become part of the poetry. We don't care if some people think yard displays are tacky, and we will ignore those who warn us, "Don't try this at home." If we haven't forgotten what hard, sweaty work feels like, we'll be able to appreciate the effort folks made to have something to show. Who knows? Maybe we'll get inspired to make something of our own. When we do, we'll be in good company. John Beardsley encourages us to try:

*These environments are the gifts of magical thinkers who recycle the waste materials and shared myths of our culture for common benefit. There is a private labor with a public aim: to find an extraordinary way to share their convictions with the world. It is consequently not to be dismissed as some form of crazy behavior, but embraced instead as a positive challenge to both our artistic and our social norms—to the limits of tolerance—to our determination to construct a more democratic culture, and to our capacity to acknowledge the marvelous.*[9]

Jesús Zertuche and daughter Alicia
Coleman pose in front of their
waterfall.

# Cascada de Piedra Pinta

Pulliam Street is a broad, open thoroughfare in the middle of San Angelo, empty of overhanging trees or impressive houses. One house, though, partially screened by shrubs and trees, is an exception. Its yard is enclosed by a low stone wall with iron pickets, including a handsome archway that frames the baby-blue concrete entry walkway. The stonework is distinctive because the bleached white limestone has been offset in dramatic contrast by black masonry mortar joints. Tall pecan and Arizona cypress trees, Mediterranean fan palms, and Ashe and alligator juniper trees fill the enclosure. On the curb, a row of sotols (*Dasylirion wheeleri*) with tall, spearlike bloom stalks are lined in a row. Behind the fence and shrubbery, the simple wooden frame house has also been meticulously clad in the same theme of white limestone with black seams.

It's only when you slow down and look closely that you see the main feature of the front yard: a towering twenty-foot waterfall made from native white limestone and boulders, again outlined with black mortar. This fantastic construction is decorated with signs in both English and Spanish and accented with darker-colored chert limestone. At the summit of the waterfall perches an assortment of limestone rocks in the shape of various animals. Adding to the menagerie of stone animal forms, long, twisted roots from the Ashe juniper have been transformed with bright enamel paint into snakes and dragons. This fabulous display completely fills one half of the front yard. Water flows energetically over three tiers of splash rocks, ending in a blue plastered pool that is illuminated at night by colored lights. In the center of the pool, a fountain rotates while tossing streams of water. On one side, the traditional though controversial "little black fishing boy" statuette patiently drops his line in the pool. Above him in a shallow niche a black plaster panther with glittering ruby-red glass eyes watches as though preparing to pounce. Amid this collection of animal forms and painted roots, a sign announces the name of this marvelous creation: "Cascada de Piedra Pinta."

The Cascada de Piedra Pinta (Waterfall of the Painted Rock) is the creation of Mr. Jesús Zertuche. It is both a monument representing his life's work and a gift to his street and neighbors. With the same meticu-

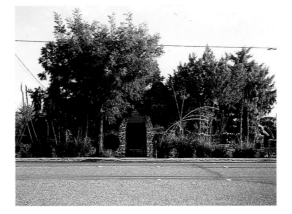

The Zertuche home is barely visible from the street.

25

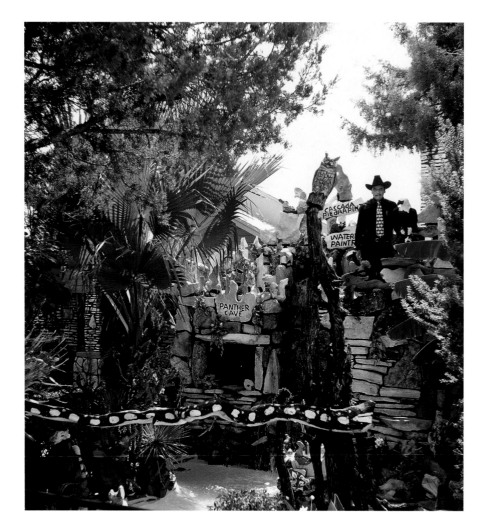

The waterfall springs from a lifetime's collection of interesting rocks and wood.

Jesús was born in Allende, Coahuila, a border state in northern Mexico. He worked in the army there as an instructor and later was hired by O. C. Fisher, the former U.S. congressman who served this west Texas district for thirty-one years. Mr. Fisher helped Jesús get his immigration papers and bring his family to Texas. Jesús worked on the Fishers' ranch near Junction, Texas, for twenty-four years before moving to San Angelo in 1979. There he worked in a foundry and later in a Western Auto store.

Accustomed to the hard work and long days as chief vaquero and ranch hand for Mr. Fisher, Jesús energetically began the long-term project of cladding his new city residence in limestone. Every day after work, from 5 to 10 P.M. during the warm seasons, he slowly added stone to the outside of the house. Eventually in 2000 he built the wall and entry archway. All the stone was hand-gathered in the country, and like many a skilled and capable ranch hand, his knowledge of masonry was picked up during his days on the ranch.

When he retired, he and his wife made plans to build a waterfall with wading pool in the back yard, where Mrs. Zertuche could take a private dip to cool off during the scorching San Angelo summers. Sadly, though, his wife died before he could accomplish this task. Instead of abandoning their dream altogether, Jesús decided to build something on a grander scale, more a monument than a functioning pool, and he placed it on display in the front yard. When asked where he got the idea for making such an elaborate work, he replied,

lous attention to detail and delight in dramatic gestures expressed in his waterfall, Mr. Zertuche greets visitors who come to admire his amazing accomplishment elegantly attired in a dress suit, hat, tie, and color-coordinated handkerchief. With his shoes polished to a bright shine, he is dapper in every way.

*I thought of making something like it, and I made it without having seen anything like it. A friend from Puerto Rico who came by while I was working said, "Where did you get the design for such a thing?" I said, "There is no other thing just like it; it's my idea."*

Though the waterfall and wall were the first large decorative yard projects he undertook, Jesús remembers that his grandmother told him that his grandfather was always picking up and collecting rocks. "Just like me," he recalled, smiling. He also remembers a small built *cerrito*, or hill, in the middle of his grandmother's garden in Mexico that was decorated with interesting rocks and plants. Later, he made a similar mound for his own family when they lived on the ranch. In his living room hangs a precious black and white photograph of his children posed formally in the bare dirt in the yard of their remote ranch house on the London road eighteen miles outside of Junction. In the background, you can barely make out the little *cerrito* shaped like a miniature mountain and arranged with interesting rocks picked up around the ranch. Obviously Jesús is a mound builder like his grandfather, and this was one of Jesús's earliest attempts at an idealized reflection of the natural world that surrounded him.

Jesús offers an example of some of the inspiration for the shape and form of the waterfall. "Now where the panther is, in Comstock [Texas], there was an arroyo, and a cave they called Panther Cave because a huge rock fell into the canyon making this cave, and they said a panther was seen hiding in there." Explaining the scheme for his patterning of colored rocks against plain white limestone, he tells us,

*In Mexico, an uncle of mine had a ranch where you can see rocks of painted colors like this, and they called the ranch Piedra Pinta, and so because of that I put "Cascada de Piedra Pinta" [on a sign] there. Also close to San Angelo there's a place called Paint Rock [a famous Native American pictograph site in Concho County], so I wrote that in English below. I did all this, little by little.*

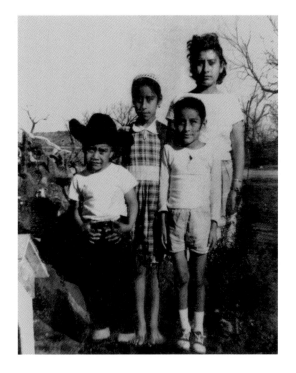

Jesús Zertuche's children pose near one of his earliest creations, a *cerrito*, or miniature mountain. (Photo courtesy of Zertuche family)

Jesús enjoys pointing out all the animal forms perched on top and on ledges of the waterfall. Collecting rocks with interesting shapes began as a game on the ranch while riding around caring for the livestock, mending fences, and other ranch chores. The waterfall provided a special place to display his varied collection. The collection includes pelicans, bears, owls, elephants, dogs, a toucan, and even a chupacabra (the goat sucker), the sinister mythical legend especially popular in border lore a few years ago. Other special rocks from his collection were used to make an elaborately decorated fireplace and chimney in the living room of the house.

Mature trees and well-tended greenery surround the cascada and provide much-needed shade to the front of

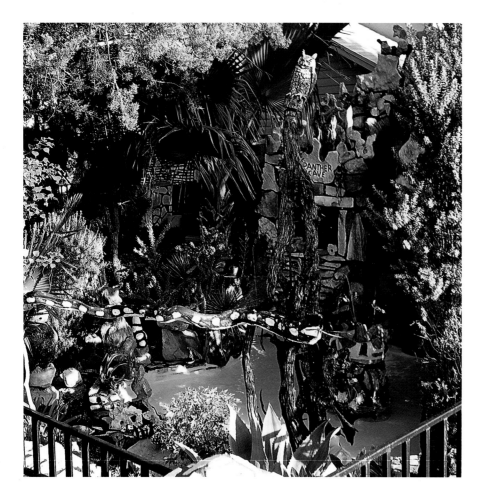

It took him just three years to complete the waterfall, archway, and front fence. Although extra limestone is carefully stacked into a five-foot cairn in the back yard, Jesús claims that he doesn't really have plans for another project. It seems for now that after completing his house and the extraordinary waterfall in the front yard, he has arrived at a point of satisfaction with his worldly achievements. Though retired, he devotes six days a week to his ministry as a Jehovah's Witness, which he describes as his "real work." Jesús is also a prolific composer of *corridos* (ballads)—425 of them, written down in two well-thumbed spiral notebooks. He even wrote a song about his waterfall.

### CORRIDO DE CASCADA DE PIEDRA PINTA

With experiences acquired over a lifetime as an all-around ranch hand and vaquero, Mr. Jesús Zertuche very deliberately collected and arranged an interesting variety of materials to make a unique creation in homage to the natural world that defined his life for so many years. In building his cascada, he used the skills that were so valued in his workplace, especially the rugged improvisational abilities that made use of whatever resources were at hand. In those days, almost every task was tied to the land in some way. The weather, the soil and rocks, the plants and animals—these were the qualities reflected in the landscape that shaped the rhythm and pattern of his life.

It is not just the natural features—the rocks, plants, *lomitas* (bluffs), and *cuevitas* (caves)—that he memorializes in his creations. His work also recalls the stories of the original places and their evocative names, and the equipment and ranch implements that were used to shape and alter the landscape his waterfall idealizes.

Exploring Jesús Zertuche's front yard and all it holds is like reading a map that represents the personal

The Cascada de Piedra Pinta memorializes a lifetime spent working on a ranch.

the house. "After working on the ranch, he was missing the Nature. That's why he was planting things so he wouldn't be missing the ranch so much," explains his daughter Alicia. Jesús adds: "When I came here, there was nothing in the yard. I planted cedars, bananas, palms." Many of the mature trees and shrubs like cenizo (*Leucophyllum frutescens*) were dug from the countryside and transplanted to his yard.

geography of his life. The map's legend is revealed when he talks about the six-foot snake made from old roots found on the ranch, when he explains the origins of the cascada's name, and when he describes where he originally dug the plant that now thrives in his city garden. Here he is gathering up a whole lifetime of experiences and their associations with place into his special monument. Jesús uses this map as a guide through memories to trace the story of his family during those years and his achievements in a harsh and unforgiving landscape, only made possible through acceptance and steady hard work. As someone looking back on his life with a significant measure of satisfaction, he shares the waterfall with all who care to stop and look as homage to his wife, his Lord, and his life. This is asserted in the *corrido* he wrote especially to celebrate his creation, "La Cascada de Piedra Pinta."

> *Las piedras que he puesto, solo Jehová Dios las hizo,*
> *hace mucho tiempo antes el paraíso.*
> *Nosotros los humanos, solo hacemos una imitación de*
> *todo lo que Dios ha hecho, en su creación.*

> *[The rocks that I have put here, only Jehovah God*
> *made them, long ago before he made paradise.*
> *We humans can only make an imitation of everything*
> *that God has made in his creation.]*

Paul Schliesing welcomes visitors
to his garden.

# A Natural and Peaceful Spirit

The Colorado River flows right through the middle of Austin, though by the time it makes a wide curve past downtown it has been tamed by a series of dams and renamed Town Lake. Today, the crowded popularity of the Town Lake hike and bike trail, the rowing clubs, and the luxury shoreline hotels make it hard to believe that until relatively recently the city virtually turned its back on the river, focusing its gaze instead on the handsome State Capitol dome twelve blocks to the north. At the south end of Congress Avenue, gravel-mining pits continued to operate on the shore into the 1960s, and the river served more as a general conduit for storm water runoff and industrial waste than as a scenic amenity. The development and enhancement of what is now surely one of Austin's most visible assets was only dimly imagined back then.

Likewise, the complex system of streams and watersheds that feed this beautiful river were also often overlooked or considered undesirable. Yet historically these flood-prone creeks have shaped neighborhoods, determined roadways, and created pockets of irregular settlement that are some of the most interesting to be found. All this has changed now, as the days when natural features limited development are over. Many creekside lots once considered too steep or too risky for building have been appropriated as prime real estate for condos and houses built on steel piers or high concrete footings. The once unbuildable ground plane is now promoted as a greenbelt amenity. In some places, the creek itself has been channeled into what engineers, with their own form of poetic terminology, call wet ponds (stormwater retention ponds) or into huge underground culverts.

### BOULDIN CREEK GREENBELT

On Paul Schliesing's street, Bouldin Creek is still the secret jewel of the neighborhood. Years ago the city converted pieces of this watershed into the Bouldin Creek Greenbelt, a loose necklace of pocket parks, easements, backyard habitats, and leftover slivers of land that wend their way through the short crooked streets. The streets themselves mimic the creek in the way they curve, dead-end, and double back on themselves. At the corner of Paul's street, little Bouldin Creek Park is maintained by the neighborhood, not the city. Picnic tables rest beneath huge gnarled and shaggy live oaks, and weeds are kept at bay with neatly mulched flowerbeds. Half a block down from the park a yellow sign with an arrow signals that the street is making a sharp curve, following the steep limestone bluff opposite that was carved by the creek. It's at this bend in the narrow road that you discover the entrance to Paul's woodland garden.

### IF STONES COULD SPEAK

You can't really see Paul's house from the street. Instead, what first draws your attention is the long curving space between the curb and the chain-link fence

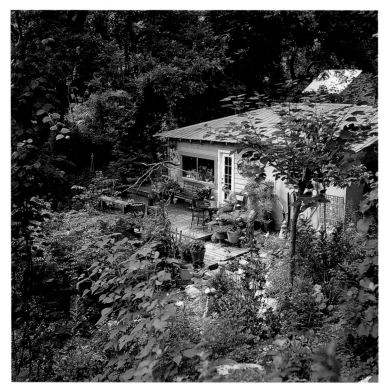

(*left*) Downhill from the street, Paul's house nestles next to Bouldin Creek.

Decks and ponds surround the cabin.

with its careful and deliberate arrangement of rocks, plants, stumps, driftwood, and fossils. Towers of smooth rounded stones are stacked, totemlike, among the plants. Up-ended stumps with interesting shapes are used as sculptural elements among native plants as well as exotic ornamentals such as discount-store cycads, palms, pansies, and fragrant osmanthus. Above, tall shin oaks, hackberries, and live oaks bend over the street. Drawing closer to examine this display reveals detail upon detail, not only in the collection of smaller objects such as rocks with interesting shapes, curved pieces of ammonites, shells, and bent twigs but also in messages spelled out with small stones. Using rounded rocks with

holes reminiscent of the pasta letters in alphabet soup, Paul has spelled his name and address on the curb, as well as other messages and admonitions: "Pray for Peace," "Pray for Leaders."

In the center of this curbside public garden is the gate that leads to Paul's home and property, set well below street grade. The gate itself is just a typical chain-link fence, but it has been transformed by fantastically twisted branches and roots woven into an archway framing the steep staircase. It's only when you stand at the gate and look down that you can see Paul's small coral and turquoise-colored concrete block cabin at the bottom of the hillside that faces Bouldin Creek

and the high limestone bluff on the opposite side. On a wooden bench next to the house, the visitor is quietly greeted with a haiku carefully spelled out with the alphabet stones: "The world of dew is the world of dew, and yet and yet."

A deck surrounds the house and overlooks a series of ponds made from plastic stock tanks nestled among limestone boulders so that they resemble more of a seep or spring than a man-made water feature. Behind the house is a large fire pit with seats made from stumps and old logs, and there's a work area where Paul assembles various sculpture pieces from organic materials.

## A WILD JUNGLE

Paul's large, irregular lot is filled with the kind of plants that make up a typical flood-scoured urban riparian habitat: a combination of native trees such as live oak, hackberries, and cedar elms and invasive plants like ligustrum, chinaberry, bamboo, and Chinese photinia. Below, an ocean of English ivy flows beneath several stump and mobile sculptures, standing stones, and other organic compositions Paul has positioned to be on view from the deck. In the spring before the vegetation really takes over, you can best see the evidence of Paul's work: the endless series of rock trails, terraces, stone benches, and grottoes that he has built into the hillside. These installations in all their different stages and materials best demonstrate the special nature of Paul's garden. Like seasonal change or the unpredictable rearrangement brought on by flooding, it is a scene where process, not product, is most apparent. The activity in Paul's garden is driven by the pleasure he receives from exploring and hiking in natural places, finding materials with interesting shapes or qualities, and then working with nature to shape his property to both reveal more of its beauty and display his found treasures.

Alphabet rocks spell out Paul's address.

*I think that my yard is a special place and I'm just really blessed to live here, and I love it for being natural. Even though I seem to be compulsive about creating things, I tend to stay in the natural genre, so that it will still have a natural or peaceful spirit about it. When I first moved here, it was a wild jungle . . . you couldn't even see that there was a cliff back there. [The previous owners] had cut down lots of trees and then just piled them up in the hidden places. You couldn't walk anywhere without tripping over something. And so my first big focus for years was just cleaning up and trying to get rid of poison ivy.*

Mother Nature initiated other changes in Paul's garden over the next few years through a series of windstorms and droughts that felled several of the larger hackberry and chinaberry trees that had once dominated the hillside. After they were removed, the sun and open space they revealed provided Paul with an opportunity to begin his trail and terrace building, and to introduce new plants. The site was changing, and Paul was working with that change, responding and cocreating with nature.

Paul has gathered each stone used in his staircases and grottoes.

Actually, much of Paul's collaboration with Nature occurs off-site. A mathematics instructor at St. Edward's University and Austin Community College, Paul enjoys roaming the vast Barton Creek Greenbelt and wooded areas around Lake Travis with his black and white dog Ruby. The creeks, woods, and rugged cliffs of these areas are important restorative places for Paul. With the same commitment some people make to playing tennis or jogging, Paul regularly dedicates a significant portion of his free time to wandering in these out-of-the-way places, and it's also where he finds the materials that make his own garden special.

### ELEVEN DIMENSIONS OF THE UNIVERSE

Reluctantly Paul tries to put into words what this kind of intuitive roaming in natural settings means to him. "When I go into the creek bed I get this elevated feeling." About just what he looks for when he's out there, he explains,

*I end up with these elements, and then I try to figure out how to put them together. I see a stone I like, and at some point it becomes connected with another one, and I put them together. I like to compose. And edit. I think those are my best skills. I'm editing a collection of objects I brought home, composing them around. Of course, they're beautiful in themselves, and I like to display them.*

Both in his garden and on his hikes, it's important to Paul that his actions not be intrusive or insensitive. He has rules to guide his gathering and selection of rocks: he never takes singular rocks, only rocks from piles, from the creek bed itself, not one that might be presenting a sculptural quality in the woods by itself. "To me, that would be changing the potential energy by moving them," Paul explains.

*I'm just taking rocks from the creek beds where there's jumbled piles of them because somehow it seems intrusive to take a stone that's in a certain place that has this relationship with the plants and the little spiders and lizards and so on.*

To someone just getting acquainted with Paul's garden, it can be difficult to realize the full meaning of this

comment. *Almost every stone, big or small, has been selected individually and brought into his garden.* Its original position in the natural world has been noted and appreciated, and its placement in the new environment of his garden has been anticipated.

*Sometimes there's just something about that particular rock that appeals to me. Sometimes I have specific things I'm trying to find, like a particular letter I'm looking for to say something. For a while I collected rocks with holes in them.*

Other qualities Paul searches for include a certain round form with a divot on the bottom that makes rocks good for stacking, or pointed ones that could be pleasing when placed on top of a weathered stump. Paul has other restrictions for using rocks:

*I don't change stones. I don't glue them, and I don't drill them, mortar them, or chip them. I don't want to make permanent changes in something that was doing so well by itself.*

Wood is also an important material for Paul, the more aged and gnarled the better. He will go to extraordinary lengths to retrieve a stump he feels has a special quality. Paul recalls one example:

*There was this beautiful cedar stump; I guess it was on its way down Barton Creek and had been weathering a while. It was all smooth and I just had to have it. The creek was flowing at that point, so I had to get it then [it was winter], and yet it was way too heavy to carry. So I had to get a wet suit and float it a number of miles down the creek until I could get it to a place where I could access it on a little trail. A kind jogger helped me carry it out. I was so cold! I turned bright, bright red.*

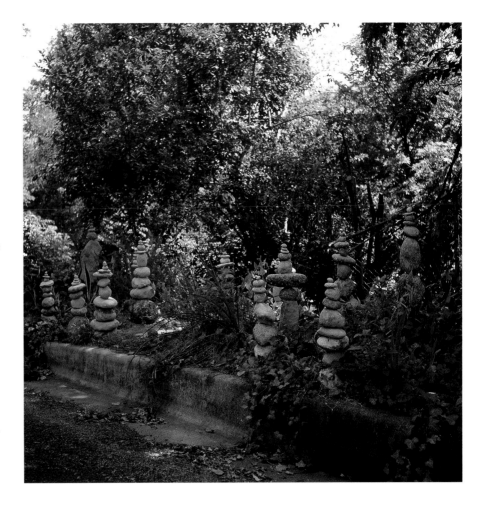

### A RIM GARDEN FOR THE NEIGHBORS

In Paul's mind, the garden is divided into two separate areas. The rim or curbside garden is open to the public and is more of an intentional display. Below is the private realm where he and Ruby enjoy working on projects or hanging around the bonfire. "People really do get a kick out of bringing their kids here, so I make things for people to look at." After September 11, he

A curbside rim garden of stacked stones invites neighborhood collaboration.

made twin towers out of stacked river cobble. The two towers grew to nine, then eleven. Over time, though, Paul wearied of restacking them as they inevitably got knocked over by a dog or a child, but when the neighbors noticed that the towers weren't being restacked, they took over the job. Paul also provides plenty of stone letters so pedestrians can leave their own messages. Like other generous place makers, Paul has set something in motion here that inspires the participation of others.

Paul's woodland garden is different from purist native plant gardens in both specific and ineffable ways. While extremely sensitive to and inspired by the natural landscape, he is not attempting to recreate a habitat or restore an ecosystem. His plant palette is not restricted to native plants, though in an unsystematic way he seeks to introduce to his hillside many of the plants he recognizes from his walks along Barton Creek. His garden is about his relationship to the natural world, and also about his relationship to his neighborhood. The upper curbside garden is his social gesture, the lower grounds his own piece of gently modified nature, arranged and rearranged, responded to, nurtured and encouraged, and most of all enjoyed.

# Little by Little, He's Been Blessing Us

Once one of the earliest settlements in Texas, San Marcos is now part of a chain of small towns that link Austin and San Antonio into one huge urban corridor along Interstate Highway 35. Despite the relentless thrust of urban sprawl, San Marcos has retained a lot of small-town charm, thanks to the picturesque spring-fed San Marcos River flowing through it and the many intact old neighborhoods that still surround the historic courthouse square.

As early as 1755, and again in 1808, the Spanish attempted to colonize San Marcos; repeated flooding on the river and frequent raids by Tonkawa and Comanche Indians eventually discouraged the last of these efforts. But by the 1840s, San Marcos had become a stable center of ranching and commerce, controlled by the recently arrived Anglo settlers.

Even if one is unaware of these larger historical themes, it's interesting to consider how in certain places the old stories still seem to pulse and beat through the generations, revealing themselves not so much in documents and deeds, proclamations and institutions, but in the private stories and struggles of those people who call it home.

To someone making her way through the old low-lying neighborhoods in San Marcos, it would not be obvious that the brightly colored home of Ruben and Irma Gutierrez is a reflection of the old historical narrative. At first glance, the house appears to be an especially lively example of a classic Latino cottage garden. Situated on a corner lot, their simple board-and-batten house is painted in a vivid yellow and turquoise color scheme, as if to match the colors of the blooming angel's trumpet (*Brugmansia suaveolens*), jimson weed (*Datura wrightii* syn. *meteloides*), heirloom roses, and impatiens flourishing in the yard. Cherry-red tire planters full of bachelor's buttons (*Gomphrena globosa*) and purple heart (*Tradescantia pallida*) add to the vibrant display, which seems almost to glow beneath the pecan and oak trees. The small front yard is neatly bordered with a picket fence, and inside, the yard is swept clean to make way for the familiar assortment of pots, washtubs, and other recycled containers that now serve as planters.

Along the fence and the side of the house, shrubs are neatly sheared, and the flowerbeds are edged with large, interesting pieces of petrified wood and karst, or honeycomb limestone. The large back yard is in full view from the narrow side lane. The carport is decorated with an assortment of antique tools, old farm equipment, and homemade signs that read "Comanche Gap" and "Apache Gorge." Piles of what at first look like rubble rocks but are later revealed as carefully selected pieces of chert artifacts from archaic indigenous tribes are combined with the chips and pieces left over from flint-knapping to serve as neat borders for the flowerbeds. A mowed lawn under large pecan trees and ligustrum shrubs leads to an unusual focal point: a dark red concrete thunderbird embedded with arrowheads that rises from a pedestal ringed by larger rocks.

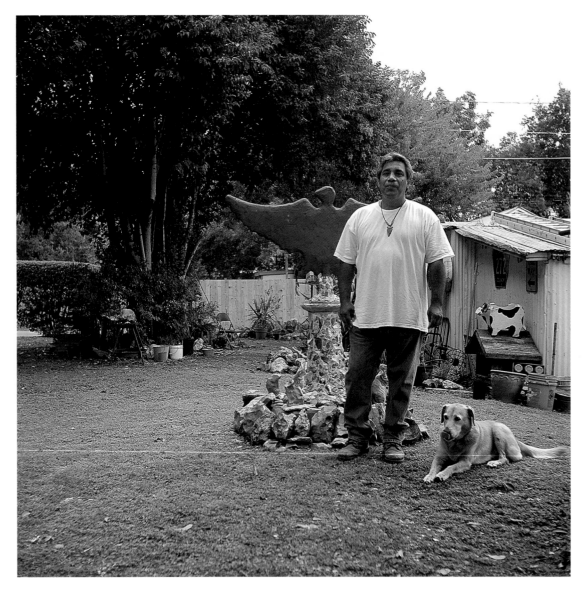

A thunderbird statue is the center-
piece of Ruben Gutierrez's back
yard.

## A GARDEN WITH DEEP ROOTS IN HISTORY

Ruben and his family have always lived in San Marcos and, more specifically, in the Dunbar neighborhood. In fact, his wife Irma's family lived on the same street for more than 120 years. Ruben's own grandparents lived to be 100 years old, continuously residing among the same streets. The name of the neighborhood comes from the Dunbar School, built for African-American children. Although black residents were historically concentrated in this area, they have always been mixed with Mexican Americans. Until third grade, Ruben himself was sent to a segregated school for children of Mexican descent. "It's been a close, tight-knit community as far as the Mexican people are concerned, and for the blacks as well," explains Ruben.

Ruben's grandfather was born in San Marcos, but his grandmother came from the state of Guanajuato, Mexico. Only late in her life, as Ruben began to explore the indigenous Mexican Indian part of his ancestry, did she tell him that she was part of the large group of Indians called Chichimecan. "For many years she harbored what she felt and kept it to herself. My aunts were amazed when I started asking these questions [about Indian ancestry]," remembers Ruben. "They had no idea. No one in the family who had any knowledge would speak to us about it. As a result, we lost all that history and information."

Times were not easy for the family on this side of the border, either. Ruben explains,

*A lot of the time we had to move with the economy and so forth, but a lot of it was forced upon us through political trickery and things like that, and my grandparents lost their property. There were many floods here at one time. In nineteen seventy and seventy-one, we had two great floods back to back here in San Marcos. We*

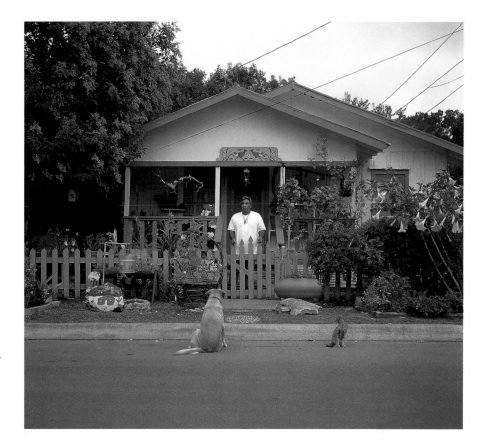

*were living on McGee Street next to the river. It was amazing that we had up to twenty individuals living in a house [so small] at that time. But because of the flood they [city officials] said it was condemned and they were never going to build any more in that area. They said they were going to build parks, but they didn't say what kind of parks, and now it's a business park. That's how my grandmother and grandfather lost land. There were many other Mexican families [who lost their land] as well—cousins, uncles. Everyone was family in that community.*

The Gutierrez home beautifies and inspires the neighborhood.

Rock shards and artifacts line the flowerbeds.

As a child in this small central Texas town, Ruben encountered discrimination and poverty as part of everyday life.

*We go to the San Marcos River, right on our river-banks, and they had a little resort there, right on the waterfall, for white people. And we couldn't swim there, or in that area. But sometimes we used to sneak in there and go for the crawfish, and I mean crawfish were crawling everywhere! We'd go in there just to try to get some bait or, you know, to try and catch us a big old crawfish, and they would shoot at us. Yeah, this was 1957, '58, and '60. But I've come to an understanding now of why things are this way, why they are that way. You tend to be angry at the beginning, but then you see laws changing for the better, even if it's just on the surface. Even if there is still racism, at least there are laws on the books that protect people, everybody, not just Mexicans.*

Ruben's narrative about his own life is interwoven with sophisticated and subtle references to Darwin, Nebuchadnezzar, archeology, geology, and art history,

so it's a surprise to learn that he only made it to the sixth grade. Later, he was drafted and sent to Vietnam. It was there that he experienced the first of what he describes as awakenings. In this chapter of his life, Ruben—the poor kid from the wrong side of the tracks—was introduced to the idea that his identity and his heritage have real value.

*When I went to Vietnam in 1970, I came across white people, draftees, who were mostly really set against the war . . . and these guys began to open my eyes and they began to pose questions I had never heard before. Never, in my whole life, had I heard a white man questioning the strategies or behavior of another white man. It was like the epiphany that just comes about and says, "Wow! What are these guys talking about? I thought all whites hated us." And then I learned from these guys that it's just not true.*

Ruben's interaction with white soldiers, combined with the emotional horrors of serving in Vietnam, were the beginnings of a lifelong desire for greater self-awareness and purpose.

*I was just trying to find out who I am. All the problems I was having and going through in life, trying to find answers. Why does this person have it better than that person? Why is there so much discrimination? Because I'm seeing it firsthand, I'm experiencing it firsthand, and I want to know. Why is God showing favoritism there and not over here?*

After he left the army, Ruben got his GED and attended Texas State University. He was finally exploring his potential, but it still wasn't easy. "Yeah, you could point to discrimination and racism, and a lot of that

leads to drugs, alcohol, and maladaptive behavior, and that can get you into serious trouble with the law," continues Ruben.

*And that's where I come from. I had to make a change. I had enough problems with the law over my hostility, about this and about that, and I said, You know what? I'm going to change my life, because it's never going to end, never. And if I can make a change in anybody for the better, I'm going to let them see what I'm doing, and that there is a better way of life, and you can do better things with your energy than being destructive. So that's what my house and yard are about. I make statements here by bettering this little house.*

## RUBEN'S GARDEN OF BABYLON

Ruben and Irma have lived in their little house for more than twenty years, but they don't own it. They rent it from someone who keeps the rent low in exchange for repair work. Ruben's improvement efforts have expanded to some of the neighboring houses, where sagging porches and weathered wood have been painted in brighter colors and rebuilt into sturdy staircases.

Describing the transformation he and his wife have wrought on their modest house, Ruben explains,

*We started with a few plants, a few boards here and there, and we said to God, "You know what? If you help us here a little bit, we're going to do something for you. We're going to build you a garden of Babylon, like Nebuchadnezzar." So little by little He's been blessing us. Little by little.*

*You guys should have seen the house when we moved in! It was on the ground, it was falling down. There was no paint on the walls. There were rocks holding the foundation up. It was like pictures you see from way*

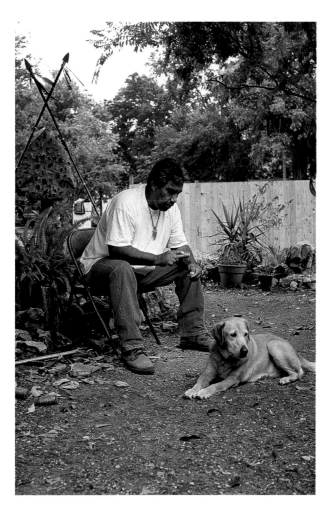

*back, like slaves' quarters. My wife does some of the painting. She chose the colors and the plants. I place the rocks. The yard revolves around aesthetics and political statements: aesthetics meaning the wife really wanted beauty over there in the front. That's what I wanted as well, and remember, the motivation was a blessing to God.*

Ruben Gutierrez thinks about the ancestors while flint-knapping.

Gutierrez arrowheads are made the traditional way.

*I'm drawn to them out of love because I can empathize with them and I can relate with all their hardships. Little did I know that what they had experienced when the conquistadores came here is exactly what I was experiencing in the 1950s.*

Ruben is convinced that paleo-Indians carved the abundant limestone in central Texas to create symbolic forms that can still be interpreted by the sensitive researcher—the one with the pure heart. He has filled his yard with careful arrangements of rocks, fossils, and other emblems, like the thunderbird totem and Maya colors for the house. In this way, the physical evidence of Ruben's search for deeper meanings in the materials the Indians left behind is on view for all to see.

Weekends are set aside as sacred times for Ruben, and he is very disciplined about regularly searching old quarries, road cuts, and construction sites for artifacts that to others look like nothing more than broken rocks. "Rocks are a connection to the Indian people," Ruben explains.

Pointing to the back yard and the Native American symbols it reflects, Ruben says, "This is the political statement over here."

### SPIRIT QUEST

About ten years ago, Ruben's continuing search for identity and meaning began to focus specifically on his Native American heritage. He started questioning his grandmother about her Native Mexican Indian ancestry, and about that same time, his wife urged him to attend the annual Native American Pow-Wow in Austin. After some initial hesitation, Ruben began to believe that knowing more about the lost pieces of his family's indigenous background might provide the answers to those deeper questions that had been on his mind for years.

*And that's how I connect with them. I pray before I go out, and I'm always in constant prayer about this. I pray and I ask the ancestors as well. I ask them to take me to those rocks that make sense; again, that goes back to the history of bad memories—Texas, for example, being the only state that either decimated, destroyed, or eradicated all its Indian peoples. They did this because they believed the Indian had no refined social skills or graces, or skills in the arts, and were therefore savages and barbarians, and they had to be eradicated and their lands taken from them. I said to myself, I have to go out there and find evidence that there was stone art.*

Ruben has amassed an impressive collection of chert, arrowheads, and spear points, as well as other kinds of rocks, during his weekend explorations. The best pieces are displayed in the house, but the little carport is as neatly arranged as a museum curator's laboratory, with materials organized and sorted by size, theme, and shape. Other rocks line the borders of flowerbeds. Ruben is intent on spreading the message he believes the ancient peoples left behind in their rock carvings.

*Even though these rocks that I'm finding are crude and abstract, you can still see that the intent and design was there. And a lot of them are not abstract. You can see clearly that some were amulets or fetishes, or represented something that they were worshiping as a religious object, and I love to go out there and collect them. And one day I'll present them to the science world.*

Many creative efforts by people are triggered by some specific event, but what distinguishes Ruben's inventive achievements these last twenty years is the intensity of the struggle that preceded the creative process. Personal difficulty, family misfortune, cultural discrimination, and the hardship of the Vietnam War have tested him mightily throughout his fifty years. Through the intentional decoration and repair of their simple cottage in a neglected part of town, Ruben and Irma stand out as a public expression of hope and perseverance. The house and all they have done in the yard represent a hard-earned declaration of personal dignity, family continuity, cultural respect, and deep spirituality. Their little plot of land provides a respite from misfortune, and states the truth that if you dare to hope, you can redeem despair.

Ruben stands on the corner, talking to visitors while looking up and down his street, the street of his grandfathers.

*It's all just replicating the same thing God's given to us. We're just borrowing from Him. I mean we can't say we're the true authors. Everything I've said, you've heard it before. Maybe you've heard a different version or a different context, but nothing is new under the sun. Everything we do, we do because it's already been done, or somebody's already set the path for us to go and finish out whatever course that was supposed to be. And I love to create just to be a part of that.*

A hand-drawn ferry crosses the
Rio Grande at Los Ebanos.
(Photo J. Nokes)

# Stories from the Valley

"The Valley"—that's what most Texans call the boot-end or southernmost tip of the state where the Rio Grande flows into the Gulf of Mexico. The complete name for this area is the Lower Rio Grande Valley, and it officially consists of four counties (Starr, Hidalgo, Willacy, and Cameron), all strung along the river from Falcon Dam to Brownsville. Removed from the state capital by a six-hour drive, to many Texans the Valley hardly seems to be part of the same state. It is often said that the border is its own country, Amexica—neither America nor Mexico. Betty Flores, mayor of Laredo, explained, "The border is not where the U.S. stops and Mexico begins but rather where the U.S. blends into Mexico." The Lower Rio Grande Valley provides both a geographical and perceptual context for exploring large ideas, such as the meaning of homeland and how borders are understood and absorbed into local and family history. Looking at the patterns of daily life here can help us understand in a less abstract way the historic cycles affecting identities, hegemonies, kinship, and land use.

Most of the Valley lies just a few degrees above the steamy Tropic of Cancer. This area has historically consisted of a complex association of very diverse, extensive habitats that evolved in response to rich river delta soils and a climate influenced by the collision of warm, humid air from the Gulf with arid, almost desert conditions on its western edge. The Valley is one of the most botanically varied ecoregions in North America,

yet torrid weather conditions and the inhospitable spiny form of many of the plants have deterred many outsiders (except intrepid birdwatchers) from either exploring or appreciating its special, if daunting, qualities.

Early exploration of the Valley by Europeans occurred in the late seventeenth century, but significant settlement didn't pick up speed until almost a hundred years later. Prosperity continued to ebb and flow in this area, with commerce and cattle ranching according to the old Spanish-Mexican model providing the economic base. The remote location and erratic hot, dry climate limited extensive agricultural exploitation until the turn of the twentieth century, when the arrival of the railroad and new irrigation technology made wide-scale farming of the rich delta land possible.

According to the U.S. Fish and Wildlife Service, of the more than four million acres of mattoral (indigenous thorn-scrub vegetation) that dominated the landscape of the Lower Rio Grande Valley only seventy years ago, less than 4 percent remains, and most of that is on small tracts. Misguided about what progress at one moment in time really meant for the long term, the U.S. Department of Agriculture provided subsidies to farmers to encourage them to bulldoze and root-plow all the brush to convert vast tracts of land to irrigated farming. Attracted by cheap land and labor and egged on by land speculators, Midwesterners began arriving by the trainful in the twenties and thirties to set up large farm operations and citrus groves. Some of the cleared land was

never farmed, however, and it didn't take long for the exposed, mostly silty and sandy soils to blow away, leaving behind barren, desertlike tracts. Today the government has allocated funds to restore a small portion of what earlier policies destroyed, by paying farmers to replant some of the edges of old agricultural fields as wildlife habitat corridors and windbreaks.

Although settlement occurred here much earlier than in other parts of the state, many of the drastic changes in land and population patterns have occurred only in the last ninety years, or less than four generations. In the early days, Mexicans and Texas Mexicans were the civic leaders. The border seemed more of a ceremonial demarcation than a rigid political frontier. Then Anglos arrived in greater numbers with their crops and citrus groves, or as winter Texans, erasing and reshaping vast tracts of the local landscape and gradually assuming political power. The border became less flexible. Today, a rising Mexican-American middle class is once again solidifying their political base, and at the same time, many farms and groves are being plowed under once again, to make way for development and manufacturing.

From the middle of flat abandoned agricultural fields now sprout marooned-looking housing developments of high-gabled brick homes that look like they could have been airlifted from north Dallas or Atlanta. Cotton, grain sorghum, and sugarcane are still important, but cheaper fruits and vegetables from Latin America make competition tough for U.S. farmers. Today's immigrants are attracted to the maquiladoras and manufacturing centers that have proliferated along both sides of the border. Instead of harvesting oranges, newly arrived workers might package frozen foods, assemble modems, or work in a paper bag factory.

What does it mean when so much of the surrounding landscape is radically modified in such drastic, sweeping cycles? Interestingly, sometimes the economic catastrophes are marked and remembered by equally disastrous spells of extreme weather. In 1983, just before the peso took a nosedive, a severe freeze killed off many of the citrus groves and left thirty-foot-tall frozen palms standing broken, dried, and forlorn along the city streets as painful symbols of everyone's hardship. Today, the displacement of vast flat tracts of former farmland with assembly plants appears to be as hasty and effortless as taking up and laying down carpet every few years. How durable are these latest changes? Will the relentless changes dilute much of the region's distinctive character?

The Valley economy may be booming, thanks partly to NAFTA, but unemployment remains high. Hidalgo and Starr counties consistently rank among the poorest in the nation. The chamber of commerce of each town eagerly promotes growth, even though water supplies are often inadequate and drought cycles frequent. Life along the border seems to be changing so fast that it's difficult to articulate what those changes mean, and yet, in many ways, the old traditions and expectations remain intact. In the next three chapters, our conversations with these gardeners from the Valley offer different but connected views on what living in this region is like within the context of their own family history.

# The Love You Have To Do It

Locals often describe Brownsville and Matamoros as one big city with a river running through the middle. Of course, the same thing has been said about other towns paired across the Rio Grande, such as Laredo and Nuevo Laredo, or Eagle Pass and Piedras Negras. But to many, Brownsville-Matamoros deserves special distinction because it's the oldest border town in Texas. Although in recent years the international border has become much less permeable, most people still regard the bridge across the Rio Grande as a familiar thoroughfare connecting them to family, work, and other activities that make frontera culture the rich and complex mix it is.

Mary Saldaña is a third generation *partera*, or midwife, having lived and practiced in Brownsville for thirty-five years. A tall, handsome woman, always beautifully coiffed and dressed, she eagerly shares the story of her lively family, her practice, and her garden that illuminates the patterns of everyday life in Brownsville, as well as other places along the border. Mary is the commanding and entertaining matriarch of the close-knit Saldaña family. A daughter, Mary Sosa, and her husband live in the house just behind Mary's corner lot. Her brother lives next door, and a son with his wife and child live in the house with Mary. Her son's neat and well-organized welding shop is attached to the back of the house. In front, a small one-car garage has been enclosed to create a clinic and birthing suite for Mary's practice. Family, neighborhood, and livelihood are all concentrated here on the corner where the Saldañas live.

## FOUR GENERATIONS OF MIDWIVES

*My grandmother was a partera in Mexico, near Matamoros. She became a midwife just to help out the neighbors. That's the way, out of tradition. My mother was a midwife, too, in Matamoros, over there and here in Brownsville. I was helping her and then I went to school here in Brownsville, and I've been a registered midwife for thirty-five years.*

Now Mary's daughter Mary Sosa is also studying to be a registered midwife while getting on-the-job training as an assistant to her mother. Mary first came to Brownsville as a teenager to study English on a student visa and later acquired U.S. citizenship. Eventually she arranged to have her parents, brother, and sister move across the border so they could all live together. Originally her mother lived next door in the house now occupied by Mary's brother. It seems it has always been important that the Saldaña family stay close together.

## FAMILY LIFE ON THE CORNER

December 2004 witnessed the rarest of phenomena for Brownsville, a white Christmas. Yards typically full of tropical foliage, even in winter, were bare and exposed. Yet this emptiness revealed one of the outstanding features of Mary's corner lot, the dramatic and detailed

Mary Saldaña greets her visitors at
the garden gate.

outlining of the layered edges of the property, the fence, the curb, and the flowerbeds. Starting at the street, the curb is painted white; farther in, additional edges in the form of white-painted scalloped concrete pavers line the sidewalk. The same white concrete edging forms circle beds around the trees, each with white-painted trunks. A chain-link fence, heavily adorned with white hanging baskets and other miscellaneous decorative objects, is set eight or nine feet back from the front sidewalk. Spare grass in front, a fringe of colorful annuals along the fence, plus a few essential shade trees like cedar elm (*Ulmus crassifolia*), *álamo* or cottonwood (*Populus deltoides*), *ébano* or Texas ebony tree (*Pithecellobium flexicaule*), pirul or Brazilian pepper tree (*Schinus terebinthifolius*), were the main plants in this sparsely cultivated area. A small back cottage, welding shop, and carport take up the entire back yard, leaving the front and side of this corner lot to be used as the family yard and garden. A large aluminum canopy connects the front house to the back and provides essential shade for the shop and for outdoor activities like cleaning fish and barbecuing. Most of the seasonal gardening takes place in narrow beds on both sides of the fence, along the front porch and side patio. The front walkway and driveway are paved in red tiles, contributing to the garden's strong red-and-white theme. A white archway frames the front walk, which passes by a large fountain on one side adorned with ceramic water-loving animals like turtles, white swans, and ducks. On the other side is a large aviary housing a menagerie of live birds, rabbits, and turtles. The red-colored driveway leading to the birthing suite annex is lined with a colorful arrangement of pots, tire planters, and statuary, including the Virgin of Guadalupe in a place of honor. It's hard to see the front door from the street, and the eye is pleasantly distracted while trying to decide what to look at first.

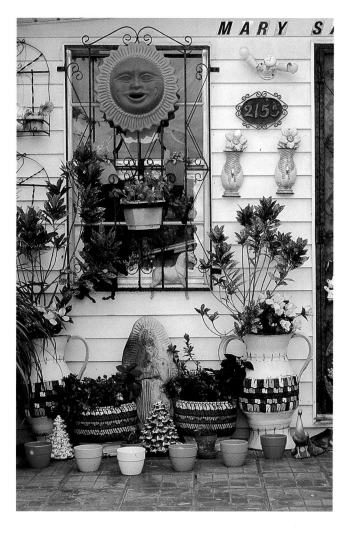

### HER MOTHER'S GARDEN

Mary's wonderfully abundant garden was created in just the last eleven years. When she bought the house, the yard was bare dirt, with no trees or plants of any kind. As with her midwifery practice, Mary learned a lot about gardening from her mother, and it was impor-

Lively containers and figurines decorate the yard.

garden. *And my mother of her own had one hundred chickens, and they made a big fence, and that was the way my mother had a beautiful garden.*

Her mother's garden consisted mostly of flowers, herbs, and a few vegetables, but beauty and decoration were emphasized above practical commodities. Neighbors admired her mother's flowers, and they approached her to sell them from time to time.

*I remember when somebody passed on out there by the ranch, they would go to somebody who has flowers to sell, to buy some flowers to take them to the funeral. And my mother would sell a little bit of her flowers. She didn't want to, she didn't like to, she didn't have that much need for the money because she loved her flowers, but still there were no flowers anywhere else, so she would sell her flowers.*

A discussion of what was growing in her mother's garden leads to a master list of those plants usually found in the typical Mexican garden. Mary Sosa is adamant:

*You* cannot *have a Mexican garden without chile pequin* /Capsicum annuum/, albaca /*basil*/, nopalitos /*prickly pear*, Opuntia *spp.*/, hierba buena /*spearmint*/, zempazuchitl /*marigold*, Tagetes *spp.*/, ruda /Ruta graveolens/, sábila /*aloe vera*/, and of *course a fig tree, for the shade. And a lemon tree, and* estafiate [Artemisia ludoviciana].

Estafiate is important to the midwife because, among its many applications, it has been used to alleviate childbirth and menstrual problems. Mary's mother's garden had a few vegetables—tomatoes, onions, chile,

(*top*) The Saldaña home adorns a corner lot.

Flea market treasures provide ornamental details.

tant to her to begin working on the garden right away. She describes her mother's garden like this:

*My mother had a beautiful garden on the ranch near Matamoros. My father had a lot of goats, so my mother had my father build a fence just for her and her huge*

and garlic, together with cilantro and epazote—the building blocks of Mexican cuisine. In Mary's garden, the ornamental plant list expands to include colorful annuals and tropical plants available at discount stores like geraniums, petunias, begonias, and bougainvillea. Hating to waste anything, Mary even plants sprouted potatoes in an extra hanging basket.

Mary's mother also passed down horticultural knowledge. To enrich or improve the soil in the garden, Mary is very specific about where to find the right ingredients.

*I don't like to buy bags of soil. I just go to the* monte *[native countryside] and get some. I go to the ebony trees; that's the best one, that's the one I have around my yard. It's natural, oh yes, it's softer. You water it, and it makes good dirt.*

Mary also uses coffee grounds and eggshells to improve the soil.

*I don't use pesticides or any kind of chemicals for my plants, I just use soap and vinegar. That's all I need to kill bugs. Rainwater is very important. I save the rainwater and then I water the plants with it. My mother would do the same thing, save whole barrels of rainwater.*

Brownsville's long torrid summers and highly chlorinated municipal water motivate Mary to continue this practice.

### THE FLEA MARKET ON SUNDAYS

Shade, fragrance, and color are obviously valued in Mary's garden, but decoration and embellishment of the garden with discarded household objects or items bought at local flea markets share an almost equal status because they involve a family activity. Every Sunday finds the Saldañas strolling through various local flea markets, where Mary keeps an eye out for the chipped or rejected object, such as a plaster of paris angel or old pot that might add a rustic element to the garden. After taking a break for lunch, they will cruise the rows again, this time maybe picking up a flowering plant or getting ideas for an iron planter her son can custom fabricate at the home shop. Another son is recruited to bring home bags of dirt, from beneath an ebony tree only. Family gatherings can take on epic proportions with the Saldañas, with the biggest celebrations often occurring at a son's ten-acre ranchito, but everyday activities are important, too. "The garden is always on our minds," says Mary Sosa. Her mother adds,

*I like to go out and smell my garden, especially when you water the garden, when you're drinking coffee, it's the most beautiful thing in the world to start the day with. The most important part of any garden is the love you have to do it. I talk to my plants. It's therapy, it's relaxation, it makes me stronger. I cannot live without my garden. I cannot!*

### INVITATION AND BLESSING

Besides creating a beautiful outdoor space for herself and her family, Mary's garden has indirectly contributed something special to the neighborhood. Mary Sosa provides an explanation.

*There was a lady who used to walk by every day. I think she was some kind of [home health care] provider. She would come down this street and then go around the corner or go straight that way. And we have a Virgin of Guadalupe [statue], and she would come and kiss Our Lady good morning, pray there, and take off. And when*

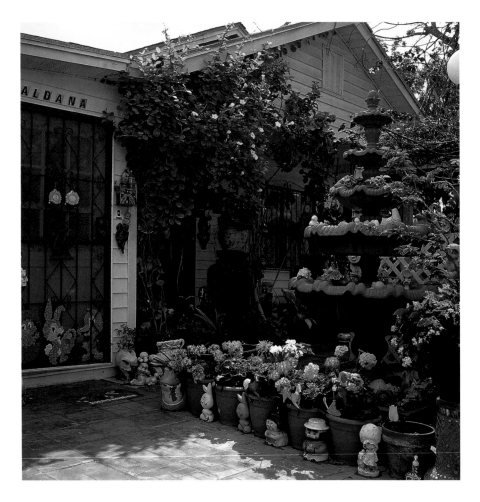

Color and decoration welcome
visitors to the birthing suite.

*she would come by in the afternoon after she got off
work, she would do the same thing—every day.*

Mary adds,

*That's what I do every day too. Every day when I go out
to walk, I say to her, "Good Morning! Thank you"—
every day! When somebody passes by and I'm working*

*there, they stop and they say they like my plants, and
now I'm inviting other people to do the same thing and
to do it better maybe.*

Near Mary's house, across from a drive-thru bank
downtown, is an old cottonwood tree that is famous for
an unusual whorl on the trunk that resembled the famil-
iar pose of the Virgin of Guadalupe. Though this phe-
nomenon occurred more than fifteen years ago, a lattice
fence with tattered ribbons, a few faded photographs,
and a lopsided kneeling bench are still in place below
the tree as witness to the crowds that used to come to
petition the Virgin. The matter-of-fact way the Sal-
dañas include this shrine on a tour of their hometown
tells us that they do not consider it unusual to find sa-
credness in public places as well as private gardens like
theirs.

Next, Mary takes us to visit her friend's garden in an
older neighborhood. Though much more humble, this
garden near the railroad tracks not far from downtown
has in one small patio many of the qualities of the kind
of Mexican garden that the Saldañas have mentioned.
In this modest setting we find the familiar expressions
of enclosure, outlook, and repose that are repeated in
countless variations on both sides of the border. It be-
gins with enclosure, in the form of a wire or wood
fence, often in combination, depending on availability
of materials and the needs of the animals. In this cli-
mate of hot, sticky weather, a breeze is more valued
than the absolute privacy and protection a thick ma-
sonry wall might provide elsewhere. What is also not as
commonly seen as one would think is citarillas, brick or
tile open-weave walls, creating a lacy enclosure that still
allows some breeze to come inside. These could be too
expensive, out of fashion, or simply not as desirable as
the chain-link or wooden picket fence. Standard six-

foot privacy fences are not common, either. More commonly seen is a four-foot chain-link fence festooned with decorative objects and hanging baskets employed to demarcate a property while still allowing a view of the street.

Inside the enclosure off the dusty street, there is deeper shade and a sensation of increased humidity from watered plants. Grass or a lawn is not common or expected. Instead, there will be flowers of all kinds growing in old cans of Costeña peppers or Alpur powdered milk, as well as hanging baskets. You'll see planters made of recycled materials like old-fashioned round washing machine agitators, tires, and rejected plumbing fixtures. There will be birds in cages, and a dog or two lying around. Kittens will just have been born under the porch. A radio will be playing somewhere inside the soothing gloom of the house, competing with the chattering of parakeets, canaries, and sparrows. The work area will be off to one side. That's where you'll find clothes drying on the line, or the table where the fish are cleaned, or the small engine repaired. A shed roof or aluminum awning may provide a protected overhang for the table and molded plastic chairs. Smells of gardenias, burning charcoal, and moist earth contrast with the dust and car exhaust of the street. Mary Sosa's must-have list of plants will be well represented, along with the popular items selected on an outing to the *pulga* (flea market), garage sale, or the Dollar Store.

Dappled light, coolness from evaporation, music and song, color and sweet aromas, especially from night-blooming flowers and *comida*, chairs and tables set outside—all combine in basic, elemental, and eternal ways to make a garden characteristically Mexican. The ancient Mexicans described these qualities in two words, "Xochitl y Cuicatl," "flower and sung poetry." Fr. Virgil Elizondo[1] explains:

*Since poetry originates from the divinity itself, then it too will be everlasting. In some mysterious way, poetry is perennial and indestructible. Although earthly flowers perish, when related to song, they are considered the symbol of beauty, and thus poetry, flowers, and music form the core of poetic expression and as such they are everlasting. The most famous poet-king of ancient Mexico wrote:*

> My flowers shall not cease to live:
> my songs shall never end:
> I, a singer, intone them;
> they become scattered, they are spread about.

Many of the old ways, the old roads, crossings, and livelihoods have become scattered and lost along the border, but it is still possible to find small special places on both sides of the river where a special kind of beauty is preserved and enjoyed. The Saldañas invite you to enjoy it with them.

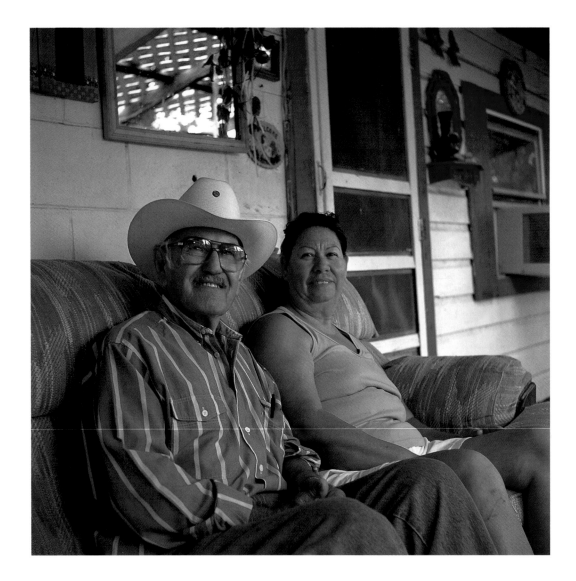

Mr. and Mrs. Villalón enjoy the
breeze on their *corredor*.

# Placenames and Family

Following the Old Military Road is a good way to explore many older communities lying close to the Rio Grande. First laid out by General Zachary Taylor during the Mexican War in 1846, the Military Road served as a supply route between Fort Brown in Brownsville and Fort Ringgold in Rio Grande City, about 100 miles away. Today this well-known route (now shadowed by the modern Highway 83), links together villages where some descendants of the original recipients of *porciones*, or Spanish land grants, still live on the remnant parcels of their family's legacy. Many of these places are named after a natural feature (that may no longer exist), such as Granjeno (spiny hackberry), Las Grullas (the cranes), Cuevitas (little caves), and Los Ebanos (the ebony trees).

Perhaps the best known of these little towns is Los Ebanos, the site of an ancient Indian river crossing, where today can be found the only government-licensed hand-pulled ferry on a United States international boundary. The difference between this low-key international crossing and the intense confusion experienced at other border bridges could not be greater. At Brownsville, a steady line of sweaty package-laden pedestrians has to endure the ferocious noise of nose-to-bumper eighteen-wheelers along with the view of heat rippling off car hoods. But at Los Ebanos, you might see two or three Border Patrol officers enjoying a desultory game of cards beneath one of the famous ebony trees, while their drug-sniffing dog dreams in his

sleep in the dirt beside them. Below the INS office at the bottom of a gravel slope, the ferry is tied to the landing with thick, furry ropes. This unlikely vessel is a simple wooden raft with room for only three cars laid end to end, and a handful of passengers. The ferry, outfitted with used-tire bumpers, is attached to a cable strung across the river that seems to serve more as a tether to keep from losing the raft downstream during times of high water than a means to haul it hand over hand to the other side. Another large rope is attached to a second line, and four or five men stand ready to pull the ferry across. A boom box wired to the wooden side rail plays corridos that blend with the bleats of nanny goats and kids streaming through a stand of carrizo reeds on the opposite shore, completing the soundtrack for this scene out of time.

Bewildered snowbirds (winter tourists from the Midwest) are further confounded after riding the ferry when they realize there is no town or much of anything on the Mexican side.

The town, Gustavo Díaz Ordaz (population 12,000 plus), is still three or four miles away from the landing. Like so much of the surrounding landscape, the original names of many places have been erased and rewritten. Díaz Ordaz, named to honor the president who served Mexico from 1964 to 1970, was originally called San Miguel de Camargo. An even earlier name for the town was San Miguel de las Cuevas (Saint Michael of the Caves), which matches up with an early recorded

The Cuevitas Cemetery is lovingly cared for by Mrs. Villalón.

name for Los Ebanos, "Cuevas Crossing." The explanation for these placenames and the mysterious unseen caves is tied up in the tangled skeins of kinship ties, memories, and binational patrimony of the older settlers. Another piece in this puzzle, the present-day village of Cuevitas (Little Caves, population 37), waits just a few miles upriver.

### CUEVITAS CEMETERY

There's not much traffic going through Cuevitas, and not much reason to stop either, unless you live there. There are no stores, churches, or gas stations. Half a block off the main road, however, is a well-tended cemetery with a metal arch entry gate that announces, "Cuevitas Cemetery 1915." Attached to the surrounding chain-link fence are dozens of red and white *moños* (bows) and ribbons. It's evident that the *campo santo* (cemetery) is still actively used, for the bare dirt is swept clean, and most of the grave markers are honored with colorful arrangements of plastic flowers or more bows. The way this humble cemetery, whose population at rest far exceeds the living residents of the town, is so lovingly tended reveals that it is valued as a homecoming burial ground by people who may not live there but still feel a tie to the community.

Back on the main road through the village, one house stands out from the others by its lively color scheme and decoration. A closer look reveals certain similarities suggesting that the same hand caring for the burial ground is also at work here. A freshly painted white picket fence borders the road and encloses the bare swept yard inside. Large Texas and U.S. flags are proudly on display, part of the strong red and white color scheme that is carried throughout the yard, including the low, one-story concrete-block house, peppermint-painted picnic tables, and child's swing set. Landscaping outside the fence includes mature specimens of native plants such as Spanish dagger yucca (*Yucca treculeana*), a honey mesquite tree (*Prosopis glandulosa*), and a nopal cactus (*Opuntia* spp.) loaded with butterscotch-colored flowers. Inside the fence, a huge billowing elm tree (*Ulmus crassifolia*) shades the house and lattice-enclosed *corredor* (porch), which are decorated with all kinds of novelty birdhouses, animal plaques, red ceramic suns, and plastic flowers. Off to one side of the yard is a small white rustic board-and-batten cabin with a red shed roof and porch. Flanking the porch steps are two large old-fashioned wagon wheels also painted red and white, paired with two plywood cutouts of howling coyotes wearing red bandanas. Here and there are dozens of small coops, birdhouses, and cages for chickens, finches, parakeets, and wild birds. In this little dusty village, this house and compound are clearly the showcase for someone's lively decorative talents.

### FIVE GENERATIONS AT RANCHITO CUEVITAS

Consuelo and Porfirio Villalón don't really seem surprised that someone would stop to ask about their garden. For thirty years they used to run a little store out of the front room of their house and people would drop

by all the time to pick up simple groceries or to visit with Reginaldo Villalón, Porfirio's father, who was well known for his storytelling.

It was Porfirio's grandmother's family, the Floreses, who first settled in Cuevitas back in the nineteenth century. Porfirio is named after his grandfather, who came from just the other side of the river to marry Amada Flores, and together they built that little cabin still on the property (now called La Casa Vieja), where Porfirio himself was born. "Today Cuevitas is made up almost entirely of Flores family [members], though mostly the older people. There are very few of us remaining," explains Porfirio. "People that are here are from the originals, like me."

Porfirio himself married and had two children, but his wife died when they were still very little. After five years he married Consuelo, who had come over from Díaz Ordaz to keep house and watch the children for him. Eventually they had a daughter together, and it was Consuelo who ran the little store while Porfirio worked for the Highway Department, and who also began the ambitious project of decorating home and garden with whatever she could get her hands on.

*Very little of this was here when I came. We built the corredor, and we fixed up and painted this house, the fence, and the old cabin. Little by little, we began to fix things up. I like to get things [to decorate with] from the flea market, and also from the dump. My husband tells me, "We came here to throw stuff away, but we end up taking back more with us!"*

By the time Consuelo gets through painting, rebuilding, or rearranging, these discarded things do not look like castoffs. The centerpiece for a separate patio is a concrete irrigation well head that serves as a large table.

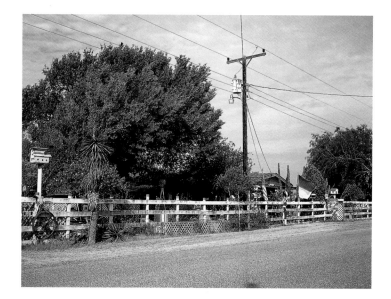

The Villalón house is a bright spot on the main road of Cuevitas.

Nearby is the barbecue grill, large pieces of petrified wood, a miniature windmill, and an old metate from the homestead days. Old sofas provide a comfortable place to relax in the shaded *corredor*, plumbing fixtures are recycled as planters, and rustic pieces of wood are recycled as birdhouses, coops, or decorative plaques. Even plants like cenizo (*Leucophyllum frutescens*), anacahuita (*Cordia boissieri*), and nopal (*Opuntia lindheimeri*) are dug up from the *monte* (thickets on the hillside) as small plants and used in the garden because they are beautiful and thrive without a lot of water.

"Like that olmo [elm] tree there. My daddy and me and I guess my uncle, we went to the river and transplanted it, and it has been here for forty years or so. We're very proud of that," says Porfirio.

Cuevitas, like many other places in the Rio Grande Valley, is a major route for migratory birds that enjoy the proximity of the river and the habitat provided by the remaining stands of thick brush or mattoral on the

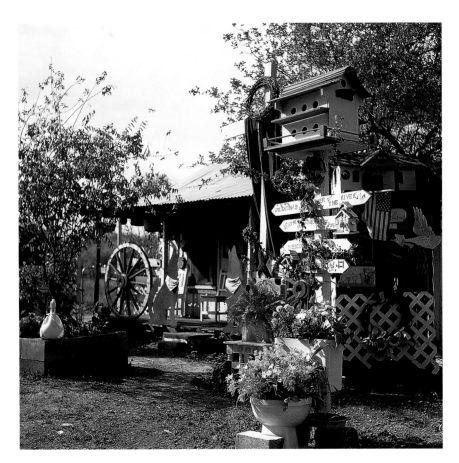

La Casa Vieja is preserved among a host of decorations in the Villalón compound.

It is very important to Mr. Villalón that people understand and respect the history of his hometown. He has taken it upon himself to question the accuracy of a report made by the Hidalgo County Historical Commission as to the origin of the Cuevitas Cemetery. "When they made a survey of the cemetery, I contributed some information. We formed a Cemetery Council, and I've got all the names of the people who have been buried there, by the plots, with numbers associated with names," explains Porfirio. Consuelo, however, is in charge of the upkeep and decoration, particularly for Mother's Day and All Soul's Day. She makes the bows and ribbons for the fence and keeps the grave sites tidy. "His uncle donated the land for the cemetery," adds Consuelo.

*When he died, I had recently married [Porfirio], and we buried him, but he did not have a cross or stone marker. So, I began to take up a collection so we could buy him a marker, which was only right, since he donated the land.*

Like others, the historical commission assumed that the name Cuevitas came from a distinctive geological feature in the area. Where much of the Lower Rio Grande Valley is level, upriver toward Rio Grande City the flatness begins to give way to bluffs or outcrops made from caliche-cemented river gravels that are part of an ancient river terrace deposited by the Rio Grande eons ago. These bluffs, called lomitas, look like they are actually composed of man-made aggregate concrete, but because the formation weathers at different rates, many of the bluffs are riddled with shallow, scooped out depressions, or little caves. These caves made perfect nesting places for migratory mud or cave swallows, and also for wild honeybees. Too rugged and dry for

low hills. Although Consuelo does not know all the names of the birds, she keenly tracks their comings and goings. Indeed, the main theme of her garden (besides the red and white colors) seems related to birds: birdhouses, birdbaths, birds in cages, miniature chickens scratching in the dust, and the steady sounds of doves calling back and forth. Even many of the neighbors whose attention to their yard could not come close to matching Consuelo's devotion have multiple birdhouses on display around their houses.

farming, the lomitas were fixed features of the landscape until the 1940s, when mining companies began buying up the surface rights, then dynamiting them to extract the various components of sand and gravel for concrete production.

Porfirio recalls the history of their land:

*In those earlier times, the family raised corn and tomatoes and things like that, but now, I just lease some land to another farmer. My grandmother leased some of her land in the late forties and fifties to a mining company. Before that, the crop dusters killed off all the bees with DDT.*

With such a dramatic feature in the landscape, it's easy to understand how someone could assume that the whole explanation for the placename "Cuevitas" comes from the sight of thousands of birds drilling nests into the soft caliche depressions on the hillsides high above the river. But Mr. Villalón insists that it came from that earlier name of the town right across the river, Díaz Ordaz or San Miguel de las Cuevas. Since early times, families have lived on both sides of the river, their connections not defined by political boundaries. Earlier settlers leaving San Miguel de las Cuevas to homestead north of the river indicated their kinship ties by naming their settlement Cuevitas, Little (San Miguel of the) Caves, or more accurately, an affectionate, shorthand way of saying "of Las Cuevas," to honor the original community. Because this particular geologic formation extends south into bordering Tamaulipas, Mexico, it's likely that the same kind of caliche bluffs are found there and could have influenced the original naming of San Miguel de las Cuevas. Kinship, natural features, old placenames, all contribute to the naming of these older settlements, the same way "Los Ebanos," the Place of the Ebony Trees, or the Place of the Large Ebony Tree

Grove, has identified that small town to this day.

The remnant bluffs are indeed beautiful. They stand high above a fluffy fringe of retama trees (*Parkinsonia aculeata*) with yellow blooms, overlooking a flat field planted in the famous 1015 sweet onions. Farther off is the chartreuse green of the honey mesquite trees and their companion thorn-scrub plants with names like "colima," "tenaza," and "palo verde" that form the *vega*, or riverbottom. Mr. Villalón describes gathering honey from the bees on the high banks, and how the birds would be flying everywhere. Today, his little village is mostly surrounded by a ruined, mined-out landscape that is only good for grazing goats. But inside the Villalón compound, beneath the shade and among Consuelo's vivid collection of so many birdhouses and decorations, we don't feel so far away from a more peaceful pastoral time. Mr. Villalón explains his sense of belonging:

*The only ones that stay here are from the* raíces *[meaning belonging to ancestral, racial lines] like me. I don't want to move, because I own land. And I can't take it with me!*

Hollowed out bluffs rise above the Rio Grande.

Alice and Thad Magyar welcome
visitors to Mango's Jungle.

# Mango's Jungle

As we have seen in the Villalón's story (Chapter 8), some yards and gardens remain faithful holdouts in the midst of an exploited and ruined landscape. When a family has lived somewhere for many generations before the landscape was devastated, land and identity are inextricably bound together. Leaving the homeland would feel to some as though they were altogether loosed from their moorings, lost to who they were, and thus obliged to form new attachments or even new identities.

What happens when this phenomenon is reversed, when a family moves into a barren, overused landscape, and brings it back to life through planting and other improvements that result in a unique natural setting and a special expression of attachment to their new home and area? This is the extraordinary achievement of Thad and Alice Magyar of Harlingen, Texas.

An aerial photo of their property taken more than twenty years ago shows a small, forlorn, abandoned house marooned in the middle of a vast flat and empty field. A few old cottonwood trees dot the front yard, and shaggy overgrown arborvitaes hug the corners of the house. Toward the rear are five huge ash trees. What the picture doesn't show is the oppressive steamy temperature and the steady hot breeze so typical of the Valley. To most people, there would seem little to recommend living in an old agricultural field, but to the Magyars, it was just what they were looking for.

Thad and Alice are originally from North Dakota. Thad's family is of Hungarian descent ("Magyar" actually means Hungarian) and had a grocery store in the Bohemian section of Dickenson. Alice grew up on a ranch not far from the Badlands. Early in their marriage they moved around the West, eventually arriving in Houston before coming to the Valley. During those few years in Houston, however, Thad got a bad case of palm fever.

Thad claims that as a child he was fascinated with the long green fronds that were handed out at church on Palm Sunday. To him, they represented exotic, faraway *warm* places, and he wondered how his church could afford to purchase something so rare and unusual. Houston was the first place they had lived where he

The Magyar property started out as a flat and empty field. (Photo courtesy of Mr. and Mrs. Magyar)

*When I came down here, I bought a real estate company. It was '83. The biggest freeze in almost a hundred years came, and it pretty much devastated everything. Our business went down the tubes shortly after I bought it. The peso devalued and this [house] was one of our listings. The house had been abandoned and was in horrible shape when we got in there. We were basically hanging on by our fingernails.*

Like other pioneers whose stamina was tested but not defeated, the Magyars were undaunted. Their desire to have enough space to grow everything they wanted provided enough motivation to keep going through hard times. "It took us a while to close [the home purchase], and by the time we closed, I had already planted more than two hundred palms in this yard. But I had been acquiring them, and I had to put them in the ground," recalls Thad. In this way, the Magyars began converting a good portion of the nineteen acres of fields, formerly sown in cotton, corn, sorghum, and watermelons, into their own tropical paradise.

**PALM NUT**

Though Thad's interest in palms began in Houston, it was the move to the Texas Riviera, as some have romantically named the Valley, that transformed fascination into full-blown obsession. "Oh, I think when you come down from North Dakota, and you come here and everything is palms everywhere you go—they are just gorgeous," explains Thad.

*Palms line our highways throughout South Texas, and it is difficult to find places in the Lower Valley where palms cannot be seen in every direction. I've got about fifty different species of palms, and some of my favorites are Bismarck palm (Bismarckia nobilis),*

The Magyars' garden stands out from the surrounding agricultural fields.

could even consider planting palms, and he became a member of the Palm Society in order to learn more about them. His yard was small, and like many enthusiastic novice collectors, he quickly outgrew his space. "You could hardly move, it had so much stuff," remembers Alice. It was time to move.

A desire to own their own business, the need for more land for Thad's burgeoning palm and tropical plant collection, and a yearning to be in a subtropical zone close to Mexico were among the reasons Thad and Alice wanted to leave Houston and start over in the Valley. He explains how their initial optimism about this new start was severely tested.

*Queen palm* (Syagrus romanzoffiana), *and the native Texas sabal palm* (Sabal mexicana).

For Thad, palms represented place, and with the old abandoned fields as a blank canvas, he and Alice began to shape and form their new homestead.

### CREATING A JUNGLE ISLAND

The Magyars' farmer neighbors told them that their property had especially fertile sandy loam that was good for growing things, and that certainly proved to be true. Employing the old-time practice of using palms as effective windbreaks, the Magyars planted many small (one-gallon sized) Mexican fan palms (*Washingtonia robusta*), which are now over forty feet tall. Although perceived as flat, the property actually has a significant elevation change, which the Magyars have exploited to aid flood irrigation from standing pipes delivering water from the Rio Grande about twelve miles away. Many people don't realize that the rainfall in the Valley is typically scant and erratic, resulting in a peculiar kind of humid aridity that can limit growth and production.

That's why Thad did not lay everything out in a master plan; the initial planting locations were instead dictated by irrigation spouts. These vegetation islands, as Thad calls them, were kept weed-free and heavily fertilized to encourage fast growth. For two years the plants remained small and sparse, dotting the yard's expanse of sticker burrs. By the third year, though, they were beginning to provide dense shade with perches for birds (which would then drop more seed), and they eventually served as anchors for guiding future planting areas. A small citrus grove was also planted at this time.

In addition to planting continuously, Alice and Thad began to build new walkways that would wind among

Mexican sabal palms provide a dense windbreak.

the plantings. Next the Magyars added outdoor seating areas that eventually evolved into extensive boardwalks, patios, decks, and thatch-covered palapas, with thatch by now provided by their own palms. Weathered beachcomber signs direct the visitor as to which path to take, adding to the Robinson Crusoe theatricality of the setting. Tropical foliage plants, such as gingers, bougainvillea, ficus, bananas, cycads, and orchid trees (*Bauhinia* spp.) were layered in among the palms. The large glossy leaves of huge ficus or rubber trees (*Ficus elastica, F. benghalensis,* and *F. altissima*) offered a contrast in form and shape to the broad palm fronds. Exotic tropical trees such as silk floss (*Chorisia speciosa*), silk oak (*Grevillea robusta*), and jacaranda (*Jacaranda mimosifolia*) quickly grew to contribute to the high canopy. The vegetation islands began to merge into one big jungle.

Homemade paths lead into Mango's Jungle.

equally outrageously colored plumage. Cockatiels, peacocks, guinea fowl, pigeons, doves, and ducks at one time contributed to the menagerie but proved to be more a food source for varmints than durable pets. Large aviaries for the remaining parrots were built along the garden paths, and the newest patios and barbecue area were given the name "Tangerine's Bar and Grill." "It's our living room!" Thad explains enthusiastically. Alice adds,

*We get up pretty early in the morning, and we immediately go outside and have hot tea. We'll sit for an hour and just visit. We just enjoy the yard, and it is a lot of work, but we spend a lot of time just enjoying it.*

It was not their intent to recreate the native habitat that had been lost when the area was converted to agricultural use. For one thing, palms would not have grown there. There are still remnants of the native brush, or mattoral, on the property, but now these species are confined to a narrow strip by the road where they serve as a privacy screen. Still, the palm grove they have planted is so dense, so full of fruit and perches, that it is loud with the sound of birds otherwise not so welcome in the surrounding open fields. Squawking grackles, chacalacas, great kiskadees, and of course the pet parrots all join in chorus with the steady breeze rustling through the palm thatch and ficus leaves. At night, screech owls and geckos take over. Hummingbirds and other migratory species are also present, especially in late winter when there are the most blooms.

### MANGO AND TANGERINE

Thad's quest for the majestic, the unusual, the edible, the fragrant, and the odd curiosity took on momentum, Alice started her own collection of tropical birds. In keeping with the jungle theme, the first bird was Mango, a military macaw with a big personality. Soon he was joined by Tangerine, another military macaw, and followed by Captain Bligh, a scarlet macaw with

### SENSE OF SATISFACTION

In less than twenty years, Mango's Jungle has grown so dense that the original, exposed little house cannot be seen from the road. From far away the flat topography

reveals a tall green thicket in the distance amid neat rows of various crops and empty fields.

Like many collectors or hobbyists, Thad is eager to share his knowledge and collection. A founding member of the local palm society, he now prefers to devote his time to conducting freelance tours. Alice and Thad are quick to point out that they are not winter Texans or snowbirds, those Caucasian seasonal Valley residents from up north, but their kinfolk are. Thad describes the origin of his tour audience:

*Alice's mother lived in a [mobile home] park. I've got a brother in another park, and she has an uncle in one of the biggest parks down here, and so all of them bring people and pretty soon we know a lot of people, and it goes on and on. I'm in the Palm Society, the Bamboo Society. We've had over one hundred people here at one time for picnics and whatnot.*

To accompany the tours of Mango's Jungle, and to keep track of his ever-increasing inventory of plants, Thad has prepared a detailed plant list and a Web site. Although trading seeds and attending society meetings were important to him in the beginning, Thad now prefers to read books and browse the Internet for information about new plants. After his palm collection reached a significant size, Thad began to diversify by adding an assortment of tropical fruit trees, including sugar apple (*Annona squamosa*), bignay (*Antidesma bunius*), and star fruit (*Averrhoa carambola*), as well as the more familiar avocados, guavas, loquats and bananas. Lately, Thad has added yet another category of plant acquisitions. "I'm going to turn into a bamboo nut instead of a palm nut. But anyway, you do get a little tired of some of the stuff you have, and you run out of what you can grow."

Palapas make fine outdoor living spaces in a subtropical climate.

In partnership with a climate that promotes rapid growth and accommodates many frost-tender species, the Magyars have built a garden that represents many of the beautiful qualities identified with tropical settings throughout the world. Their garden is not so much a replication of a real plant community as an idealized, romantic landscape that is strongly influenced by their soulful connection to the Valley's rich border culture and travel experiences in Mexico. Though the Magyars are relative newcomers to the Valley, they seem more enthusiastic about the area than many natives. The creation of their garden strengthened their attachment to their new home and also increased their sense of belonging to this part of Texas. The modest eighty-year-old house originally on the property is in good repair now, but it's clear that most of their resources and time have been spent building the garden and outdoor living spaces. The wonderful pastime of obsessive col-

lecting was directed here to create an entire environment, not just to showcase their collection but also as space to inhabit, to entertain, and, most of all, to share. Thad describes the whole effect on his Web page:

*The Valley is the land of fiestas, warm tropical nights, and romance. Lifestyles are relaxed and recreation is served with gusto and accompanied with dancing, margaritas, limes, music, and of course, macaws. The appeal is reflected in the faces of the many people who have wandered throughout Mango's Jungle.*

# The Ardent Virtuosity of Collectors' Gardens

Throughout the Middle Ages, there was a common belief among Europeans that the Garden of Eden, along with Noah and his Ark, had somehow survived the Great Flood. The desire to rediscover a remnant piece of paradise remained on the minds of monarchs and religious leaders. Some said the original garden would be found on a hidden mystic island, or on a mountain peak blessed with an eternal springtime, or perhaps faithfully tended by Prester John in his fabulous mythic kingdom somewhere in the east. During the great age of geographical discoveries that began in the fifteenth century, navigators and explorers searched for the Garden while also pursuing the worldly goals of new trade routes and oriental riches. As exploration expanded over the next few centuries, learned people began to acknowledge that although the original Edenic location itself may not be found, they could console themselves with the belief that with grace and diligence, it might yet be possible to gather the scattered plants of creation into the botanic garden, thus co-creating with God a new Garden of Eden. By the seventeenth century, European exploration and plant collection had evolved into a new systematic study of plants that eventually became the modern science of botany. The earliest botanic gardens aspired to become exhaustive encyclopedias, where plant discoveries were greeted with enthusiasm and new species were identified and named.

Perhaps there remains a bit of the romantic explorer in those gardeners whose devotion to their hobby has surpassed average ambitions of mere decoration and style. It's as if through passionate expertise and collecting, they attempt to create their own version of paradise with the plants that have most captured their imagination.

Though the subject of their respective obsessions may differ, the hobbyists who tell their stories in chapters 9, 11, and 12 have many things in common. All gained expertise through membership in a society or club of like-minded fanciers. These clubs are fascinating subcultures with specific and even arcane language and terminology, which can become a code by which insiders recognize each other. The acquired ability to identify a plant by both scientific and common nomenclature, including the names for trademarked and horticultural selections, confers status on the namer as well as providing a sense of power and control over the subject. Many of these clubs have established traditions for initiation of newcomers through mentoring and sharing of information. The Magyars and the collectors in the next two chapters, having benefited first from the experience of club elders, eventually took their rightful place as knowledge-keepers and guides to the newest members in the club. Education, tours, competitions, and the warm social network these clubs provide are more important overall than even the other facet of connoisseurship—that irresistible compulsion to collect the novel, the exotic, and rare. All of the collector-gardeners profiled here enjoy sharing what they know and seem energized when they respond to people's interest in their showcase gardens. For the serious hobbyist then, avocation leads to community, which encourages expertise, and a quest for perfection.

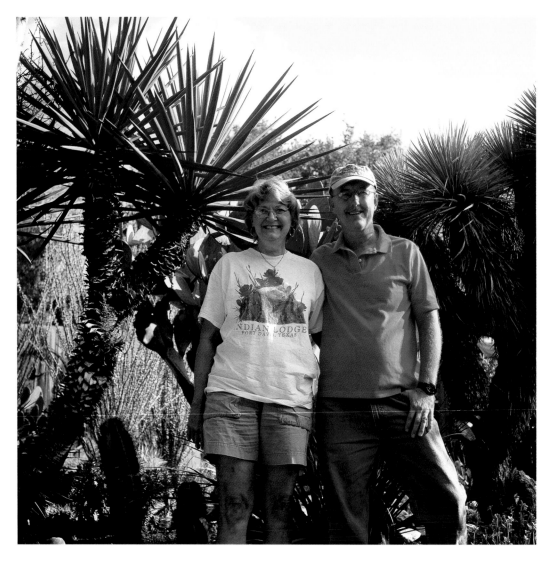

Carol and Richard Blocker have
turned an ordinary San Antonio
yard into a showcase garden.

# One Big Cactus and Succulent Dish Garden

For such a short street, there sure are a lot of cars hustling by. Many are going way too fast, especially right at the end, where there's that fish-hook curve making a shortcut to Broadway Street and the San Antonio airport. This neighborhood of typical sixties ranch-style homes was meant to be a quiet alcove, not an alternative thoroughfare for people trying to avoid overcrowded main streets. The speed problem used to be worse, before Richard and Carol Blocker's spectacular cactus and succulent garden matured into a display that literally stops traffic.

Like those of their neighbors, the Blockers' front sidewalk makes a straight shot to the door. A low-slung gabled roof frames the left side of the house, and on the other side, a long extended carport reaches out over the driveway to shelter a truck, a boat, and a neat assortment of tools and equipment. Landscapes in the neighbors' yards tend to be minimal; most contain just a single overblown Arizona ash tree and small lawn. The Blockers departed from this norm by using their front yard to showcase their remarkable collection of cactus, succulents, and desert plants. Even at 45 miles an hour, it's easy to be suddenly impressed by a yard that has been converted into one huge, magnificent dish garden and rock collection.

Without grass easement strips or sidewalks, the Blockers' garden extends to all four corners of the property. A double layer of landscape timbers is set right at the curb, framing and elevating the entire planted area on either side of the long entry walkway. Every square inch is filled with plants of all shapes and sizes and edged with low piles of interesting rocks, yet it doesn't appear crowded or haphazard. Specimen Thompson's and Spanish dagger yuccas (*Yucca thompsoniana* and *Y. treculeana*), along with blackbrush and bullthorn acacia (*Acacia rigidula*, *A. cornigera*) provide the tallest layer of form and texture, while also casting delicate freckled shadows on the sidewalk and gravel paths. Upright stiff bouquets of spiny ocotillo (*Fouquieria splendens*), coarse mounded tassels of sotols (*Dasylirion wheeleri*, *D. texanum*), and a tightly sheared cenizo (*Leucophyllum frutescens* "Green Cloud") are

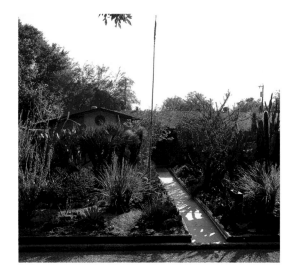

The Blockers' yard is like one big cactus and succulent dish garden.

69

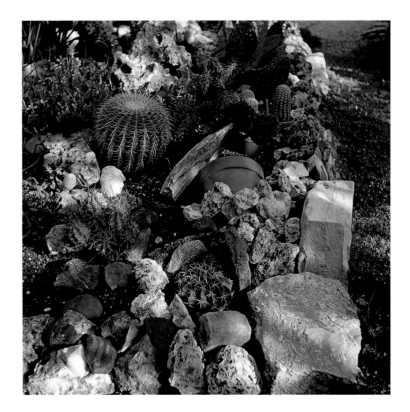

Close inspection reveals an intricate arrangement of plants and rocks.

Here and there different species display unreal-looking blooms in delicious colors of tangerine, fuchsia, and saffron. Succulents creep among the cacti, and the reddish brown fine-textured gravel is meticulously raked free of weeds like Bermuda grass that mar most cactus gardens. Playful western accents such as old mining buckets, rusting ranch tools, railroad spikes, glass insulators, bleached skulls, and rubber snakes and insects give the garden the dramatic appeal of a detailed desert diorama. A white-wing dove placidly nests in a tall, knobby cholla (*Opuntia imbricata*) near the front door.

The back yard, however, reveals the overwhelming evidence of the Blockers' expertise and commitment to their hobby. Two extremely clean and well-organized greenhouses contain both their champion show plants, and their successful propagation operation. Tiny baby cacti are lined out in trays of two-inch plants. Other benches support small containers of newly grafted cacti. Here's where the mother plants and the field-collected specimen plants are taken in and potted up. Materials, tools, pots, and soil are more neatly arranged here than the supplies in many people's kitchens. On shelves along the fence, protected by a fiberglass ledge, is their collection of still more exotic plant genera like *Adenium* and *Pachycereus*. After surveying the whole scene of gardens, planters, container plants, patios, and greenhouses, the visitor begins to understand that the Blockers are amateurs in the purest sense of the word. Simply for the love of these strange and exotic plants, they have become connoisseurs, experts, and educators.

### I CAN'T BELIEVE I HAVE THIS FOR A HOBBY
The hobby that would gradually absorb a great deal of Richard and Carol's lives began rather innocently in 1980 when Carol's daughter gave her a fuzzy, columnar succulent. Not long after that, the Blockers made a trip

placed here and there to disperse the complex diversity of the smaller plants below. Broad, thick pads of trunk-forming prickly pear or tuna cactus (*Opuntia ficus-indica*) and the sturdy columnar trunks of watermelon or cone cactus (*Neobuxbaumia polylopha*) provide a nice contrast to the small leaves of most of the other plants. Closer to the ground are arranged an uncountable variety of cacti. The genera *Echinocereus, Mammilaria*, and *Ferocactus* are particularly well represented in their many forms: round, finger-sized, or barrel-shaped. Some cacti, like horse crippler (*Echinocactus texensis*), have thick, menacing thorns, while the spines on others form a fine web over the waxy surface of the plant.

to a cactus grower in Alvin, Texas, and added a few more plants to their tiny collection. Richard grew up in Florida, where his father had grown tropical plants, so raising exotic and other unusual kinds of plants was already a familiar occupation, but Carol had never thought of herself as a plant person.

*Back in high school I didn't want to take biology because it involved memorizing all those long Latin names. But what do I end up doing? I end up having a hobby where I have to remember all those names!*

The tipping point for them was their first cactus show, as Richard explains:

*We went to Central Park Mall [in San Antonio] and they were having a cactus show and we walked in there, and that was it! There were all these plant dealers selling cactus and succulents from all over the world, and we never dreamed there were so many kinds. We didn't know there was a cactus and succulent club, so we found out about the local club and joined it, and that was it! We were hooked.*

Richard and Carol are good examples of people who, by joining a club or organization of hobbyists, open a door to a world where talent, expertise, and enthusiasm can be expressed in ways they could not have imagined earlier. At that first show, they got the bug and they got it bad. They soon took advantage of all the resources the Cactus and Succulent Society had to offer. Carol explains why they began identifying with this group of enthusiasts:

*The cactus club has given us a lot of things. It's given us good friends, it's given us a whole lot of informa-*

*tion, it's given us access to trade with other collectors that might have plants we like and we might have some that they like. The club has done a whole lot in pushing us toward this hobby and making us aware of so many things that we don't know about.*

The initial infatuation phase of most new hobbies is characterized by an obsession with collecting as many different kinds of the thing you have been attracted to as possible, whether it's Beanie Babies, Limoges porcelain, or cacti. Special-interest clubs or societies provide regular opportunities to swap plants, seeds, and offshoots with more seasoned aficionados who also serve as mentors and guides into this rarefied world of specialized expertise. Carol remembers their early years as rookie club members.

*We would seek out members who had a knack for one thing or another. We met one man who was good at grafting, and Richard spent a lot of time over at his house, watching him, and mimicking him. Other people might grow plants well from seed, so we would go over to their house and talk to them. Through the club we met members in other cities, so it's really sort of a link.*

### IT'S REALLY A BEAUTY CONTEST

Collecting, learning botanical names, and refining propagation techniques are some of the opportunities a special club provides for new enthusiasts. It didn't take Richard and Carol long to attempt the next level and step up to the rigorous challenge of raising and showing plants competitively. By entering plant shows, the Blockers were indicating their commitment to move beyond mere dabbling in cactus appreciation; they became serious players. Competitive plant shows are another way to reinforce one's identity as a club member be-

cause the rules and criteria for judging can seem very arcane and obscure to the outsider. Only an experienced club member would understand what the judges are looking for and be able to appreciate the subtle differences in quality that elevate one plant above the other. "When we first joined the club, we thought, We have some nice plants. Let's put something in the show," remembers Carol. "We put together this big cactus dish garden about three feet wide and two feet deep, and we had some big things that grow in west Texas." Richard describes their first show entry.

*It had some South American columnar plants, and then it had a bunch of little barrel cactus in it, and we had put things like all different kinds of rocks, dried-out cholla sticks, and some horseshoes and things like that. The whole garden probably weighed a hundred and fifty pounds, and we're trying to get several people to lift this and put it on a table for display, and we're thinking, "This thing's going to collapse!" We thought bigger was better back then.*

Carol continues,

*I think the judges were just kind in giving us a white ribbon, which is third place. So we started looking at the people who won and, I don't know, I guess it's a kind of competitive thing, knowing we can do better.*

Since the mid-1980s, Richard and Carol have won the Best Cactus and Best Succulent prize many times. After nearly twenty years, the Blockers matriculated to the expert and mentor level in their club. In an effort to make room for newcomers, Richard admits,

*We need to slack off entering all these good plants where we know we could win and let some of the other members learn how to show the plants and pot them and groom them and get interested in them.*

The patient attention to details and the creative arrangement required to win appealed to both of their perfectionist personalities. Although they may not have thought so at the time, the experience the Blockers gained in these competitions was to have a strong influence on the way they would go about making their own garden.

### OUR WHOLE GARDEN IS A DISH GARDEN

Having long outgrown every available leftover space around the apartment where they first began collecting, Richard and Carol were more than ready to find a permanent home for their collection and to apply the skills they had developed in preparing dish gardens and plants for competition on a larger scale. Carol remembers what they had to start with:

*When we first moved into this house in 1990, we had five trees, and they were all dying. We had to remodel the entire house. It was a dump. The yard had no grass because the trees were so overgrown, nothing would grow there. That was fine with us, because we wanted to plant cactus anyway. So we just cleared the whole yard. We started out on the side closest to the carport. We had the big Thompson's yucca that was about half its current size at the time. The front garden wasn't very big at the beginning, maybe a third of this size, so the rest of the yard was just blank dirt, and I'm sure the neighbors were wondering when we were going to finish. It took about three years to fill in, and that was 1994. Now it*

*has changed shape since then because we decided that our original soil mixture did not have enough nutrients. So we went to a little bit more compost and gradually built the little gardens within the pathways that you see here. Now if we get a wild hare, we might change up the little gardens and move the pathways somewhere else. It's always a work in progress.*

To maintain the gardens according to their high standards requires real commitment. The Blockers spend about two hours a night in the garden after getting home from work and about fifteen hours on the weekend.

Carol and Richard are co-creators of the garden, each participating in every aspect of growing, designing the layout, and grooming after installation. Richard describes the intent of the garden design. "I try to make it as realistic looking as I can, planting them with rocks to try to make it look natural." Carol explains that while the garden layout is naturalistic, its main intent is to showcase as much of their collection as possible.

*We have a lot of things out here that don't normally grow together. This is an example of a whole lot of different areas—from Texas, from Mexico, South America—but they all require similar growing conditions.*

The design of the Blockers' front garden, while not an accurate reconstruction of a native plant community, has been influenced by many field trips they have taken with the cactus club to visit private ranches. After having achieved a high level of competence in propagation and cultivation of cacti and succulents, learning to read the natural landscape and discover previously unknown

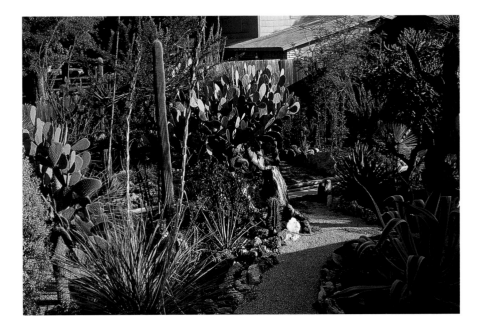

populations of cacti provided a new challenge. Carol talks about the thrill of searching for new plants.

*We always go on club-sponsored field trips, whether we know we already have every single plant that's going to be on this ranch, because we've read books and we know what to expect from certain areas, but still, it's the thrill of the hunt and the chance of finding something really unusual.*

Recently they discovered a previously unrecorded population of a tiny inconspicuous plant called living rock (*Ariocarpus fissuratus*) on a friend's ranch just east of the Pecos River. Richard explains further:

*It's not necessarily finding them and taking them; it's*

The garden makes use of every square inch of space.

Claret cup cactus blooms among the vast collection of plants. (Photo J. Nokes)

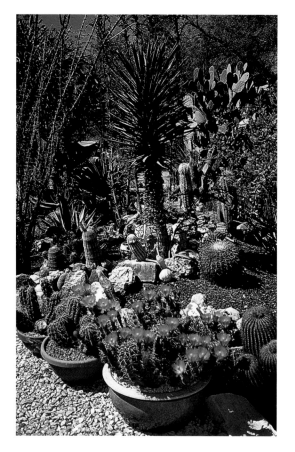

*looking for something rare, and through years of being out in the field and looking for these plants, I could drive along in the truck and I could look at a hillside and tell you, you're going to find this here on this particular hillside, or certain cactus will only grow on real rocky soil.*

Like most cactus growers, the Blockers are also knowledgeable rock hounds. "We try to learn what the different rocks are. There're a lot of fossils in Texas, so we're constantly looking for fossils while we're looking for plants. We've taken some trips just to look for rocks," explains Richard.

Many of the older people who were their mentors have died, and now the Blockers are the expert elders of the club. People seek them out for advice, and they are well known in trade circles not only for their expertise but also for the quality of the plants they sell at cactus shows. Their house is filled with plaques, statues, and cactus-shaped awards from all the shows they've won. Their garden is established, and the urge to collect is mostly satisfied. Richard talks about how they enjoy the attention.

*Most people like the yard, and kids especially are really interested in the plants. We'll be inside and look out, and kids will be coming and walking through the garden, and they're really interested in the plants because it's different from just a normal yard with grass and trees. I like that a lot, and I love to show the kids the plants. And Carol likes to put little rubber snakes and bugs in the garden. It's like a treasure hunt for them.*

Sometimes Richard regrets that he didn't decide earlier in his life to become a botanist specializing in cacti. But he is underestimating the valuable role played by amateurs like himself in teaching people to appreciate these plants and the natural places where they grow. At cactus shows, Richard enjoys explaining each plant in detail. He hands out little pieces of window screen to cover the new plants, explaining that, contrary to what people assume, cacti can actually get sunburned. Richard and Carol hope that if they can help these new gardeners succeed with their first plants, maybe their customers will get the cactus bug just as they did twenty years ago.

# A Surprise Comes Every Day

Craig Hoyal stands in the middle of his rock garden with the confident pose of a Major League pitcher at rest. Long arms crossed in front, he relaxes next to a decorative miniature windmill inside a rock garden edged with petrified wood, fossilized palm, and mossy sandstone. Though he was indeed a pitcher in the San Francisco Giants' farm system during the golden age of Willie McCovey and Orlando Cepeda, today Craig Hoyal's winning streak comes from the recognition he receives as an outstanding daylily breeder and collector.

Dormant daylily varieties are planted as far north as Canada, but the long growing season, deep soils, and forty to fifty inches of rainfall in southeast Texas, where the Hoyals live, are especially favorable for raising a multitude of different *Hemerocallis* hybrids. The Hoyals' typical suburban neighborhood lies just outside Vidor, Texas, a few miles east of Beaumont on the Gulf Coast. Their street has a rural feel to it: large yards shaded by the same tall pine trees, sweetgums, and pin oaks found in the surrounding piney woods. Most of the neighbors don't fuss with much more than keeping the pine needles from smothering their lawns, but at the Hoyals', the whole yard is a well-tended showcase. Groups of trees are gracefully connected by a series of curving beds filled with mophead hydrangeas, camellias, and ferns. The front yard is one big display of annuals and semitropical plants, and along the side of the house, carefully arranged rocks, boulders, and shells form a special area for succulents, a few cacti, and groundcovers. Although the variety of plants tells you that Mr. Hoyal enjoys collecting and growing many different things, it's the back yard where his major passion is revealed. The view from the back patio is of one huge daylily production garden, so large that it takes up almost the whole lot by itself.

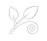

Mr. Hoyal is always looking for a winner among his new hybrids. (Photo John Fulbright)

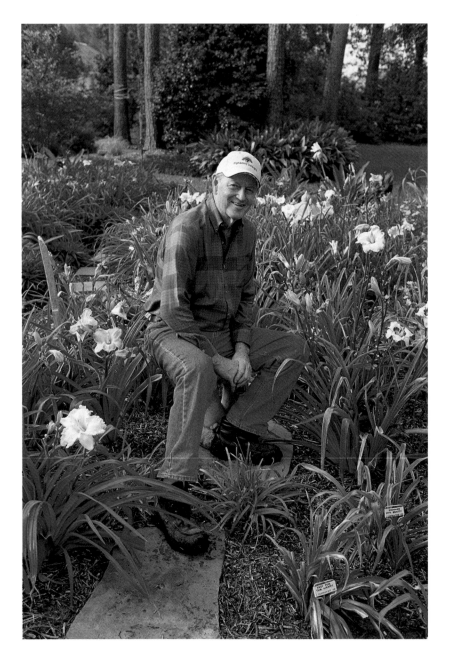

Craig Hoyal examines outstanding
specimens in his daylily garden.
(Photo John Fulbright)

## "CHICKEN FAT" AND OTHER DESCRIPTIVE TERMINOLOGY

In the heart of Craig's collection, raised beds showcase row after row of dramatic forms, colors, and patterns. Some daylilies are tall, some dwarf, and they come in a full spectrum of colors ranging from tawny yellow to pastels, burgundy, and carmine. As he leads a tour through his garden, Craig helps the uninitiated visitor notice the amazing details that differentiate the flowers. The shapes can be round, triangular, double, or "spider" (meaning narrow petals and sepals). Still others have variations in the throat or center called "eyes" or "watermarks," terms that are used to describe the abundant variety in daylily hybrid selections. Some are further distinguished by variations along the petal edges: these can be ruffled, enlarged or narrow, or even a different color from the rest of the flower, a characteristic called picotee, derived from a French word originally used to describe ornamental embroidery. Off-purple petals with a yellow throat and an extravagant yellow ruffle along the edges that he calls "chicken fat" set apart a hybrid recently created by Craig. He plans on watching the performance of this plant before deciding to register it as his own unique hybrid selection.

Like other categories of plants, the diversity of daylilies invites elaborate showmanship and collection. "For a flower show, they have different divisions that you can enter," explains Craig.

*That has to do with whether they're double, or large, or so on. You have to have so much of the scape [stem], and it has to be very well groomed, as well as the flower being good. There's quite a bit that goes into the flower show.*

Originally from China, species daylilies first brought into cultivation had a limited color palette of orange, orange-brown, and yellow. Today, the look of the daylily is rapidly evolving, thanks to both amateurs and professional horticulturists. Breeding may be simple or complicated, depending on the goals and skills of the grower. Commercial growers know which hybrids and species can be crossed successfully to obtain certain characteristics such as color, flower form, foliage quality, and size and season of bloom. In the 1960s breeders discovered that applying colchicine, a powerful alkaloid taken from the autumn crocus, could further enhance daylily flower forms. Colchicine doubles the number of chromosomes, and the resulting tetraploid hybrids often tend to be larger, with more intense color and other interesting details like ruffled edges and a sturdier scape. Societies, fanciers' magazines, and flower shows keep the daylily collector's appetite whetted for new hybrids, rare selections, and the flat-out unusual. Members are always eager to see the results of the newest innovation in hybridization.

## THE LUCK OF THE DRAW

Mr. Hoyal explains how he makes his hybrids:

*Well, some things are just by luck of the draw. You take this and you put it with that, you might get something good, you might not. But if you take good and put it with good, the chances of getting good are a lot better.*

Craig's own method for hybridization is simple: he cuts the anthers (male part) out of one flower with certain characteristics and uses them directly to dust the pollen on the stigma of another to see if they will make a successful cross. If he's lucky, this simple procedure will produce something wonderful. In this process there is still enough of the unknown, of luck, to make each

The plant breeder must come up with a new name for each selection. (Photo John Fulbright)

the name of the selection. The names are as varied as the tiny details that distinguish one daylily from another. Some are romantic, like "Wind Beneath My Sails" or "Fairy Bliss," while others, like "Stinking Fingers," "Octopus Hugs," and "Skinny Dipping," are silly and amusing. Seeing so many daylilies together in one place like the Hoyals' is the only way to begin to appreciate the diversity and beauty of this group of plants.

Like many people who develop an expertise in a certain category of plants, Mr. Hoyal admits that his love for daylilies came about indirectly and gradually.

*When I bought this place out here about forty years ago, it didn't have landscaping or anything. It just had the big pine trees. I decided I wanted to plant things, and I saw some daylilies and I kind of liked them, so I bought some from an old man in Beaumont and planted them. And then I saw a place where they were tearing down a house that had some daylilies, and I brought over a bunch of them. But they were those old yellow ones. I don't even have those anymore. I got rid of them.*

Daylilies are easy enough to grow that even the novice gardener can quickly gain confidence. Some are content with the common varieties, contributing a color accent and a clump of foliage to the perennial border, but other growers like Craig soon get the fever for more, and for more of everything. "One of the great joys of daylilies is that it is so easy to create your own hybrids," says Hoyal.

### WHAT'S IN A NAME?
Craig's daylily beds are lined out in neat rows, each plant carefully marked with a metal tag that announces day's stroll in the back yard exciting, and all the hard work worthwhile.

### FLORIDA BACKGROUND
Craig thinks he inherited a basic green thumb from his parents in Florida:

*My parents bought a place that had a lot of hibiscus.
The original owner had a slat house where he did a lot
of hybridizing. I, of course, had to tend to the grass, do
edging, pull weeds, and so on, so it sort of stayed with
me. My mother was always interested in plants. She
used to grow cuttings of crotons and various things. She
had a little place by the water faucet where there was
sandy soil. She would just leave the faucet dripping and
stick something down in the ground, and it would take
root.*

## WAKING UP TO SOMETHING NEW

When you have as many daylilies as the Hoyals, and
you have enough expertise to make a few successful hy-
brids of your own, each morning in the growing season
comes with the sweet anticipation of discovering some-
thing new.

*During the middle of the day I may just walk out here
and say, "Hmm, I wonder how I got that. That sure is a
pretty thing. Man, I'm going to have to watch that. I
believe I'll use that one for pollinating or crossing."*

Craig follows a meticulous system for labeling all
his plants, as well as recording the parents of new hy-
brids that turn out to his satisfaction. Here is where he
relies on his wife, Millie, for the record keeping.

*Millie keeps an up-to-date list of the registered
daylilies I have. For the crosses, each one is marked
with a plastic tag. I only assign a number if it is some-
thing worth studying further after it blooms. I like see-
ing new cultivars for the first time, and I enjoy all
types: large, small, doubles, spiders, but most of all,
the frilly and exotic edges. Millie's tastes are quite dif-
ferent; she prefers the pastel colors.*

Craig might be the detail man, but Millie's participa-
tion is essential in maintaining such a big yard and
daylily collection. She's the one who mows the grass on
their triple lot, freeing Craig to spend an average of
four to six hours a day weeding, grooming, hybridiz-
ing, preparing new beds, and other tasks in the endless
cycle. Millie also represents the Hoyal family hobby as
an officer in several garden and daylily clubs in their re-
gion. Almost every year, their yard is on a tour during
one of the annual meetings of these societies, or recog-
nized as Yard of the Month. Mr. Hoyal very willingly
shares his knowledge and plants with others who seem
sincerely interested and committed.

## A GOOD THING

Though Craig has been growing daylilies for several
decades, it's the actual work of gardening rather than
the finished product that is most enjoyable for him.

*I get satisfaction out of doing it, and showing what I
have done. I don't mind getting down on my hands and
knees and picking weeds out of the flowerbeds or what-
ever it takes. You get peace of mind, and, I don't know,
my mind will go blank sometimes whenever I'm work-
ing. I'll be thinking of how I can improve something.
It's just a good thing.*

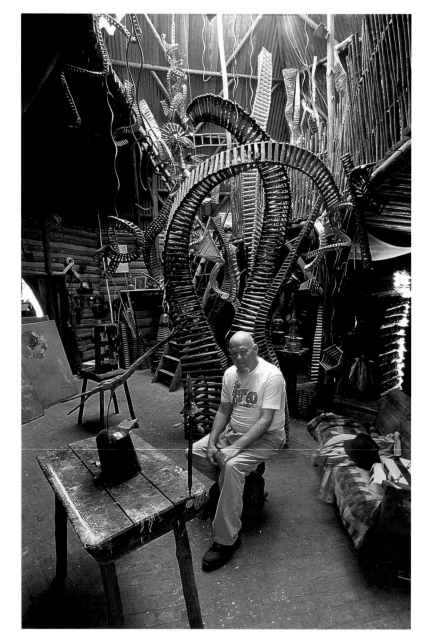

Charlie Stagg is surrounded by his
sculptures in his original studio.
(Photo John Fulbright)

# Sculpture You Can Live In

Some people call Charlie Stagg a visionary or outsider artist, as if that is enough to explain everything. Yet there is so much more behind his life and work than any renegade art category could contain. By rushing to interpret and name what he has made, we risk being distracted by the peculiar nature of his achievements rather than understanding the life and place that produced them.

**THE HOMEPLACE**

The turnoff to Charlie's place is just past the Assembly of God Church on Highway 105 in Vidor, a few miles east of Beaumont in far southeast Texas. Someone has to show the uninitiated just where it is, because it's really more of a track than a road. Even with instructions, the mud-rutted trail curving through a stand of pine trees doesn't look like it leads anywhere in particular. If you follow the road farther into the woods for about half a mile, over the creosoted plank bridge across the bayou, the trees open up into a clearing, and suddenly you're not sure you're in Vidor anymore.

Framed by tall pines, pin oak, sweetgum, and Chinese tallow trees, a gray concrete igloo-shaped structure lies squat on the ground, flanked by several onion or gourd-shaped attachments, each topped with tall twisted spires stretching skyward like spooky dried stems. A round cistern-shaped structure studded with green and blue bottles stands apart in the center of the driveway. The main entrance has a Hobbit-style Gothic arch with wire gate that invites you into the first domed chamber, which in turn leads to a larger bottle-studded dome in the center. From inside, the bottle wall leans and dips crazily like a stiff beaded curtain or a storm-blown stained glass window that's about to fall. In other rooms, spiky-looking bottle ends poke through the thin concrete screen like crystals inside a rough geode. Beyond, there is a large hexadome cabin-studio made from pine logs and concrete chinking, where inside, wild teetering wooden sculptures resembling DNA helices lean over and peer down from the loft. Other side rooms, courtyards, openings, walls, and tunnels migrate off the central structures. Trumpet creeper vines sprouting outside are free to explore indoors through many windowless skylights and openings. There is no electricity, plumbing, or even much in the way of furniture. Apart from the more or less organic nature of the forms of these constructions (akin to a termite's or dirt dauber's nest), nothing about this place seems to belong to the setting, until you know more about Charlie's story. This is Charlie's own private world of ideas, but also his home, studio, and family land.

**LAND WAS MY DAD'S LEGACY**

Back in the 1920s, when Charlie's folks first moved from Louisiana, the virgin piney woods had already been clear-cut, and Vidor was just a small sawmill town. Mr. Stagg was a farmer, and his wife, a preacher's daughter. During the thirties and part of the forties,

A small track in the woods leads to the unexpected discovery of Charlie Stagg's studio. (Photo J. Nokes)

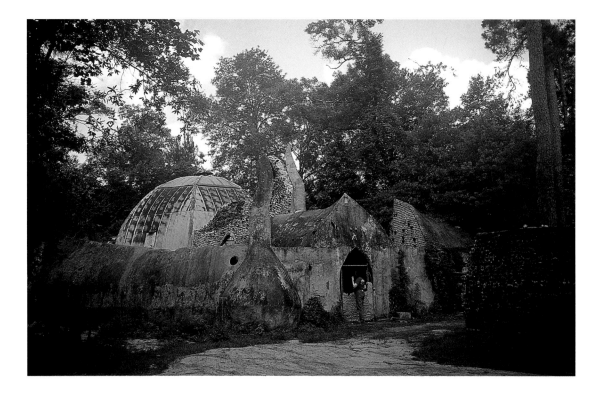

Mr. Stagg grew rice, and Charlie would accompany his mother when she carried food to the field hands.

*I remember as a kid we'd go over there and bring tons of white bread, and rice, and some of the field hands would eat anything—turtles, coons, whatever—and she would cook it for them. It was wild nature out there, and they always had a lot of southern kind of small game, rabbits, and so on. I can remember hearing those tractors coming in for lunch and coming also for the evening meal.*

Cajuns are well known for their improvisational skills with food, but this kind of on-the-fly resourcefulness seems to have marked Charlie's whole life.

In the late forties, Charlie's dad quit rice-farming and turned instead to raising hogs, setting up the pens for them in the same spot where the studio compound is today. Of those days, Charlie remembers,

*I helped to raise the hogs, and we had a lot of hay, and I did all the farm chores. Since my sisters were older, I didn't have a lot of playmates, and I spent a lot of time out here in the woods alone. I loved this area, even when we had hogs back here. Right in this area is the highest point on the land, and that's the reason I chose to build back here, because I knew that as a fact. And I did a lot of drawing and stuff too out here, just little scenes of fishing and all kind of cartoonish-looking little drawings.*

After high school, Charlie left Vidor for the army and was stationed in Germany. The world was opening up for him. Then, like other young men in southeast Texas, he returned to work in one of the many oil refineries in the area, where reliable salaries could keep your mind off how dangerous and dirty the job really was. In quick succession, he married, divorced, and remarried, all the while growing more and more fed up with refinery work. His second wife encouraged him to quit and attend college on the G.I. Bill. Like his parents, she was a good Baptist, and she wanted him to go to Baylor University, but first he had to go to McClellan Community College to redeem his abysmal high school grades in order to qualify for admission to the university. That's when he met the first of a series of influential mentors, Robert "Daddy-O" Wade, part of the famous Texas Five artists at that time, in the early sixties.

Charlie describes those days when his life took another direction.

*Robert and I were talking about me going on to Baylor and going into commercial art, and he said, "No, you left a place where you can make a living [the refinery]; why do you want to go into commercial art?" I told him I wanted to be creative, and he said, "Forget that! If you really want to be creative, commit yourself. Forget about money or anything else, go for fine art!"*

Slowly, the idea of becoming a serious artist was taking shape in Charlie's mind.

At Baylor, Charlie came under the influence of another mentor, sculptor Italo Scanga, who was visiting Waco during an exhibition. Scanga encouraged Charlie to join him at Tyler School of Art (part of Temple University in Philadelphia), to get his MFA. Charlie decided to start taking himself and his art seriously and move to the East Coast, even though it meant divorcing his wife and leaving Texas behind.

Charlie got his graduate degree in fine art and at that time focused mostly on painting, although his connection to Scanga had encouraged him to explore sculpture as well. Charlie fit right in to the vagabond culture of the late sixties and seventies, making life up as he went along, occasionally returning to Beaumont when he was broke, easily finding jobs in construction or once again in the oil industry.

## PRODIGAL SON

By 1980, Charlie's dad's health had steadily deteriorated, and he told his son that if he ever wanted to see him again, he should come home. Still basically footloose, Charlie came back to Vidor to help his mother care for his dad.

*I came here and I picked up a couple of little jobs in construction, and although I didn't enjoy it, I told Dad I'd like to build a little place out in back, and he said okay. Most of 1981 I spent building the hexadome.*

The studio was always meant to be more than just a cabin in the woods; it was a way of having some privacy in a small town and also to have his own space away from his parents, who had come to rely on him more and more. In its design, Charlie consciously employed what he had learned from his study of sculpture and also from conversations he had had with Buckminster Fuller.

*I was privileged to meet him formally in class, and then informally outside of class a few times when I was a student in Philadelphia. We were talking about space and balance and intuition, all three things together, and*

*he freed me a lot from convention. You've got to trust. It's hard for a sensitive person; it's all vocabulary, and you can get pretty tangled up sometimes, but if you're with him, you understand what he's talking about. What Buckminster told me to do is reach deep within myself and drag it out, don't get it from other people. Bring it from yourself. No matter how insignificant it is, it will still be better than if it comes from outside. It will be a true idea coming forth. So I physically set myself aside, in all kinds of ways, like not having electricity, not having a bank account, like not having plastic.*

Charlie stayed on in Vidor after his father died in 1995 to care for his increasingly frail mother. His rustic hexagonal studio was also his home, though he spent a lot of time at his mother's house half a mile down the road.

*I thought, What in the world am I going to do? I'm out here, with my family, I want to continue making some art. So I began by making a little construction out by the road, and I started getting people to come and take a look at it.*

Charlie cut some tree trunks with a chain saw and made a kind of Loch Ness Monster sculpture, as he calls it, but the reaction from the locals annoyed him, so he took it down. Charlie turned to building as a way of working out ideas—ideas that were important to him and not concerned with outside input. Charlie tries to explain:

*It's very broad and extremely epic in hindsight. Expressing the need for a house is different for everyone. In my case, as an artist, I wanted seclusion. I really didn't have a product. I didn't have anything that anyone was*

*really interested in. If anything, I had a personality that people were interested in. I had pretty much left painting behind. I began to get interested in constructing sculpture, constructing ideas. What I have in my mind is just the sculpture that you can inhabit or live in. You can actually make a life inside of it. There's no electricity, of course, no running water.*

## BUILDING A WORLD OF IDEAS

In the mid-eighties, Charlie's sculpture-making became energized after taking on a new form. He started making the spiral DNA strand sculptures from the boles of young pine trees sprouting on his land. As he was clearing the undergrowth from an old field, he discovered that the young, straight trunks would peel easily, providing a straight smooth pole. After saving the wood pieces for a year, he began putting them together in a hexagonal shape, later switching to a triangular form, carefully wiring each level together for structural stability, while at the same time letting the otherwise rigid material twist, lean, or bend over.

*By '89, I had a large body of work, some large pieces. I started making them go out and around, playing with balance and illusion. It was becoming very exciting to me. I realized right then that I had gotten something that would make me happy the rest of my life.*

Charlie's sculptures received enough attention to be included in a few art shows and galleries, but many of the larger pieces never sold, and eventually the physical demands of cutting and tightly wiring the pieces together proved too demanding. "So I quit trying to sell them, I just started to keep them." says Charlie. Eventually, some were used as armature in his magnum opus—the concrete and bottle sculpture-structures.

## SCULPTURE TO LIVE IN

One of the jobs Charlie had in construction was to build concrete forms. This requires a lot of stamina and patience, because poorly built forms break apart easily when a heavy load of wet, vibrating concrete is dropped inside. "I thought, if I can ever learn to use concrete without building a form, then that would be something: free-form concrete," explains Charlie.

*I found that bottles allow you to do that, as well as chain-link fence [as armature]. It gives you something to build with, not just the concrete. The bottles weaken it, but they also extend it, because they make it a lot, lot lighter. I've gone and put up stuff that I wasn't sure it was going to work. I've torn up more stuff around here than you can imagine, just experimenting with shape and form and balance. I'm really just an intuitive engineer, you might say. I don't know materials, which is good, because that way I'll use anything.*

Charlie started building these glass and concrete structures about eight or nine years ago, using bottles collected from friends, the local cafe where he eats his daily meals, and the honky-tonk down the road.

## WONDER AND AWE

Today, Charlie is probably best known for his bottle and concrete constructions and also for the extreme way he lives, completely off the grid, without phone, electricity, or water. Yet for someone who intentionally separates himself from what he believes are unacceptable compromises with society, he nonetheless receives and enjoys a lot of visitors. Each year an art professor from Lamar University in Beaumont brings his students out to see Charlie before assigning them a concrete

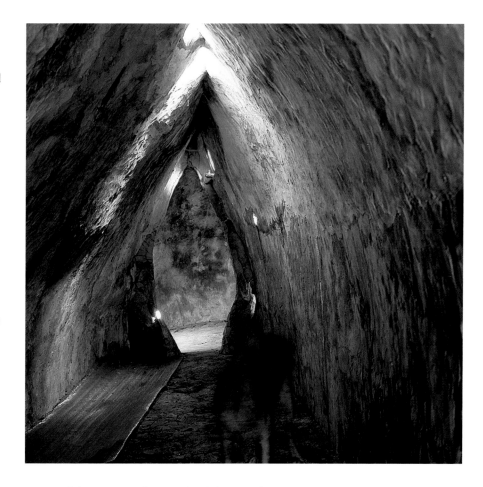

project of their own. Well-known local photographer Keith Carter also introduced his students to Charlie, who has been the subject of many of his photographs.

To Charlie, it's the hometown visitors who matter most. For years, children wandering through the woods have stumbled upon Charlie's strange encampment, on bikes, with pellet guns or fishing poles, exploring in the random ways that rural youngsters have always done. "I didn't go out and invite anyone," says Charlie, very

Tsuze the dog ambles down a tunnel to the Volcano Room. (Photo Janna Fulbright)

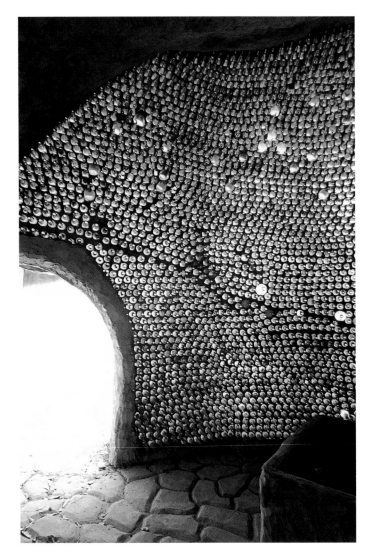

mindful of the appearance of anything improper regarding kids and a "crazy old man in the woods."

*I didn't allow them to camp out or whatever, but they kept on coming, and now all the children in Vidor know about me. Some of these kids who first started coming are now thirty-five years old. They were the ones that first got me known in the community. Because all I'm doing is playing. I'm having fun. I'm playing and employing ideas that don't have immediate consequences. Day to day, I really didn't plan anything. I'd get up and feed on what had happened before, trusting my intuition, mimicking the work ethic of a bee or ant.*

Most of us aren't very good at experiencing something radically new or different. At least most of the time it's hard for us just to lean into the experience itself and see where it takes us, but if we can manage to step into Charlie's world for a moment without relying on our analytical apparatus, we may discover something new.

*Maybe society will forgive me, I don't know, maybe if I produce something that will be a benefit to the community. That's my life's hope, at the end of my life to be able to give something back to the community and to everyone, if I can. Art is discovering truth. That's how you bring more knowledge into the general consciousness, and that causes, in turn, this culture to be less fearful and less warlike. I just hope when I die, people have a little sense of wonder and awe.*

Deep green light shines through the wall of the bottle room.
(Photo John Fulbright)

If land was his father's legacy, then perhaps what Charlie will leave behind is a vivid testimony of someone persistently committed to creativity on his own terms. By returning to the familiar climate and natural

surroundings of his home, he was able to whittle his own physical needs to the bone and thus was not so dependent on support or approval in order to pursue his ideas and abilities as an artist. It could even be argued that the extreme or primitive way he has chosen to live is an inseparable part of his art form, necessary to the fulfillment of his unique built landscape. Does living without running water and electricity really provide him with more freedom as an artist? It may be that Charlie's ideas and the memory of his outlaw purist philosophy will be the things that last, for the structures themselves are as fragile as the life that built them.

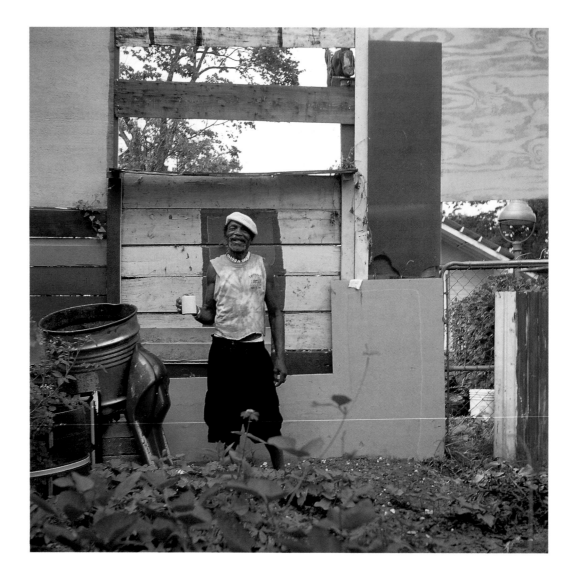

Meet Mr. Cleveland Turner, the
Flower Man of Houston.

# The Flower Man

Everyone knows the Flower Man. Mr. Cleveland Turner has spent the last twenty years decorating a series of homes and yards with such joyful extravagance that it would be hard to miss him, even in a big city like Houston that tends to overlook his kind of neighborhood. Today he is regarded both in Houston and all over the state as a genuine folk artist, local treasure, and the best-known ambassador for the Third Ward.

There aren't enough words to describe and catalog the innumerable details and items Cleveland employs to decorate his property. His simple wood-frame house, painted canary yellow with John Deere green trim accenting the fascia and windows, stands out like a giant bright piñata on a gray day. Starting at the curb is a series of layers in the form of fences or borders to accentuate the approach to the house. At the curb, sections of ready-made wooden trellis panels painted Pepto-Bismol pink are propped up like a picket fence, with floor registers used as accents on either side of a bright daisy centerpiece. Next, the sidewalk is painted in different solid or polka-dot squares to suggest an entry carpet or welcome mat. Along the sidewalk, cylindrical concrete corings are also painted and set in the ground to edge a flowerbed filled with cotton plants, gourds, chile pequins, and zinnias. Behind this floral display is a four-foot chain-link fence draped with large foil Christmas garlands and other decorations. Each of the front steps to the porch is painted a different color, and the railing is also used as a backdrop to display more of the uncountable number of found trinkets, toys, plaques, signs, artificial flowers, shiny bicycle wheels, and bows. The porch itself is nearly smothered by a colossal sour orange tree on one side and stalks of a large banana tree on the other. At the far right corner, a life-size plastic sarcophagus of King Tut and part of a toy kitchen stove climb halfway up the trunk of a tall pecan tree. As you pass through an entry hoop made from PVC pipe and covered in Christmas garlands, a path of many-colored carpet remnants protects your shoes from Houston's sticky clay gumbo soil.

Once in the side yard, you are surrounded by flowers: old heirloom roses like Seven Sisters, grown from cuttings from Cleveland's mother's yard in Mississippi; fruiting trees; and old-fashioned annuals including four o'clocks, vinca, and impatiens. In the back of his long narrow lot, a garden patch is set aside for a few of the essential southern vegetables, such as black-eyed peas, okra, candy yams, peanuts, corn, and even poke salad. A large plastic trophy fish hangs above two chicken coops, and behind the vegetable garden, painted plywood panels form tall backdrops decorated in colorful, irregular geometric patterns reminiscent of traditional African-American quilts. A fence between his property and a neighborhood park has been converted to an outdoor gallery. Both sides are used to display brightly painted murals, backdrops for other decorative items, and remnants of floats from Houston's famous Art Car parade.

Mr. Turner's Third Ward home is all about curbside appeal.

(*right*) A pharoah surveys the scene from the pecan tree.

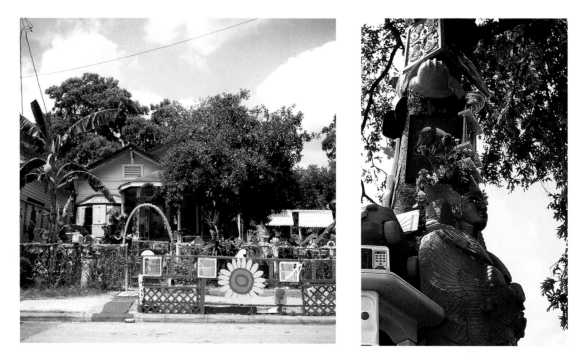

A big red cow poised on the ridgetop of the house calmly surveys a world so wild and wonderful you can hardly stand it. Completing this rainbow tableau is the spectacular presence of Cleveland himself, who often greets visitors in his own color-coordinated outfit, complete with top hat, vest, and, best of all, a delighted smile and expression. Everything in his yard and home seems celebratory and inviting, like a special party with extravagant decorations, and Mr. Cleveland Turner seems genuinely happy that you came.

### BEGINNINGS

Cleveland's love of flowers, color, and his knowledge of gardening came from his mother. "She said a house wasn't a house if it didn't have flowers, and that was

her belief. She used to get us to pull the weeds in her flowers," he recalls. The other children were careless in their chores, stomping down the plants behind them as they weeded in front, but Cleveland was careful and paid more attention. "I come to be her special one," he told us. The Turners had a traditional swept-dirt yard in Mississippi. Cleveland remembers his mother working in the garden. "[The yard] was sugary sand. She just swept it with a broom. We used to get out there and keep it clean and then shoot them marbles. She kept the flowers and roses around an old barbed wire fence."

### COMING TO THE BIG CITY

As a young man, Cleveland worked in a livestock auction barn in Mississippi and was fascinated by the Texas

longhorn cattle that were sold there from time to time. He decided that if he ever got the chance, he would travel to Texas to see for himself those famous steers roaming free. His opportunity came when a sister offered to get him a job at an auto assembly plant in California and even sent an airplane ticket so he could join her out west. Cleveland decided to take a short detour over the weekend on his way there to visit a friend in Houston, and maybe get to see those longhorns before showing up for his new job on Monday. That weekend detour lasted more than twenty years.

"My friend came to pick me up at the bus station about eight on Friday morning," remembers Cleveland.

*We walked back to his house. He had a fifth of Thunderbird wine and I started drinking then. In Mississippi, you had to go eleven miles to get anything to drink. When I got out to Texas, why, you got a liquor store here, a church there, liquor store there, church here. I said, "Woo! I'm in heaven!" Instead of eleven miles, I just go a block and get something. My drinking wasn't killing heavy then, but I was working on it. But just on down through the years, gradual, gradual.*

By Saturday afternoon he had sold the airplane ticket and proceeded to enjoy a full-blown binge. Cleveland's lost weekend forecast a serious downhill slide over the next couple of years. When Monday morning came, all he had was a hangover and a sick feeling of remorse as he found himself stranded in Houston. His increased drinking eventually undermined the good jobs he found afterwards. Cleveland explains,

*I saw I was going downhill, and I thought I could pull out anytime I wanted, and I went on skid row. A sick,*

Cleveland's art expands to the park next door.

*sad mind [to make] somebody drink like that. I stayed on skid row seventeen years.*

Cleveland joined the increasingly visible numbers of homeless people wandering the streets, vacant houses, and empty lots of Houston in the late seventies and eighties. His diet consisted of Church's Fried Chicken scavenged from dumpsters, and his daily occupation was gathering scrap metal and bottles in an old grocery cart to pay for Thunderbird wine. He might have become just another sad, nameless statistic had not a brush with death changed his destiny.

**A NEW START**

By the early eighties, Cleveland's drinking had reached

the first stages of alcohol poisoning. Some days, he would pass out cold and only another drink would revive him. One day he collapsed "like a dead man," he says. A woman going to work saw him on the side of the road and called an ambulance. Cleveland was in Saint Joseph's Hospital for three weeks before he woke up from his alcoholic coma.

*So I woke up one morning and I didn't know where I was, and a lady came in there with a white uniform on, and I said, "Ma'am, could you tell me where I'm at?" And she said, "Mr. Turner, you don't know where you're at and you been in the hospital going on* three *weeks?" I was just becoming civilized, and I didn't know what happened.*

The better he began to feel, the more restless Cleveland became, and soon he was eager to leave the hospital. A nurse warned him, "You know what, Mr. Turner? You start with that drinking again, and you'll be right back." Cleveland then began to understand his options: "That helped me to keep that wine out of my mouth. Just that harsh feeling. So far, I haven't had a drink, and that was in '83."

### THE VISION OF THE BIG PRETTY THING

Besides the stern nurse's valuable advice, Cleveland received a big gift to help him start a new life after leaving the hospital. He experienced a vision that showed him the beautiful activity and occupation that would save him.

*Where my art came from is, about three days before I got dismissed from the hospital, about three o'clock early that morning, I had this pretty vision: it was going around like a whirlwind, picking up stuff, taking it up*

*high and making it look pretty, and this vision was showing so many people just looking out at space, you know, just wanting to know, What is that? The vision was just that clear. So I said, this big pretty thing was just getting me ready to have something to do when I get back.*

That night, Cleveland vowed,

*If I keep that wine bottle out of my mouth and the good Lord takes that taste [desire] out of me, I'm going to get me a little old house and just pick up junk and hang it on the house and see will it look like the vision in my head. And I tried it. I tried just picking it up, hanging it up, and it just didn't look good. And then I started to washing it off, painting it up, and it started to looking better then. And that's the reason why this house you see here now, is on account of that vision in my head. I made this vision in my head.*

### THE FLOWER MAN

According to Cleveland, from that day on he never strayed from his desire to fulfill his vision. Help came at just the right time to get him started. In outpatient Alcoholics Anonymous meetings he met another recovering alcoholic, a wealthy man whom he calls "Mr. Joe." Mr. Joe and he became friends, and soon Cleveland had a job as the gardener at his new friend's large West University home, where he continued to work for twenty-two years. With the money he saved, he was able to rent his first house and set to work expressing his vision.

Cleveland's routine during those years took on a comfortable pattern. With an old bike custom-fitted with large wire baskets on the front and rear, he rode the eight miles each way to work, checking out the curbside trash on the way for castoff items he could use

as decoration. Cleveland prefers the thrill of the hunt in locating his treasures, rather than buying them at garage sales or receiving them as gifts. After a few years he moved to another house on a corner lot, where his gardening and artistry really took off.

*I was as broke as a peahen, but I said I was either gonna die with the money, or die with the house, one of the two. And so I said, when I die, I can't take that with me no ways, so I'd rather have a home, because I get more enjoyment out of decorating than I would saying, "I got such and such money."*

He rented this second house for nineteen years. His most cherished possession was a collection of antique plows that he brought back from Mississippi during the five years he traveled back and forth caring for his aging mother. By this time, Cleveland was receiving attention from folk-art organizations such as the Orange Show Center for Visionary Art, and even schools regularly brought busloads of children on field trips to meet him and see the yard. When his plows were stolen, around 2001, Cleveland decided it was time to move again. That's when Project Row House invited him to be a neighbor.

Project Row House began in 1992 with the reclamation of twenty-two dilapidated shotgun houses in the heart of the Third Ward, one of Houston's traditionally African American and chronically impoverished neighborhoods. The project's goal is to revitalize the neighborhood by providing low-income housing and space for nonprofit organizations, and to integrate art into everyday life. The renovation helped preserve a historical architectural form (the shotgun houses) and also offered spaces where artists could create and display art. In Cleveland's case, they knew he needed a home of his own that could become a more or less permanent installation for his art, without fear of eviction or vandals. In exchange, Cleveland has expanded his decorative artistry to the public park next door, and his work attracts attention to both the Third Ward and Project Row House programs.

At the beginning, Cleveland's house (although newer than the other row houses) was in sad shape. Slowly ruined from years of use as a crack house, it was spruced up in 2003 by more than thirty volunteers who helped Cleveland clean out the debris, paint the walls, make repairs, and relocate the collection that he would slowly and deliberately apply to every surface, indoors and out. Cleveland appreciated the help, but he was adamant about arranging the treasures by himself.

Cleveland's arrangement of objects actually starts inside: the floor and walls of the front parlor are filled

Cleveland rides his Flowermobile in search of castoff treasures.

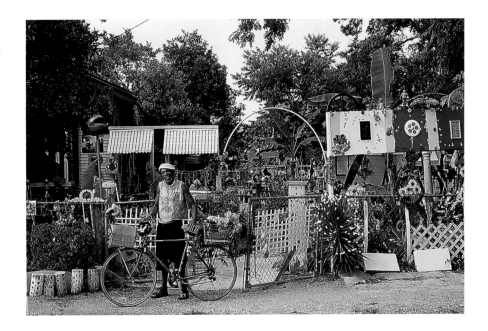

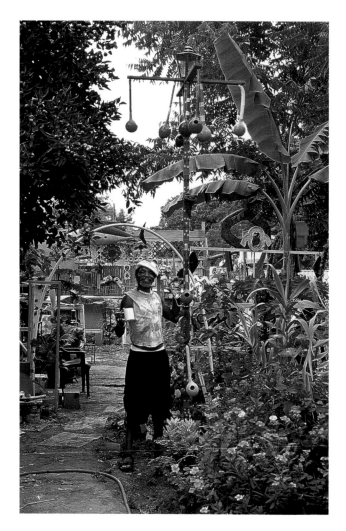
The yard preserves memories of his mother's Mississippi garden.

pulling fried chicken scraps out of a dumpster, he rescues plants from the trash outside a downtown florist. His gardening skills are evident in his ability to revive plants and use them to a wonderful effect.

## LANDSCAPE AS STORY

Like many folk artists, Cleveland receives a lot of attention simply because his home and garden seem so wonderfully outrageous and free from convention. Although the sheer volume of things displayed in his yard makes the arrangement seem random, the story Cleveland tells his visitors points to the deeper themes that guide his artistry. First, there is fulfillment of the vision that he received in the hospital, which still seems to inspire his work and remains as the centerpiece of his often-told narrative. This mystical component to his creativity adds to his appeal as a folk artist. Cleveland's visionary experience is similar to that of Felix Fox Harris, another folk artist (now deceased), from Beaumont, Texas. As John Beardsley relates in *Gardens of Revelation*, Felix believed that his "appetite for alcohol disappeared with his vision. 'God took the taste right out of my mouth.' Like Rodia's towers, Harris' work seems in part to have been the expression of reconstructed self-esteem. As he took nothing and made something out of his life, so did he make his art, finding various kinds of industrial and domestic discards and fashioning them into . . . [a] colorful assemblage of treelike totems."

Second, many of the plants (cotton, gourds, peanuts, old roses) and even some of the objects in the garden, like straightening combs, flatirons, wash pots, and prehistoric canned figs recovered from his mother's barn, are used by Cleveland to recreate a version of the traditional landscape of his Mississippi childhood. Colors, toys, decorations, and castoff items represent an abundance he probably never experienced in those old times,

with carefully placed toys and vessels with silk flowers, Nutcracker and Barbie dolls, antlers, Mexican masks, Avon perfume bottles, Kewpie dolls and other carnival toys and prizes. Although retired from his work as a gardener, he still makes daily collecting journeys on his special bicycle, the Flowercycle. Today, instead of

but the plants, old farm tools, chickens, and family me-mentos—all within a swept dirt yard (though there's not much bare dirt available)—preserve the best memo-ries of childhood. Enclosure, color, familiar flowering plants, and vegetables, together with roadside hospital-ity, are essential components of a rural African Ameri-can yard. In Cleveland's yard those features have been exaggerated and embellished to such a degree that even people unfamiliar with the more humble country ver-sion can appreciate them.

Cleveland's first introduction to city life in Houston led to his downfall. Later, the same city lifted him up with a steady supply of castoff treasures for his ever-changing installation, something that would not have been available in a small town. With the city also came an urban sophistication that could appreciate and sup-port his special kind of vivid artistry.

Cleveland sums up his pride in his achievement:

*Why I don't put a price [on tours of his place]? You paid your price when you come by and see it. I get that much joy to [see you] come and see what a little old wino done. You know that makes me feel good! Eat out of Church's chicken dumpster and all, and now you got people from out of town to see what you done did! I have to pinch myself to see if this really happened. That's the way I feel.*

And seeing Cleveland's yard gives *us* joy.

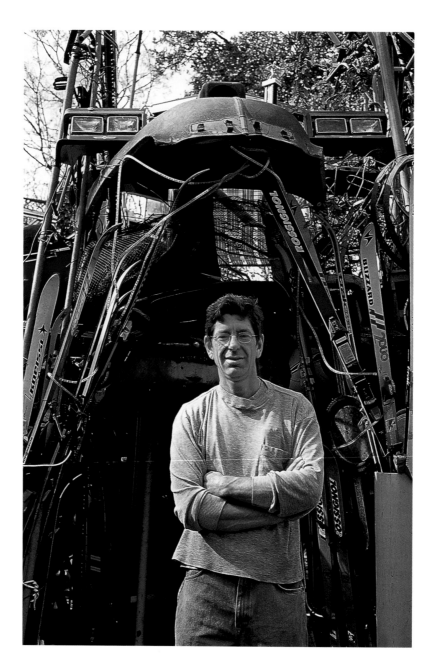

Vince Hannemann is the dean of
the Cathedral of Junk.

# The Cathedral of Junk

In many ways, it is easier to find the Cathedral of Junk on the Web than in real time and space. The actual Cathedral is not noticeable from the street because Vince Hannemann built it in his back yard in a working-class neighborhood in far south Austin. The virtual space is more accessible because fascinating constructions like his tend to show up on Web sites, blogs, and Internet lists devoted to outsider art and other things considered outlandish and peculiar. Indeed, Vince has found it a practical necessity to post visiting times in the hip local weekly newspaper in order to have some control over the steady flow of people who have been showing up in his yard for more than sixteen years. In some communities, what a person does in his back yard might remain his own darn business, unless it's a public health hazard; however, because Vince has submitted to virtual publicity as well as the interest provided by word of mouth, his private backyard garden project has become a public art phenomenon.

## CHINESE-PUZZLED TOGETHER

How do you describe something like the Cathedral of Junk? A visitor would hardly know where to begin in a physical exploration of the site, and verbal descriptions can likewise be confounding, as the sheer number of details simply overwhelms any generalities. Vince admits that the whole thing is like a giant bowerbird's nest made of shiny metal items all wired together. The basic shape is a series of compact arched domes formed by scrap-metal trusses. On the domes, innumerable objects have been wired and woven, similar in a way to those unruly macramé wall hangings of the seventies. Instead of organic materials and hemp strings, the filigree of details is provided by metallic flotsam and jetsam from our consumer culture: CDS, flatirons, snow skis, hubcaps, bicycle parts and wheels, car bumpers, kitchen utensils, and tiny toys. The layering and encrustation of the invisible support structure appear to have no beginning or end. The spaces, or rooms, themselves seem small and cramped, yet somehow it's easy to get lost and become confused about which way to go next as the proliferation of unexpected items begging examination keeps the explorer distracted. At the same time, the desire to see more keeps you going all the way to the top tower, which brushes just beneath the lower craggy branches of the massive ancient live oak filling the back corner of Vince's yard. "Vince's site is extraordinary to me in its elegance," says Susanne Theis, director of the Orange Show Center for Visionary Art. "All the disparate objects merge in a new form that resonates with the powerful associations of a place of worship. Its monumental scale and the countless number of objects that make it up leave me breathless nearly every time I see it."

## THE POWER OF A NAME

Like other creators of yard-based projects that have taken on a life of their own, Vince has had lots of practice telling his story. Rather than reciting a set piece or

Vince describes his structures as "Chinese-puzzled" together.

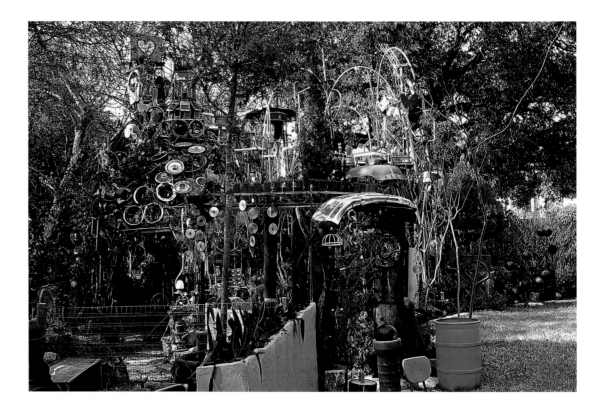

spiel, Vince delivers an honest narrative that captures the matter-of-fact chronology of how the Cathedral came to be, as well as suggesting the mystery and meaning behind it that still eludes his own complete understanding. As we have seen in other elaborate yards, the mundane and the sublime coexist within an inevitable tension that surely contributes to the energy and appeal of creating something outside the every-day workaday world.

*I've been asking myself this question: Why am I doing this, exactly? What is it? It's been a journey of self-discovery, but I really didn't think about it consciously like that at the beginning. It really started out as a pri-*

*vate little sitting area, and it just grew from there. I don't think it was anything more complicated or mysterious than that. I began building it in 1989 toward the back of the property where an old chinaberry tree used to be, and I put hubcaps along the fence. Then it became a single tower that arched over, and then arched over again. The reason it's like a maze is that I always just expanded it a little bit at a time. I kept telling myself, Oh, I'll just do a little bit more. That's the way it starts off, very loosely, everything just gradually Chinese-puzzled and tacked together. Then I just keep adding more stuff to it, wiring them on, so everything is just sort of connected to everything else. I begin with PVC*

*[pipe sections] to sketch out the shape, but then I replace those with heavy metal before I come back with other stuff to fill in. I really do think that it's the Chinese puzzle effect that really holds it all together. The swirling [roof ventilator] fans kind of remind me of onion domes. A lot of shapes seemed classic in that way, and that's why I named it the Cathedral of Junk, because at the time, I was collecting flatirons, and they have that perfect Gothic arc. So I thought, it looks like a church. I ought to copy that form. The same with the snow skis and these crutches. They have a nice Gothic shape and they're symbolic; you know, "Hang up your crutches and be healed."*

Continues Vince,

*I didn't really want it to get this big, but it grew to the point where somebody asked me, "What do you call it?" And when I called it the Cathedral of Junk, well, that was it. People started coming almost immediately.*

**WHAT THE WORLD THROWS AWAY**

When Vince got inspired to build that first little patio, he had a treasure trove of materials at his fingertips. "Oh, for the first few years, I really collected stuff," Vince remembers.

*I worked for Ecology Action at the landfill. We didn't actually get a salary. Our salary was the stuff that came in there, and we were the only people allowed to scavenge, so basically everything that came in there was ours. There was a guy visiting one time from some South American country, and he told me, "Boy, we just don't have junk like this lying around to build something like this with. All this stuff are things people would probably use, either melt it down, beat it into*

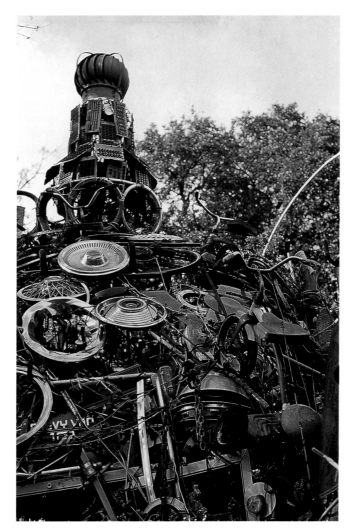

*something, or make something out of it, but not just lying around."*

"Shortly after the contract with the city landfill was up, I quit dumpster diving altogether," continues Vince.

Tubing and dangling metal objects resemble a giant bowerbird's nest.

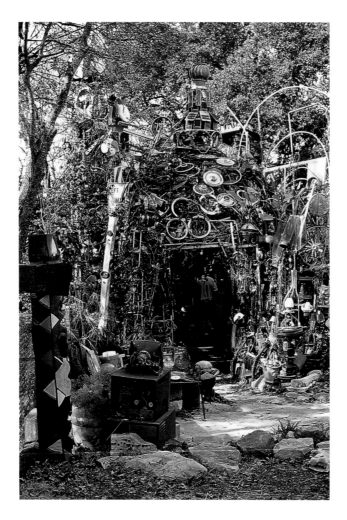

The main entrance beckons
visitors inside the Cathedral.

sism, most recently summed up in a marketing slogan
for local businesses, "Keep Austin Weird." Weirdness
in Austin most often gets expressed in a deliberate poke-
in-your-eye way for outrageous effect alone. Not sur-
prisingly, the Cathedral of Junk is on the Keep Austin
Weird Web site, but Vince sees the Cathedral as much
more than just a crazy tourist attraction.

*I think they should call it "Keep Austin Diverse" in-
stead, because I think it's important to support differ-
ences and variety. Even if I were the grumpiest guy in
the world, and put a big barbed wire fence around here,
people would still come. You never know if or when
people are going to show up, despite the way I try to
control it through the newspaper ad. And I could fight
it and dig in my heels and say, "No, absolutely not."
But what a struggle that is. Besides, I get to represent
Austin to people from all around the world, which I
think is a pretty important thing to do. They don't need
to speak English or anything. There was this group of
Japanese teachers that came over one day, and they
cracked me up. They were giggling and laughing the
whole time. It was contagious, even though I didn't
know what they were giggling about. But who cares?*

### IN THE EYE OF THE BEHOLDER

Over the years, Vince has observed the reactions of
enough visitors to be able to speculate about why peo-
ple come to the Cathedral of Junk and what it might
mean to them.

*I think it makes them happy to see somebody or some-
thing that gives them a little bit of freedom. They think
that maybe they could do something, too. A lot of De-
pression-era people come by, and they relate to the recy-
cling point of view, and also I've had people cry, because*

*There was a specific point when I was thrown out of the
dumpster by a nun at Saint Vincent de Paul. I thought,
I think I've reached a limit. And besides, it's a lot more
special when people bring stuff here. It's better that way.*

### KEEPING IT WEIRD AS AUSTIN'S AMBASSADOR

Austin cultivates a homegrown form of playful narcis-

they're overwhelmed by something in it. They didn't expect to cry and they can't talk very much about it.

For the real answer, just ask the kids. It seems to make them happy, and they are the best audience. I've had the whole second-grade class from Saint Elmo Elementary over here, and that's when I get my biggest kicks, because they don't ask the deeper questions. They just enjoy it. And I think, you know, it's going to stick in their heads, and hopefully it's going to help them if they remember, "Well, that guy did it!"

I've actually come to think that what I'm doing is important. I want to let people know that there needs to be stuff like this in the world, and more of it. Whatever led me to do this—maybe I'm a fool and have no self-control—but I still think we need the freedom to make a mistake and not know what the outcome might be. As a friend of mine once said, "Vince, the world is never going to end as long as somebody is doing something like this."

Not everybody agrees, of course. Most of Vince's neighbors are supportive, but there is always that person who is outraged and offended by actions and people who persist outside the norm. "I've heard things like, 'How come you can do that? You shouldn't be allowed to do that. There should be a law!" says Vince. "People are afraid of the unknown. The unknown is not that scary, and you can survive it if you have a little faith."

At different times, people have tried to shut the Cathedral down. Once someone sent over a city inspector to make Vince dismantle what he called "A Zen Garden of TVs."

I had about two hundred TVs in a mound around a patio where there were some irises, too, but it wasn't anything formal. But the inspector said it was just a pile and it couldn't be just a pile, and I had to clean it up. And I said [pointing to the Cathedral], "Well that's just a pile, too." And he said, "Well, it's off the ground and structured. I can't go back to my superiors and defend this pile of TVs." I said, "What kind of expert are you exactly on piles?" But I finally gave in because, at that point, I realized that it is a public work of art, and like it or not, I have to compromise.

## COMING UP WITH ANSWERS

Now that the Cathedral of Junk is well into its second decade, Vince's reflection on what it all means has had time to change and evolve just as the structure itself has been dismantled and rebuilt from time to time. A grandmother's recent death and a trip back for her funeral in the north Bronx, New York, where he spent his earliest childhood, has revealed the influence of his urban Italian roots on his art. Here is where Vince first became aware of the patterns of neighborhood life— front-yard display of decorative objects and plants, Catholic symbolism expressed in bathtub niches and statuary, and curbside interaction with friends and family. "People making the best of what they had," sums up Vince.

It's about community. I see the same things here in my neighborhood, except, instead of Italians, we have Mexican Americans. It's mixed, really. I try to explain this, and I've gone through the same thing a million times here, and you start to believe your own propaganda about it. You think, This is the story I'm telling today, and then you go with it. But then you think, Is it really like that? I'm not quite sure. There are all the pat questions: Why and when did you start it? So I had to come up with answers. And then my answers kind of change as I figure it out a little bit more.

Somehow it's easy to get lost here.

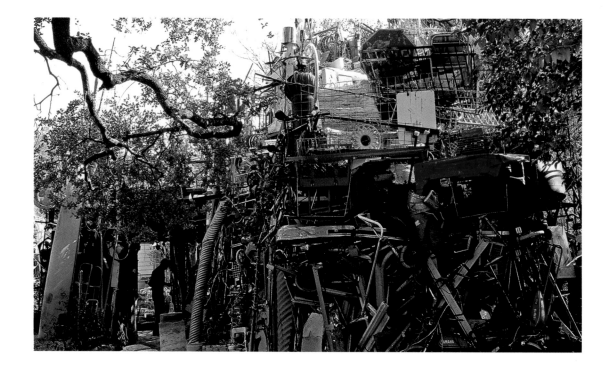

**THERE ARE MANY KINDS OF SACRED GARDENS**
It's difficult for many people to accept how a conglomeration of junk could possibly have a higher purpose. They don't understand how these idiosyncratic private projects available to the public have an inherent power to transform their makers. Like the action of yeast that slowly transforms raw materials into bread, the process of working and rearranging gradually changes the creator, often in ways that are understood only in hindsight. This is true in Vince's case, too. "I suffer from depression," he admits.

*Sometimes I think if it wasn't for this, I don't know where I'd be, exactly. It's some sort of anchor. It's something that helps keep me doing something. On the other hand, it can be depressing to be around, too. I see work that I still have to do, and I get tired. But I try to focus on the happy part. I get a lot of spiritual stuff out of this. I feel like God talks to me here. I don't have that "voices in my head" kind of thing, but in a way, I do believe that God told me to do this. This is what I'm supposed to do, for a purpose that I don't know what it is, exactly. And I don't need to know what it is. That's*

*where the faith part comes in. I have some faith that there's a reason, and it's a good one. It's not about suffering; it's about fun! This isn't some sham. I'm not being tricked into something, and I'm not tricking others. Healing is spiritual, and it's healing my mind. This is something I can share with everybody and that they want to see.*

**ADMISSION IS FREE**

Little did Vince know, when he began his little patio retreat more than sixteen years ago, that visitors from all over would put his Cathedral of Junk, along with the State Capitol building and the Governor's Mansion, on the list of sites to see during their stay in Austin. Along with the out-of-towners are schoolchildren by the busload, hipsters and artists, grandparents, and neighbors, each making the pilgrimage to a small street off the main road just to see a handmade, one-of-a-kind monument to one man's passionate search for meaning and peace of mind.

It's true that Vince gets a lot of strokes for his achievement, yet his life's project has been emotionally expensive, too. Vince has grown accustomed to the constant invasion of his privacy, but it's been hard on his personal relationships. He refuses to charge admission and feels strongly that what he's offering should be free of any monetary transaction. He offers public access to his Cathedral as a gift, and you can take it or leave it as it suits you.

Vince is looking forward to finishing the final remodeling of the last dome, so that he can concentrate on draping and embellishing the framework with all the tiny things that make the structure so interesting. He's invited collaboration with his public by accepting most random items they bring to the site as offerings. His other artwork is expanding into collages and sculptures that are for sale. Mostly, as he says, it's about community. "I'm very protective and indulgent of the people who come over, and even though I call them tourists, I consider them part of my extended family." In a world that seems frayed and battered to the breaking point, we can be grateful for experiences that dissolve differences and remind us that we are all one family. Maybe being a little weird helps us remember that.

Mr. Loya, El Mero Maestro,
proudly surveys his creation.
(Photo J. Nokes)

# Casa de Azúcar

Perhaps one day on your way back to El Paso from Alamogordo you caught a glimpse of something—right there—on the access road just below the elevated part of Highway 54. The sudden question "What was that?" may have crossed your mind, but soon the traffic streaming into El Paso's northeast side demanded your attention, and that was that. At least until the next time your route included rushing down what locals call the Patriot Freeway. Or maybe you were traveling on that same highway at night and you noticed spotlights beneath you shining on something—a building, a sign, or a mural—it's hard to tell at 70 miles an hour, but it didn't make sense. Was there a church over there? The light came from one of those remnant pocket neighborhoods, marooned by the construction of the highway on one side and the blank sprawl of Fort Bliss on the other. Highway ramps and one-way streets make it hard to know how to find your way back into those neighborhoods. Anyway, was anything special supposed to be down there? You probably meant to come back some day and check it out, but something always seemed to come up that was more important. "Maybe later," you told yourself, "when I have time."

## THE FLOWER BORN IN THE TRASH HEAP

The world is full of unexpected visions, but we often miss them because we've become numbed by the steady bombardment of popular culture or worn out by the frantic nature of our modern lives. These are two familiar conditions that, as Christopher Lasch writes, "give rise, not to enlightenment and independent thinking, but to intellectual passivity, confusion, and collective amnesia."[1] If, in this instance, we would just give way to our impulse to stop, turn around, to go back and see, we would be rewarded by the experience of visiting Mr. Rufino Loya Rivas's stunning personal tribute to the city of El Paso. A friend of Mr. Loya describes it as "la flor que nació en el basurero" (the flower born in the trash heap).

The Loyas' small wood-frame house is on the corner of a street that dead-ends into the freeway's eight lanes. On the west side, the sky is filled with the looming view of the massive Franklin Mountains, which deceptively appear to touch down just a few blocks away. Though the house is as white and clean as a marble sepulcher, that's not what a visitor notices at first, because the modest structure is enclosed inside an elaborate system of carefully painted concrete block walls and columns topped with ornate finials. Every surface is embellished with molded concrete flowers, leaves, garlands, and other rhythmically repeated decorative motifs, all painted immaculately white, though edged with a light blue shadow trim that cleverly draws out the details that may otherwise become indistinguishably bleached out by El Paso's perennially bright, sunny skies. On the east side, Italian cypresses (those familiar sentinels of El Paso's landscape) stand side by side,

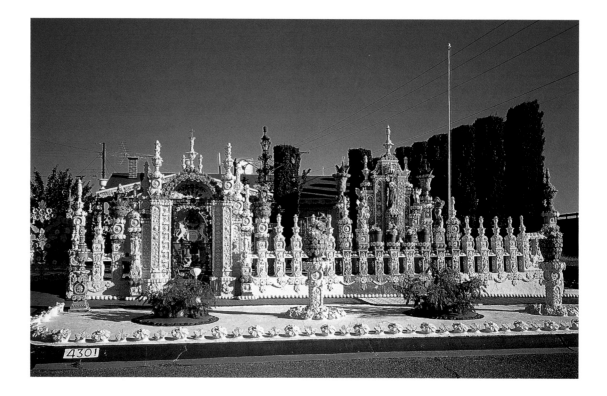

their tops somehow crisply sheared just below the power line high above, forming a tall wall of green. They provide a screen from the elevated deck of the highway, but perhaps more important, the trees also serve as a dark green backdrop for the most intricate of the constructions: monuments dedicated to the Sacred Heart of Jesus and the Virgin of Guadalupe.

These roadside shrines are marked by an intensity of both creation and style that clearly shows their connection to the great churrigueresque (the Mexican form of baroque) retablos or altarpieces that adorn so many Mexican colonial churches. They have been built in a hierarchical order of ascending panels and framework,

all emphasizing the centerpiece, where the statue or *retrato* (image) is displayed. Flowers, angels, and walls with graceful swooping swags are just some of the opulent uses of ornamentation contributing to a scene of magnificent adoration.

In the front yard where the driveway was, a double metal gate is decorated with a floating lacy filigree of aluminum metal flowers and vines. The former dirt driveway and the sidewalk have been paved in a red tile that matches the roof and other accents. Even the curb is painted. Concrete flowers dot the perimeter like hard candy candle holders on a grocery store birthday cake. An elegant iron gate with two heraldic lions as the cen-

terpiece invites visitors to enter beneath a red concrete archway. Inside, the small grass area bordered in tiles serves as a simple carpeted foreground to the house, which has the same metal flowers elaborating the eaves and grillwork on the windows. There is nothing haphazard or unfinished about this creation. Everything is pristine, freshly painted, swept and washed. The whole site is so stunning in its execution that one visit is not enough to take it all in.

## WHERE THERE'S A WILL

"This house is like a wedding cake, you know. That's why people call it *Casa de Azúcar* [House of Sugar], because they think it looks like the decorations on a cake," Mr. Loya explains to his visitors above the pulsing din of the highway.

*Everything was just dirt when we bought the house [in 1973], and it was really ugly. But I didn't have a lot of money, so I had to do things little by little. Just about all of this was my own idea. But the most important thing to be able to do this is to have the desire, the determination to do it. You know the saying, "De querer es que poder"? Where there's a will, there's a way.*

Mr. Loya's first decorative improvement in his yard was a simpler, more rustic and folk-art antecedent of the sophisticated and elaborate constructions that came later. A picturesque painted brick arch has an angel perched on top. Inside the arch is a red and white pedestal supporting a bowl, and a red-painted olla that serves as a vase for flowers. The arch has red, white, and gray flowers and is framed by the tall Italian cypresses, with their trunks painted white. A curving red border embedded with pebble mosaics separates this decorative arrangement from the clipped lawn. "When

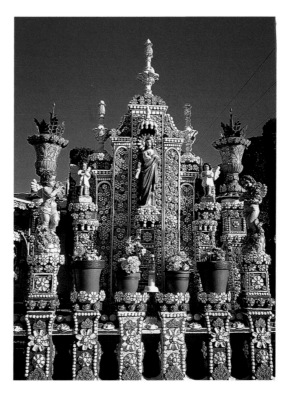

A monument to the Sacred Heart is embellished in the Mexican baroque style. (Photo J. Nokes)

I first started with this little shrine," recalls Mr. Loya,

*I thought, ¡Dios mío! How I would like to do more things. Since that time, I began to develop ideas of how I would do the rest. One idea followed the other, and the more I did, the more I wanted to do. The first thing was very simple, the most simple thing of all.*

Every day, for twenty-six years, Mr. Loya worked at the Levi Strauss factory, cutting fabric to make blue jeans. At night, on weekends, and holidays, he devoted himself to fulfilling his vision of what his property could become. His family was astonished. A story in

Mr. Loya's first creation is sheltered by Italian cypresses. (Photo J. Nokes)

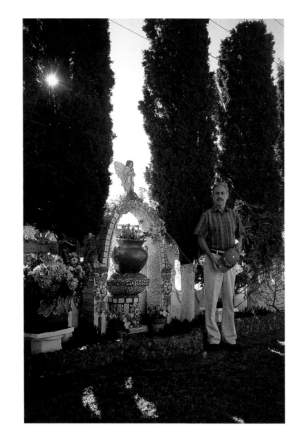

the *El Paso Times* reports his wife, Celia, saying she never knew how talented her husband was until they bought their home in northeast El Paso.

*He used to tell me, "Just wait until we have a home and you'll see what I'll do." And I used to think, "He never even picks up a hoe! What is he going to do?" But now I look at my house, and I think it's a dream.*[2]

Unlike some other creators of elaborate sites, Mr. Loya has a public modesty that prevents him from describing himself as an artist, though clearly he is very proud of his considerable achievement. "No, I'm just a worker, but I knew I would be able to do this because I had the desire to make it," explains Mr. Loya.

*There are many constructions like this. Well, not like this—better! In Mexico, for example, in Oaxaca, Guanajuanto, and Zacatecas. No one taught me. I just admired the churches and the work of the artisans in Mexico, and then I adapted it to my own ideas, my own imagination. But I had just seen them; I didn't know exactly how they were made.*

His walls began as plain cement block towers that were then adorned with concrete flowers and other decorations shaped inside custom wooden or metal molds designed by Mr. Loya himself. Next, he carefully painted them.

*I had to experiment after seeing them. Working with cement is difficult. At the beginning, I had problems with getting it just right, and I had to struggle with it. I used Portland cement. If you have problems when you begin, you feel afraid, and if you're afraid, you won't achieve anything. You have to keep on and on, rising above the problems. The determination has to always remain alive. And I had the desire to build something special.*

### LOYALTY AND AFFECTION KNOW NO BORDERS

Mr. Loya is from Juarez, which in combination with El Paso is one of the largest binational urban areas along the Mexican-American border. Mr. Loya recounts how his ancestors were among the founders of El Paso del Norte (the former name of Juarez) originally identified by the channel cut through the mountain range by the ancient flow of the Río Bravo, or Rio Grande, forming a natural passageway that eventually became a conti-

nental crossroads. In spite of the position of his fore-bears, Mr. Loya, like others before him and since, emigrated to El Paso seeking better work opportunities. Many come to this city as transients, military families or others just passing through, working awhile, never staying long. But Rufino Loya felt welcomed by his adopted city. "I love El Paso a lot," he explains,

*because when I came, everything always went well. El Paso welcomed me with open arms. So I thought, I have to do something for El Paso, to show my gratitude. That's why I put that sign: "These Mexican Art Works Are Made in Homage to the City of El Paso 1973–1998." Sometimes I find that lots of people don't like El Paso because they feel they are treated badly, or they have bad luck here, so they complain. And I say, "Hush! Don't say one bad thing against El Paso."*

Like border residents we have visited elsewhere, Mr. Loya feels no conflict in his dual affection for his birth-place and his adopted hometown. Both cities and the family histories that occurred there contribute to his identity. Other plaques positioned around the garden declare, "This is a little piece of Mexico" or "Keep El Paso Beautiful." The most touching and personal of all reads, "Dios Bendito Y Estas Humildes Manos Hicieron Posible Esta Obra de Arte de 1973 a 1998: Rufino Loya Rivas y Esposa" (God's blessing and these humble hands made this work of art possible). Once some American ladies visiting the site doubted he was Mexican. "Your yard is too clean. A real Mexican yard wouldn't be this neat," they informed him.

Rufino Loya's yard has gradually become a local landmark. Adair Margo, the owner of a well-known local art gallery and a fourth-generation El Pasoan, regularly brings visitors to see Casa de Azúcar on a tour

The yard is decorated in homage to an adopted hometown. (Photo J. Nokes)

she describes as "the best of El Paso." Among other dignitaries, these visitors have included the chairman of the National Endowment for the Humanities. The priest from the local Guadalupe Church came to bless the site, and many people regularly leave flowers in front of the principal monuments. Other visitors may not have the same VIP status, but they make their pres-

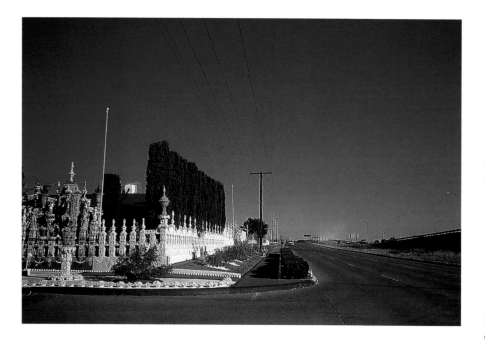

A shrine to the Virgin beckons to the highway traveler. (Photo J. Nokes)

site that is a memorial to his city, his heritage, and his religious faith. With the bravura of a dedicated artist, his own quick facility and achievement fueled the unfolding of a project that grew more complex and varied over time. Having mastered the difficulties of concrete art, Mr. Loya found he could express himself in other media as well. He drew the traditional portrait of Our Lady of Guadalupe. He designed an elaborate lantern candelabra, which he then had fabricated in Juarez. "I have so many more ideas yet, but now I'm old, and also I don't have any more room!" declares Mr. Loya.

*If I was young again, I would like to be an architect, to make something big and magnificent like a cathedral, here in El Paso, something that would be the most beautiful thing in all the USA. I sure would like that.*

Mr. Loya, *el mero maestro*, may not have built a cathedral, but El Paso should feel lucky that they have a citizen who loves his new hometown so much that he dedicated twenty-five years to creating a beautiful tribute that satisfied his exacting standards and would delight visitors from all over—at least those who take time out to stop and see.

ence on the site known in dramatic ways. Rufino remembers an especially vivid occasion:

*Two years ago, on December twelfth, a girl came [to the shrine to the Virgin of Guadalupe] at one a.m. I was sleeping when I heard the music, and I thought, What's going on? So then I put on the lights, and I saw them right here. They were singing "Las Mañanitas" [the traditional Mexican "Happy Birthday" song] to the Virgin, because that was the first hour of her feast day.*

### A MEMORIAL LANDSCAPE

Like an artesian spring provided with a constant source of clear water from many invisible underground rivulets, the inspiration that feeds Mr. Loya comes from many sources, emerging as a single, ardent elaborate

# Stories from the Panhandle

It's not always easy for someone driving through the High Plains to appreciate the wide-open landscape of the Texas Panhandle. The expansive flatness, the vacant air, and the seamless connection of earth to sky all contribute to a sense of unfamiliar and uncomfortable exposure. The uninformed visitor convinces himself that there is no reason to feel so small and insignificant when surrounded by all this space, and in self-defense retreats into numbed boredom, deciding instead that there is really nothing interesting to see. Other extreme landscapes like deserts or tundra may elicit similar responses from those who mistake simplicity of form for lack of complexity, but it's the vast scale of the scenery that tempts us to make this judgment. Huge forests can distract us from this feeling of being small, because up close there are so many details to examine at our own eye level.

There's no getting around the harshness of the Panhandle landscape. It includes 25,610 square miles of what were originally semiarid grasslands. In less than one hundred years, the region has been changed forever by mechanized agriculture that was especially suited to the infinite flatness. Except for the upper tributaries of the Red and Canadian rivers, the Panhandle has almost no watercourses, especially on the part called the Llano Estacado, or Staked Plain, which lies mostly east of a large geologic formation called the Caprock. What little runoff does occur is gathered in shallow natural ephemeral basins called playa lakes. In the winter, blizzards often roar in on 50-mile-an-hour winds to hammer the frosty ground, only to be replaced by scorching summer temperatures and drought. Most rain, when it comes, arrives in June and can range from twelve inches in the west to twenty-one inches in the northeast. Delivery of this scant rainfall brings to mind the old joke about the rancher who, when asked by the stranger how much rain he got that year, replied, "Oh, about fifteen inches, and I can remember the night we got it!"

Still, the region has an austere, dramatic beauty that seems to put a stamp on the inhabitants who work very hard to live there. Those strong-minded, independent, and even contrary people of the Panhandle believe they have earned the right, from the hardships experienced in the Dust Bowl until today, to run their farms and way of life the way they see fit. It's not too hard to imagine the satisfaction a farmer must receive from surveying the geometric perfection of curving rows of cotton shaping a flat square field to conform to the radius of center-pivot sprinklers that stand above like giant Erector sets. The way the fruiting head on the grain sorghum matches the sienna hue of the soil also has its own dramatic beauty. Along some roads, rows of nodding sunflowers fill the foreground all the way to the low cloud curtain in the distance. The horizon is in full view, interrupted only by thin strands of high-power lines or the majestic thrust of concrete grain elevators beside the rail depot. On slightly elevated ridges in Gray and Roberts counties are hundreds of huge

The Rolling Plains stretch across the eastern High Plains. (Photo J. Nokes)

high-tech white windmills standing like alien towers against the curving sky while delivering electricity to the power grid. Surely these latest stakes in the Staked Plain are as impressive to the motorist as those wind-mills on La Mancha were to Don Quixote. To the east, the flatness begins to roll and fold as the grasslands re-sume. It is still so unpopulated in some areas that the traveler can imagine what it must have been like to see the ground disappear beneath the roiling flow of the southern buffalo herd streaming down from the North-ern Plains. Proudly on display in many communities are artifacts of the area's extensive Paleo-Indian cul-ture, the fossils of wooly mammoths, and the homespun relics and honored machinery of pioneer settlement. Geologic, historical, and modern time do not seem as compartmentalized here as in less land-dependent places. Instead, even casual conversation often includes them all as part of the ever-present reality of today.

In the Panhandle, nothing can be hidden. Not the fields of modern agribusiness that line out fences, crop rows, and roads with the precision we expect from a computer, nor the view of a million head of cattle in a feedlot, nor the lonesome ranch headquarters that can be seen from the narrow ribbon of a county road while still twenty miles away.

The Panhandle stories in Chapters 18, 19, and 20 are about individuals who went to extraordinary lengths to modify and change the space around their house in order to separate it from the surrounding fields or grasslands, by planting trees as windbreaks. Windbreaks, or shelterbelts as they were called in the Dust Bowl days, were a tool of the newly emerging science of applied agronomy and land technology that were offered as solutions in the Drought Relief Act of 1934. In his book about the Dust Bowl, Donald Worster explains how the shelterbelt program was initiated.

*The idea was to manipulate the climate, stop the winds, and save the soil. A row of trees around a house, everyone knew, cut the wind's velocity and cooled the air in summer. Expand the row around the farm, across the plains, and the dust would cease to blow and crops would have a better chance. The Russians had planted shelterbelts in the Ukraine in the 1880s, in strips lining the fields. President Roosevelt, himself an ardent tree planter on his New York estate, was sure that the same remedy would work in the American west. Nothing appealed more to him as a solution for the Dust Bowl. Trees would humanize the inhospitable Plains.*[1]

Today, though energy costs are affecting the sustainability of deep-well irrigation, windbreaks are less used to mitigate wind erosion in the open fields. Instead, they represent the desires of a people who have come to terms with the landscape but still yearn for an enclosure to defend them against the unending openness. This is not tree country, and getting trees established requires a long-term commitment few people can make. By virtue of their sheer size and longevity, the windbreaks in these stories have added a special feature to the landscape. The sense of achievement they offer differs from that of a successful harvest or roundup in that they are not just about this year's yield and production. They provide a necessary middle ground that allows these flatlanders to be outdoors around their own home by modifying the landscape in a dramatic way. These windbreaks have become a family's legacy, a community landmark, and a special habitat for turkey, pheasant, and other creatures that otherwise would not linger on the open prairie.

The last story in this Panhandle trio is about a family who converted a trash-filled caliche pit into a protected setting for a back yard and then later added some surprising features as a gift to the community. What the Gearns did on their place would not be the same if it were in a big city, or if there were not plenty of room to accommodate their toys for grown-ups.

Panhandle natives almost universally express a preference for open space, and they also share a sense of close connection to their pioneer heritage, a determined work ethic, and a matter-of-fact appreciation for the special kind of beauty this region offers.

Tim and Keith Ann Gearn offer a
playful gift to Hereford, Texas.

# A Great Peaceful Place

Keith Ann's initial response to the building site her husband, Tim, had in mind for their new home was guarded. "I'm going to get on board with that dream as soon as I get what it is," she told him. Tim had always wanted to own a house set way back from the road down a tree-lined drive, on land with some special natural quality that made him feel as though he were in another time and place. It was hard for Keith Ann to picture that happening on the old remnant field he showed her down a dirt road just outside Hereford. As far as she could tell, the only prominent feature on this property was a raggedy old caliche pit that had also served as a garbage dump.

## SOMETHING FROM NOTHING

Tim Gearn is one of those people with an optimistic engineer's gift for seeing the potential in things people have either tossed aside or otherwise don't value, whether it's old machinery, used building materials, or land, so the challenge of converting the caliche pit into a suitable and attractive building site did not seem that daunting to him. After work each day, he borrowed a friend's bulldozer to tackle the first job, removing what would amount to more than twelve bobtail-trailer loads of trash. Next, he spent weeks moving dirt around and carefully grading the contours of the pit to shape it into a graceful bowl or swale, eventually forming a large earthen enclosure that fanned out from the back patio.

He cut a road to the house and took Keith Ann back out there. "Then I could see that it was a beautiful place to set a house," remembers Keith Ann. Surrounded by a completely flat landscape as far as the eye can see, even a slight change in topography seems like an exotic novelty. More important than its visual interest, the mounded earth would provide valuable wind protection, making the back yard more livable than the exposed open plain.

Keith Ann and her two sons helped make their new home a special place by planting more than two hundred windbreak trees along the new drive and the basin that forms the large backyard area. "As we planted, we said a prayer to dedicate those tiny trees and this ground to be a great peaceful place of hospitality, welcome, and friendship," recalls Keith Ann. That was sixteen years ago. Their conscious intention to share their property in a loving way set something in motion, so that the next time Tim was inspired to build something extraordinary, the place for it was ready and waiting.

## MECHANICAL KNOW-HOW IN THE NEW WORLD ORDER

Tim's father owned a machine shop that supplied irrigation equipment essential to the huge farm operations in the Panhandle. "I was one of four boys, so we were all raised around mechanical stuff. We built go-carts and that kind of thing," recalls Tim.

*Over the years, my own family's been in a lot of different businesses. We used to have a feed yard, but now we've developed an offshore business that represents probably a third of what we do. We send equipment— giant marine winches, among other things—to the Persian Gulf, the Gulf of Mexico, and we also have a mining operation over at the old Imperial Holly sugar plant. The plant used to process sugar beets, and the by-product of that polishing of sugar was a form of calcium carbonate.*

As just one example of his ingenuity as an engineer and inveterate recycler-tinker, Tim devised a way to take this waste material, which had been stockpiled in huge mounds for more than thirty years, and dry, sift, and clean it, and then sell it as a calcium-rich component of cattle feed. With more than a million head of young cattle on feed in Deaf Smith County, and each calf eating about half a pound of this supplement per day, Tim figures he has a built-in customer base for five years, by which time the original pile will be all used up.

### THINKING GLOBALLY, ACTING LOCALLY

Hereford is a small town of only 12,000 people, but it is nonetheless an important center for multinational agricultural business. As rising energy prices make irrigation prohibitively expensive, farmers are once again struggling to adapt to change. Some are even returning full circle to cultivating only dry land crops. This time, however, they are not facing an adaptation to catastrophic climatic factors, like the droughts of the thirties or the fifties that rendered farmers so vulnerable before technology provided the option of siphoning underground rain from the region's vast Ogalalla Aquifer. Instead, the challenge is finding one's place in the new global economy. Tim explains,

*We no longer compete with the farmer down the road. I own a business where one of the things we do is build irrigation equipment, and my biggest competitor now that's really giving me fits is mainland China. So I'm sitting here, a little guy in Hereford, Texas, that's competing against the country of China. We don't just sit at home anymore; we have to be thinking universally. I don't think our forefathers had to do that. I think the biggest problem we face is just the change itself. You know, learning to adapt, and that we have to play a world market in agriculture.*

The world may be coming to the Gearns' doorstep via their various business ventures, but Tim and Keith Ann's thoughts and connections to their own community are never far away. Both are Panhandle natives who returned to their hometowns after college and are active in church and community activities. A few years ago, Tim designed and built a large puppet playroom for the children at his church. It was such a success that soon he began looking for another project.

### A MACHINE WITH NO PRACTICAL PURPOSE

Tim explains how he began the project that would turn his back yard into a local landmark.

*We were doing a puppet theater for the children's church and it was kind of a fun endeavor, and I just got to thinking, you know, why can't adults have something that's fun? You know, I got a big yard!*

Inspiration was soon provided when a traveling carnival came to town for the Lion's Club fund-raiser. "I saw how much fun everyone was having on the rides, and that got me to thinking."

After researching different kinds of carnival rides

An old caliche pit becomes a magical playground.

available for sale on the Internet, Tim decided to buy a used Ferris wheel, and eventually he found one at a defunct amusement park in San Antonio.

*When I was a kid, they had models that they moved all over the country. This particular type of wheel fell out of favor because it takes a lot of labor to put up. The new ones now are almost self-erecting, but they're very expensive. The older stationary types were more affordable.*

After collecting the dismantled Ferris wheel, Tim spent about six months rebuilding all the seats and refinishing the wheel before it was ready to set up. He even bought a sewing machine and learned how to make the covers and the seats.

It took five people ten hours to raise the magnificently refurbished Ferris wheel, but once it was up, it was installed to stay. It quickly became a recognized feature in the minimalist Hereford skyline. "Everybody knows about the Ferris wheel," says Keith Ann.

*You can see it from the football stadium. We light it up when we win, and, oh, gosh, people love to come out here. We had a group of women come out here who had been in this little club for twenty-five to thirty years, and some of them were in their seventies and a few were younger, but you could just tell when they walked in that they were all great friends. Well, we put them on the Ferris wheel, and they became little girls again. And before long, they were at the top going Wooo!, raising their*

A Ferris wheel ride provides a sweeping view of the Panhandle landscape.

*them or Tim will take them round, and pretty soon these old guys soften up and they start saying things like, "Well, I remember back when I was with my dad, and he took me on my first Ferris wheel ride." You can't quite get ahold of what it is, but something changes and they're better when they leave. They're softer, they remember the essence of their youth that was really special to them, and it just brings all the good stuff to mind, and that's important for them to remember. They've just maybe put it too far away and the ride brings it all back up.*

Although Keith Ann and Tim did not anticipate the power their Ferris wheel would have to transform people, it has become the best part of having the carnival rides in their back yard. Tim adds,

*At first when people get on it, they'll be a little apprehensive, and then it kind of lullabies you; it's kind of like rocking in a cradle. It's very soothing and relaxing, especially at night when you can see all the lights. It adds a lot to life to enjoy a machine that's not built to do anything except to be fun.*

*arms and giggling and laughing. They were probably the rowdiest bunch we've had out here, and that includes the time we had eighty teens over for a party.*

It was obvious from the first that folks were going to have a ball riding that Ferris wheel, but despite all the thought they put into it, even the Gearns couldn't have predicted how a simple ride could have such a profound effect on people. "When you get on the Ferris wheel, something happens," ventures Keith Ann.

*I've had some of the hardest businessmen out here, you know, because we work with oil fields, cattle, mining, and so when they come out for dinner or for business, we always get them out here for a ride. And I'll ride with*

Though the Ferris wheel was a big hit, it wasn't long before Tim realized something was missing. "We really didn't have anything for little kids," Tim recalls. "You can't put a little kid on a Ferris wheel by himself. It didn't seem fair that they didn't have anything to ride." More Internet research told him that carousels had become expensive collector's items, so Tim decided to design and build one himself out of surplus oil field parts. He discovered that many of the old classic Parker wooden horses and animals had been copied into molds in Juarez, Mexico, and were then used to make aluminum castings out of recycled beer cans. Tim then

took the rough castings and painted them, installed them on his carousel, and completed the job by sewing a classic Big Top canopy to cover the whole thing.

## IT'S NOT ABOUT MONEY

From the Ferris wheel, riders get a panoramic view of the whole Panhandle landscape: the huge feedlots, the endless fields of milo sorghum, the high school stadium, and the town of Hereford five miles away. The huge dome of the sky above makes you feel like a child again, enjoying a turn on a miniature ride. Beneath you, the bright red tent of the carousel is nestled in the grassy embrace of the rehabilitated pit, and on the hill behind, an old wooden windmill companionably rotates in its own squeaky rhythm. Time seems to slow down, and you begin to hope your turn will last forever. Tim describes the joy of sharing fun for the sake of fun:

> *It's a lot of fun because it brings a lot of people in from the community, and there's no ulterior motives, just people having fun, enjoying their days. It's not about trying to make money; it's not about trying to impress anyone. It's just, "Hey! Come over to my house and play with my toys!" It's just fun. There are a lot of pressures in life, and there aren't a lot of things that are just for fun. I wanted something that was right here at home, where we could interact with the community, and something that little kids would like.*

Keith Ann puts it best:

> *It's not the big moments, but the series of little moments that matter when you're turning your place into what really matters: peace, hospitality, goodness, and welcome.*

Come on and take a ride.

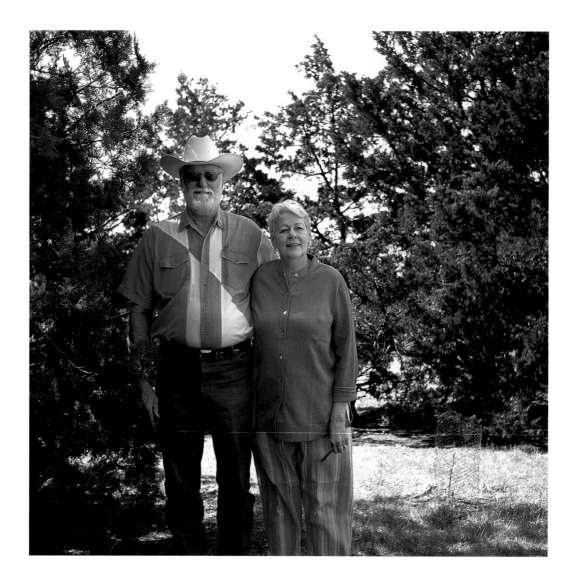

Robert and Penni Clark welcome
visitors to their ranch.

# The Only Trees for Miles Around

You can see the headquarters of the Clark ranch from a long way off. It's situated about eighty miles northeast of Amarillo, on the other side of the Caprock escarpment in the Rolling Plains part of the Texas Panhandle. This is the region where the mostly flat High Plains to the west begin to break and fold into gentle slopes and draws, providing good rangeland for cattle. Because the terrain here is often too rugged for farming, there are few irrigation rigs, grain silos, or towns cluttering the landscape. In fact, Miami, the county seat, is the only town in the entire county. Turning off onto Clark Road, still a good fifteen minutes from the house, you can't see any buildings, yet you know they are there because the most prominent ridge in the distance is covered by a thick shaggy wall of trees and shrubs that drift along the hillside. Checking the sweeping panorama of the horizon, you soon realize that these are virtually the only trees to be seen anywhere.

## WINDBREAKS AND RANCHING HERITAGE

The approach to the ranch headquarters is lined on one side by a dense planting of arborvitae (*Thuja occidentalis*). Enclosing the other side of the broad yard are multilayered rows of eastern red cedar (*Juniperus virginiana*) mixed with other trees and shrubs. Openings in this rambling windbreak reveal a compound of several buildings, including a home, barn, garage, corral,

breezeway, and large front herb garden. At six foot six, ranch owner Robert Clark greets his visitors looking like a casting director's dream of a real cowboy. With a crisp straw Stetson hat, hand-tooled boots worn high up on the pants legs, a grizzled beard, and a 200-watt smile, Robert introduces himself and then quickly explains what he thinks you must be wondering: why his wife, Penni, has a different accent. "You may have noticed that she doesn't sound like she's from around here. That's because she's from Lansing, Michigan," he says, setting everything straight. Robert is merely observing a common ritual in this part of Texas: identifying yourself and your family according to where you come from, thus indicating your ranking in the pioneer history of the region. Identity here is closely tied to the land and the way you work it, especially in a remote place like Roberts County, with a population of fewer than 900 people, and few newcomers.

Willis Clark, Robert's dad, began ranching here in the 1920s with his father and brothers. In those early years, the Clarks were one of the first families to plant a multiple-row windbreak around their ranch headquarters (still referred to as the old Clark ranch, despite changes in ownership). A Texas Forest Service bulletin from 1997 quotes the elder Mr. Clark:

*We started a windbreak around the house before they started those government programs [the shelterbelt pro-*

The Clarks' windbreak presents a striking contrast from the road.

buffalo-grass yard completely empty of trees and shrubs. Though the house was modern in design, Willis also appropriated a valuable building principle from the old dugout shelters used by early pioneers. A scarcity of timber and a need for protection from wind and blizzards motivated early settlers to build their first homes mostly underground. So Willis used his new D-4 bulldozer to embed the first floor of the house into a berm, like a half-basement. No shrubs were planted next to the house, for fear that moisture would seep inside.

Having experienced the benefits of the windbreak they had installed at the old Clark ranch, Willis and Adelia Sue began planting right away around their new home. Robert explains how important another machine was to this ambitious project.

*gram]—we were ahead of them. We could see the advantages of windbreaks. There were very few houses that had them. None of our neighbors had windbreaks.*

By 1939, Willis had married Adelia Sue Cowan, and in the late forties they broke away from the other Clark brothers to operate their own ranch. Robert described the family's new location.

*We're on the mini continental divide, right here, where this house is sitting. And I mean on a divide because you walk out this way in the yard and all the drainage goes to the Canadian River. You walk out on this side of the yard, beyond that road up there, and all the drainage goes to Red Deer Creek.*

Adelia Sue named the homesite Breezy Point. Early photos show a very exposed low-slung house, with a

*I can remember coming out here before we built the house, with Mother and Daddy and all of us, deciding where the windmill was going to be. That was the first thing. We were the first people in Roberts County to have a windmill with sixteen-foot-diameter blades. We're three hundred and thirty feet to the top of water here. It's deep, it's good quality water; it can't be any better.*

The windmill was necessary for the house and animals, but Willis knew they would also need plenty of water to establish their new windbreak.

They surrounded the headquarters with an L-shaped windbreak with multiple rows of eastern red cedar. In the gaps produced by the staggered rows of cedars were planted Austrian pine (*Pinus nigra*), lacebark elm (*Ulmus parvifolia*), a few piñon pines (*Pinus edulis*), smoketree (*Cotinus obovatus*), and American plum (*Prunus americana*). Aromatic sumac (*Rhus trilobata*) grows here and there beneath the larger trees and serves as an understory and wildlife plant. All and all, they

planted more than 1,500 trees at the headquarters alone. Robert remembers what the original trees looked like:

*I can remember those cedar trees when we planted them. They were about a foot tall. We took one lister-bottom plow behind the tractor to make the rows and then we planted on top of the bed. Then we went back and put a posthole digger on the back of the tractor, and we dug that in there about two and a half feet, and then we filled that back in, whatever size root we had, and then, with just hand labor, we made a bowl around each tree that would hold twenty to thirty gallons of water. We didn't have hoses or anything like that; we had a tank on a truck and we just went around and watered it from there. We watered those little trees, depending on the weather, once every two weeks. The secret to establishing a windbreak on a rangeland situation is to keep it clean-tilled. We had to go back in and hoe weeds around it, every time. And then eventually we went back and plowed all the grass that grew up in between the rows that were about thirty feet apart. We did it until we couldn't plow anymore, because the limbs got so big. We didn't stake them, but some of them, we had to put shingles around them to protect them from the wind.*

Adelia Sue had a few rose bushes and a shade tree in the front yard, but Willis was reluctant to use precious water provided by the windmill for ornamental plantings. Today, with ample well water provided by an electric pump, Penni has added considerably to the gardens, planting shade trees as well as impressive herb gardens. The cover and food the trees provide has also increased the wildlife.

*It's not normal up on the High Plains like this that we'd have turkeys that would stay around all the time, but we've had them for about four years, and also the monarch butterflies.*

One season Penni signed up to tag some of them. "On a windbreak just east of here where I am standing, they were just solid. You couldn't see anything but clouds of butterflies," Robert remembers.

By 1959, the Clarks had acquired the 7-Bar Ranch, about five miles from the homeplace, and in 1969 they added another parcel, eventually accumulating 15,000 acres. The Forest Service bulletin explains, "As the Clark's acreage grew, so did the number of windbreaks. Multiple-row windbreaks were planted around the headquarters, barns, and corrals at each of the ranches."

### MACHINERY TO SHAPE THE LAND

Windbreaks are not a quick-fix solution in the Panhandle. They require many years of constant care and attention before the benefits of the trees are realized. Robert explains how long it takes for the trees to reach an appreciable size:

*At least ten years, and of course, that depends on how often you water. We could have watered more, but we were trying to work it in with our ranching at the same time. We had a lot of farmland, and Daddy had this dirt-moving business that kept growing, and us boys started running the bulldozer in grade school. I was driving a two-ton wheat truck from the old Clark ranch down there when I was ten years old. It was a '49 Chevrolet truck. It didn't have a synchromesh transmission. You had to mash those gears every time, without stripping them, and you had to double-clutch it every time you went from one gear to the next. Daddy taught us young, you know, driving through the gates when I was five years old.*

By the time Robert was fourteen, he and his brothers were building tank dams for customers all by themselves.

That access to earth-moving machinery proved to be an important aid to the windbreak projects. Willis and his sons had become heavy equipment operators, supporting their ranch operation by building roads and tanks for oil and gas companies, after oil was discovered in Roberts County in the late forties. Robert continues the story of his family's ranch in the arcane terminology of someone who has had equal experience on a horse and on heavy machinery, by citing model numbers, horsepower size, and engine dimensions to explain how they went about shaping the land.

> *By the time we moved here, we had a D-7 dozer and a road grader, and we made the windbreak channels following the contour of the land around the buildings. We always built on the north, northwest. We went in there and first dug out all the topsoil clear down to the caliche and stockpiled it on the upper side. We went back in there and took out all the old clay stuff and made a terrace berm to hold water. Then we ripped that thing with the back-ripper attachment to our dozers to get it all pulverized up. My brothers and I learned to put all three dozers side by side, like one big dozer blade together, to put that top soil back in.*

Next, the channel was graded from one end to the other, with a certain amount of fall put into the grade, so the water would "syrup-pan" back and forth from one terrace to another, down the side of the hill. At the bottom, the Clarks planted a small orchard to take advantage of any overflow from heavy rains or the runoff from the roof of their huge airplane hangar and machine shop. In this planting, they used lacebark elm,

Austrian pine, Scotch pine (*Pinus sylvestris*), Ponderosa pine (*P. ponderosa*), mountain juniper (*Juniperus scopulorum*), and one-seed juniper (*J. monosperma*).

The advantage of designing windbreaks on the natural contour or on a built terrace is that it is an effective way of not just blocking but also directing the wind. The planting rises from a lower elevation or uses smaller trees on the windward or outer side, graduating to the largest trees in the middle before sloping back down to the inner side. Robert describes the difference between the inside and the outside of the windbreak:

> *Well, it can be blowing thirty miles an hour, and you won't feel any wind right here. You'll see it hitting the top of those pines, but you won't feel any wind at all. The wind just hits it and goes over.*

His granddaughter Shawree adds, "It's the difference of having your hat on securely inside here, and going out there and having it blow off."

### SKY KINGS

In the early 1930s, Willis became a pilot, and the airplane soon became an essential part of the ranch operation and earth-moving business. He would fly his boys west to Skellytown or east to Wheeler County, drop them off on the nearest dirt road, and then pick them up around seven that evening. "You got to work there quicker," explains Robert.

> *He'd land on the pavement where we'd left the pickup, and we'd be driving the bulldozers in fifteen minutes. That way, you got to work more hours, he got more out of us, and it only took fifteen minutes to bring us back to the headquarters, and we got to fly. He'd always let us fly.*

Using the airplane as others might use a car enabled the Clarks to develop an understanding of the vast and subtle nature of their land that otherwise could only be gathered piecemeal from the ground. The bird's-eye view and the ground view became familiar spatial knowledge that showed them how to use the earth's natural contours when planning their terraced plantings, thus the scale of the Panhandle that is intimidating to outsiders never seemed remote or abstract to this family.

Including the windbreaks Willis Clark began planting in the early thirties and continued at every place the family owned since then, the Clarks have over seventy-three years of experience in this practice. The planting wasn't limited to the homestead. Because they felt that the livestock also needed protection, they planted trees around every corral, barn, and windmill-fed stock tank. The Clark windbreaks are noteworthy not only because they are so old and extensive but also because of the way in which the family used their expertise with heavy equipment, their skill at grading, and their capacity for flat-out hard work to plant, cultivate, and care for thousands of trees. Robert observes that few people are willing to invest the time and energy that a windbreak requires.

*I think it all depends, that if they're going to be living out there, they'll plant some kind of windbreak. But if they're not living out there, then the hell with the hired hand. But what they don't understand, it's not just for the hired hand; it's for the livestock you have around your headquarters. I just feel you need to give them some protection around there, too.*

Windmills, barbed wire fences, Hereford cattle, and windbreaks are among the most iconic of the tools that people employed to make a go of it in the Panhandle, and the stories, descriptions, and explanations of them are still told with deep respect. Used properly, they represented a bargain the people made with the land, where hard work and commonsense stewardship were employed to persuade the earth to yield some of her resources. It's also true that these tools tempted some people to exceed the limits of what is sustainable in this landscape. The land here takes a long time to recover from overgrazing and rough treatment. The Clark family's lifetime of planting windbreaks is an unmistakable gesture of reciprocity and respect for one's home and way of life, as well as a natural legacy for man and beast alike.

The Clarks survey the layout of trees from the air. (Photo courtesy of Mr. and Mrs. Clark)

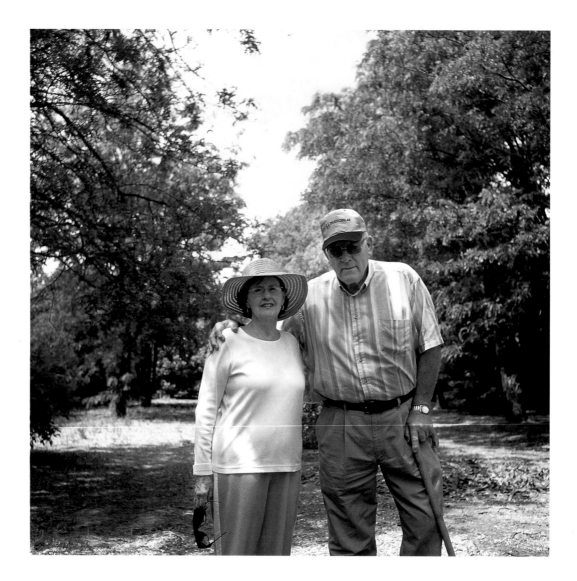

June and Eldon Owens stroll
among their well-loved trees.

# A Windbreak for the Homeplace

Viewed from the window of an airplane, Deaf Smith County looks like one huge patchwork quilt, the uniform fields matching up end to end all the way to the earth's curve at the horizon. The colors of this quilt might be limited to a humble homespun palette of greens, browns, and rusty reds, but the way the individual parcels are laid out with crisp geometric precision is stunning. Because the topography here is so completely flat, farmers have found it possible to arrange the entire landscape into large squares and rectangles. This large-scale orderliness in the landscape clearly demonstrates the uneven outcome of our human attempts to rule over the natural order. Live in the High Plains long enough, and it's a sure thing you will experience being on both the winning and the losing side of Mother Nature.

### WHERE THE WIND BLOWS

Highway 60 runs right in front of the Owens place, making a straight shot to Hereford. A busy rail line runs parallel to the highway, delivering feed and other supplies to the million head of cattle that populate the county's famous feedlots. From the ground, the road appears to have an orthogonal relationship to the house, but the aerial view reveals a slight angle, just cutting off the lower right-hand corner like a dog-eared page in a book. A low, one-story brick, ranch-style house is set well back from the road on a smooth green lawn that seems as big as a football field. On the west and north sides, six rows of trees, 90 feet wide and 600 feet long, form a thick, dense wall surrounding the house, garage, and small equipment shed in the back. Along the east side, a single row of eastern red cedars neatly follows the 300-foot-long driveway. However misleading the boundaries might appear on the ground, an aerial view shows this extensive windbreak surrounding the house as impossibly straight, in precise alignment with true north and west. This monumental planting is a well-known local landmark, the pride of the Owens family, and a testimony to the dedication of one man, Eldon Owens.

Though in recent years Eldon's health has not been what it once was, it is still obvious that this tall, sturdy-framed man possesses the same characteristics of self-sufficiency, resourcefulness, and a huge capacity for work as many other Panhandle natives. Like many of his neighbors, Eldon held other jobs while also farming his section of land. As director of Transportation Services for the Hereford school district, he was responsible for keeping the buses in good running order, an important job in a large rural district. June Owens is an attractive, petite woman with strawberry blonde hair and a lively manner, who also worked for the school district as a teacher and counselor. Both have lived in Deaf Smith County since the early fifties.

### A NEW HOME DOWN THE ROAD

In 1978, the Owenses got tired of house-to-house living

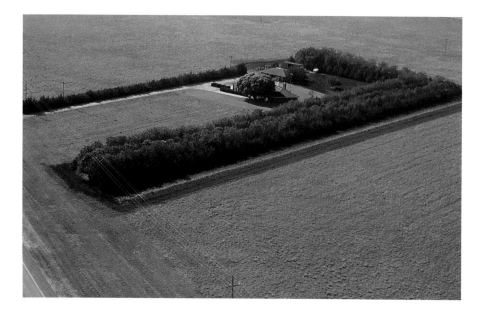

The trees protecting the Owens place are planted with geometric precision. (Photo courtesy of Eldon and June Owens)

*I went over to the county road and found old survey markers. You know, you don't want it [the windbreak] going crossways on your land. Anyway, to get that straight north and south up here, I had to go over to the county road and measure across to this end of it to get it square. I worked all one day. I had a chain, I'd go get it, bring it back. Eventually I measured it all off, and I drove some stakes to mark it. The next morning, my stakes were all up here on the front porch. At that time, I had a border collie, and he had brought them to the house. Anyway, he and I had a little talk, so I went back and got the chain and measured it all over again. I thought, well, I'm going to plant a few trees while I'm at it, so I planted about forty trees just so they'd be there when I started again the next day. But the next morning, there those trees were on the porch. So me and the dog had a* real *good talk that time, and then he left them alone after that.*

in town and moved just a few miles outside Hereford. They found a place next to the farm Eldon's parents had traded their implement business in Oklahoma for in 1953. As one indication of his versatility, Eldon designed the new house for his family and then quickly turned his attention to the windbreak project that would occupy him for twenty-six years. "I built a new home and I wanted a windbreak. I wanted it to look nice, and I wanted something I could be proud of," explained Eldon. "There's an awful lot of work in a windbreak to make it right, but it sure has been worth it."

### MAN'S BEST FRIEND

Eldon's windbreak project was ambitious from the beginning. For one thing, he more than doubled the number of rows of trees typically planted by most people. He also went to great pains to plant them straight. Eldon explains how he marked off the windbreak:

Meanwhile, June began documenting the whole project in a family photo album. "My children said that I was the only person in the world who would take a picture of a hole in the ground," says June with a laugh. "But anyway, my husband dug holes and I took pictures." June and their youngest daughter also helped to plant the tiny new trees. "They were just about as big as my little finger when we got them."

The Owenses got their trees from the local Soil and Water Conservation District office, which distributes them for the Texas Forest Service. "I had six rows to start with," remembers Eldon.

*Mondale or Afghan pine on the outside* [Pinus eldarica], *then eastern red cedar* [Juniperus virginiana], *green ash* [Fraxinus pennsylvanica], *then two rows of honey locust* [Gleditsia triacanthos], *and, finally, an-*

*other row of eastern red cedars on the inside. The ever-*
*green trees came in a little old tarpaper tube about eight*
*inches long, and that thing wasn't any bigger than a*
*toothpick. I planted about a thousand trees in all and*
*didn't lose a one, until many years later when disease*
*got the Mondale pines and drought got the green ash. I*
*planted the rows twenty feet apart, and left fifteen feet*
*between the trees. I probably could have spaced them*
*further apart, but you know, when you're planting trees*
*you think, Golly, there's just a twig here and a twig*
*there. You can't visualize that they're going to be to-*
*gether before too long and then you can't even walk in*
*there.*

## A KNACK FOR TAKING CARE

The trees provided by the local conservation districts
are very inexpensive (less than fifty cents for a small
seedling) and represent only a tiny fraction of the in-
vestment a landowner will have to make in order to
have a thriving, worthwhile windbreak. Technicians at
these agencies will tell you that most people who buy
the trees expect them to grow tall overnight. But Eldon
knows better.

*It takes more planning than just getting the tree and*
*sticking it in the ground. If you're not ready to grow*
*one, you're not going to grow one, and that's just all*
*there is to it. You have got to provide irrigation, and*
*you have got to keep things clean-tilled. A tree can't*
*compete with grass and weeds. The grass and weeds will*
*beat it to the moisture.*

Doubting a visitor could fully appreciate the effort
Eldon devoted to raising those trees, June remarks,
"You have no idea how many hours and money he has
spent, fertilizing and spraying, and he had a well dug

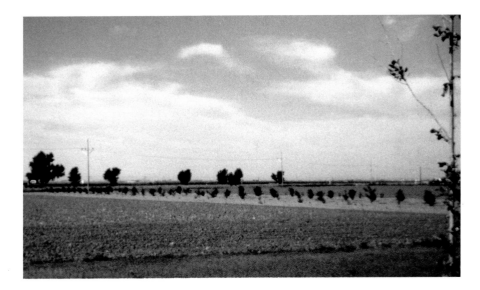

just for the trees themselves." Like other gardeners,
who have earned a special kind of expertise through
zealous devotion, Eldon is happy to advise others.
"We've always had a lot of people stop," reports June.
"It's fine, I'll do anything I can to help them," adds
Eldon, "but, well, you see a lot of them that's put in,
and they're just not going to make it."

At first, they watered the little seedlings with miles
of garden hoses from the house, until Eldon was able to
flood irrigate from the well. With irrigation came the
weeds, and that required regular plowing with a small
tractor, and raking up the tumbleweeds and leaves so
that they wouldn't prevent the water from soaking in
the ground. The rise in fuel prices in recent years has
meant a significant expense each time the well is run
(about once or twice a month during the summer).
Other regular chores included chipping pruned limbs
and thinning out dead or dying trees—projects that
took days of work.

The windbreak was still quite
small a few years after planting in
the early 1980s. (Photo courtesy
of Eldon and June Owens)

A grove of trees provides a rare respite on the High Plains.

spinning at the top, but here inside it stays real pleasant," says June. From their patio they are able to enjoy the view of their huge vegetable garden as well as the variety of wildlife their trees attract.

## A SACRED GROVE

When the central row of green ash had to be taken out, it may have been a blessing in disguise, for down the middle of the now mature but closely planted rows of trees is a broad, shady lane that is wonderful to walk through. Beneath the cool and dappled shade of the trees, one can fully appreciate Eldon and June's awesome achievement. The dense foliage of the cedars shields the stroller from the bright open fields outside, while the branches of the honey locust on the inside reach across the empty row to touch tip to tip, forming a delicate canopy. Here and there through the cedars you can glimpse the wide-open fields. There is nothing like this long straight grove anywhere else in sight. The multiple rows make you feel removed and protected from the noise of the road and trains. The branches are filled with birds, many white-winged doves, but also a barn owl, which suddenly dips down from her nest in a honey locust tree. It was Eldon's two decades of steady work that created this, but we can also imagine that the work itself was satisfying and provided a break from the endless cycle of chores that are part of any agricultural life. June knows that

"For years, I used to tell people that I could limp through the living room and he didn't notice, but one leaf on those trees could curl, and he was out there tending to it," jokes June. But Eldon's patience and extraordinary care paid off; after about seven years they had a windbreak that made it possible to sit out in their back patio when the wind outside was blowing 40 miles an hour. "There's some times when the trees are just

*he enjoyed the work, whether it was raking, hoeing, dragging a long garden hose, running his little tractor between the tree rows, spraying for insects, trimming, or whatever," explains June. "It was always a work of joy even when he was very tired. He and I are very proud of those trees.*

When Eldon started this windbreak, his intent was daunting but simple: to plant trees along the entire length of his property line in order to enhance the looks and value of his property, and to do the job right. Perhaps he never dreamed it would result in a place that has the feel, on this treeless plain, of a sacred grove or sanctuary. Yet the experience of stepping out of the broad open sunshine into the speckled and shady light beneath the long rows of trees is truly like entering into a special, set-aside place. Reflecting on a project that represents so much of his life's work, Eldon says,

*I consider it a blessing to have the trees and be able to care for them all these years. I'd spend hours out there. I just like the solitude it gives you. I'd do it again.*

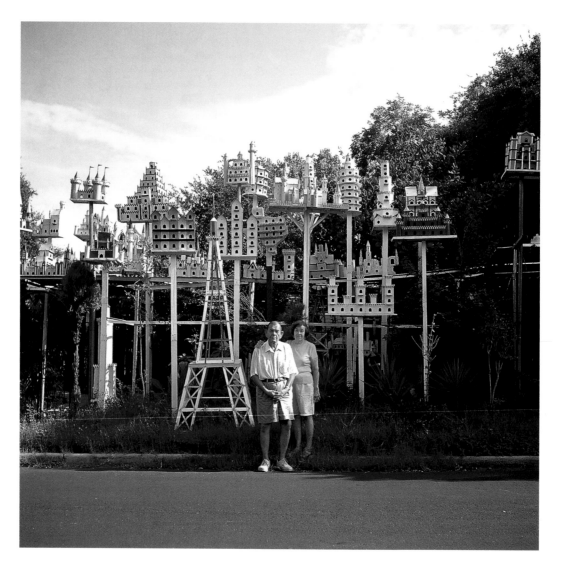

A forest of birdhouse towers
above Sam and Lupe Mirelez in
their front yard in San Antonio.

# God and the Birdhouses Brought Us Together

Back in the 1950s, the northwest side of San Antonio was still mostly wide open and rural. In this part of Bexar County, ragged pastures and remnant fallow fields of the South Texas Plains still remained at the city's edge. The relative flatness and affordability of large tracts of land made it attractive to developers, who had figured out that many soldiers returning from World War II and Korea with the G.I. Bill in their pockets would make good first-home buyers. Like other postwar housing developments, this new neighborhood came with schools and wide streets and offered a limited selection of floor plans for modest single-story ranch-style houses boasting picture windows and broad carport awnings. Fast-growing trees like Arizona ash and fruitless mulberry were planted in the neat front lawns that linked one yard to another. Soon a whole generation moved in, often the first in their clan to leave the old inner-city neighborhoods and small hometowns that no longer beckoned them. Many of these veterans were attracted to the abundant civilian jobs available at Kelly Air Force Base, and they proceeded to settle among these fresh new streets for the duration of their working lives.

Fifty years later, what do these neighborhoods look like? What's most obvious, of course, is that they are no longer on the edge of town but instead are regarded as centrally located, because they are "inside the Loop," the ring around San Antonio created by Highway 410 that used to separate the city from exurbia. Most of the houses remain well kept and practically unchanged. Other houses have enclosed their carports and converted them into indoor space. About one out of every three front yards is once again bare, the original fast-growing inexpensive trees planted by the builders having already exceeded their life span. In other yards, live oaks planted decades ago by the homeowners have grown so large that they almost smother the small, low-slung houses. On these quiet streets with cars parked in the driveways, a single tree in the yard, and the hot Texas sun shining off composition roofs, there is one house that stands out from the others.

### A DIFFERENT KIND OF LANDSCAPE

The Mirelezes' yard is so different, so implausible and unexpected, that it has achieved celebrity status, at least in San Antonio. The carport is still there, but the rest of the house is hard to see beyond an extensive elevated network of corrugated aluminum trellises erected on poles, forming a latticelike awning over most of the yard. On the roof of the carport, along the side of the house, and displayed throughout is a forest of ornate birdhouses of all descriptions: many are multistoried castles and mansions elaborately made with turrets, arcades, pagoda roofs, and crenellated parapets. Others are immediately recognizable as scale models of familiar landmarks like the Alamo, the Hemisphere Tower, the Empire State Building, or Saint Paul's Cathedral. Many birdhouses rest on low metal tables beneath the

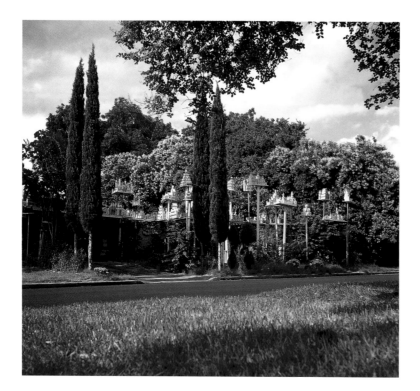

The Mirelez yard is a surprising wonderland in an ordinary neighborhood.

are punctuated by the sharp barks of several Chihuahua dogs, together providing a lively soundtrack for this special garden. A quilt-pattern pathway of shiny glazed scrap tile pieces invites the visitor to wend his way under the canopies and beside the ponds and birdhouses to the front door. When Mr. and Mrs. Sam Mirelez invite you inside, you discover that the back yard is even more crowded with ponds, birdhouses, and birds.

## A SPECIAL ANNIVERSARY GIFT

The week after his first son was born fifty-two years ago, Sam Mirelez moved into this house as its first and only owner. After serving in Korea, he moved to San Antonio and worked at Kelly Air Force Base for thirty-eight and a half years as a fine-instrument mechanic. Sam originally came from Kenedy, Texas, a small town in Karnes County just south of San Antonio, where he developed precision mechanical skills early on by learning the watch repair trade from his father and also by being an avid model plane hobbyist. His mother taught him how to care for animals and the large gardens she kept around the house. From uncles, he learned the carpentry trade. All of these skills would be useful to him years later when he began to build and display his birdhouses.

Life went on over the years for the Mirelez family. An early marriage ended in divorce. A second marriage began to founder, but after a separation, Sam and his wife, Gregoria, reunited. Later, on their twenty-third anniversary, Sam was inspired to make something to commemorate the occasion.

*I wanted to give her something special for staying with me for twenty-three years, but I didn't have any money. I was still making payments on my house. So out of Folgers coffee cans I built the first birdhouse. I had al-*

dappled light of the canopy, arrayed along narrow pathways that wind among raised ponds and small fountains. Some paths are made of brick pavers or leftover roofing shingles that help keep invasive Bermuda grass under control. The birdhouses and their pedestal tables are all made from aluminum siding, their silver, white, and gray tones matching the awnings above. Huge bowers of bougainvillea, wisteria, and crossvines provide bursts of color among the shadows and sheen of the dominant metal material. Along the driveway, a dramatic row of groomed Italian cypress trees competes with the castles on poles for sky space. The chirping of sparrows and house finches and the more exotic sounds of caged doves and parrots from the back yard

*ways built little birdhouses out of wood, but they had rotted after two or three years, like a rotten tree. Well, what can you do? I decided to make a replica of the San Fernando Cathedral, where I married her.*

Sam's gift was a big hit. His wife rushed across the street to show a neighbor the miniature cathedral birdhouse, and that neighbor called the newspaper and the local TV station, which both did stories on his touching anniversary present.

*After a while, when everything died down, I set her house on a post in the back, and the birds started nesting in it right away. The only thing, after three or four years, it started getting rusty and falling apart and she started crying. I said, "Don't worry, I'll make you another one."*

The second birdhouse was a replica of the Alamo.

## RETIREMENT INSPIRES MORE PRODUCTION

Sam's birdhouse production really stepped up after his retirement from Kelly Air Force Base in 1987. By this time he had decided to switch materials altogether and use something durable, something that didn't rust or require paint: scrap aluminum siding that was provided by a friend. His ideas for models of the birdhouses came from various sources: picture books on famous buildings of the world, postcards that people sent him, and San Antonio's rich inventory of architectural landmarks, such as the missions, the churches, and the Gothic towers of Incarnate Word College.

Sam explains how his garden grew to include plants and attract birds:

*I didn't want to spend my retirement just drinking beer and watching TV. I wanted to do something that people can appreciate and I can appreciate. That's when I began to make more and more birdhouses. I can show you pictures of the early versions of my yard. It was altogether different. I didn't have the canopies. I realized that it would enhance the appearance of my birdhouses if I would have some pretty plants around them, and you have to have running water to attract birds, and by having plants all year round, you attract insects and mosquitoes in the water and that's what birds eat.*

Even in San Antonio's mild climate, a cold snap can knock back many flowering plants, but the canopies provide just enough extra protection so that much of his garden is green year-round.

Sam wasn't interested in making ordinary birdhouses. If this was going to be his major occupation after retirement, he decided from the first that his time was worth making something out of the ordinary.

*Yeah, I can take and show you a plain birdhouse like that . . . even if you put a chimney on it; they're still just a birdhouse. But when you put something like that [a turret] onto a birdhouse, it makes it look more realistic, like a mansion. It's not just a hut. Who wants to see a hut? Everything is high-tech nowadays, so you want to see fancy structures. It bores me to make something that's so plain.*

Sam likes to search garage sales and flea markets for inspiration for his birdhouses. He looks for toy models, plastic Barbie Dream Castles, miniature Victorian Christmas villages, train sets, and picture books. Some of Sam's ideas came from a book about purple martins that had pictures of farmers in Ohio going all out to build multistoried complexes made from gourds or

The birdhouses reunited Lupe and Sam.

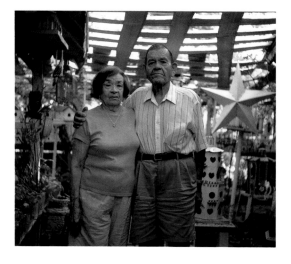

wooden replicas of large apartment houses. Sam learned all about the migratory habits of purple martins, but his attention was drawn more to the challenge of matching or surpassing the pictures in the book of the houses built for them.

It wasn't too long after Sam retired that Gregoria became very sick and, after a difficult four years, finally died. Sam was devastated. He could not focus his attention on his birdhouses, or on much of anything for that matter. His sons began to worry about him. "I didn't feel like splurging on my birdhouses because I was unsettled, I was grieving," recalls Sam. Gradually, Sam's lifelong habit of getting up early and being productive pulled him out of his grief, and he returned to making birdhouses. They started to fill up the front yard and then the back. The newspapers and TV stations regularly ran human interest stories on him. "I tell them, I'm a celebrity! I've come out on Channel 41, 29, 4, 5, and Channel 12. I've even come out on Ripley's Believe It or Not!" Sam remembers. It was the attention that his ever-expanding display of birdhouses received that led

to the reunion with his present wife, Guadalupe, eight years after Gregoria died.

Forty years earlier, during the time he was separated from his second wife, Sam began a romance with Lupe. Eventually he decided to reconcile with Gregoria and said good-bye to Lupe, not realizing he wouldn't get to know the infant daughter she was to bear him. Although they were only across town from one another, they lost touch completely. Sam thought she had remarried, and he didn't know her new last name. One day Lupe was watching Univision and saw one of those stories about Sam and his birdhouses. She tells the story this way:

*I wasn't living very far away. I was watching the TV all the time, Channel 41. My daughter had wanted to find [her father]. She said, "I can't believe you don't know anything!" I said, "I don't know where he is!" Then I saw him on the TV and I said, "Oh! There's Sam!" So my daughter took me over there and knocked on the door while I waited in the car. She told Sam, "There's somebody who wants to see you. Can I bring her in?"*

At first Sam thought it was just another lady coming to look at his yard. Lupe hesitantly approached the door. "Remember me?" she asked.

"I think God played an important hand in bringing us together. Yeah, God and the birdhouses. My daughter tells the story to her friends, and they can't believe that God works in mysterious ways sometimes," reflects Sam.

With his marriage to Lupe in 1993, Sam's birdhouse-making and yard decoration rose to a new level. They began to put up the corrugated aluminum canopies over the entire front and back yard and to add more ponds and fountains. The canopy idea came from a desire for more shade, and also because they had a ready source of corrugated aluminum, a material that proved too dif-

ficult and labor-intensive to flatten out for the other structures. So with Lupe as willing partner, they removed all the old birdhouses and models, built the canopies, and then rearranged all the houses, some on poles, some attached to small metal tables, some screwed to the awning, making them easier to retrieve for potential buyers. Sam plants the plants, but Lupe waters and cares for them. She also cleans and helps to organize his shop behind the house. She feeds the fish and the birds, and joins him when folks drop by to visit.

Sam's repertoire diversified as well. Postcards from Lupe's son stationed in Germany offered ideas for more and more elaborate castles. He began to make not just birdhouses but also models of famous buildings like the Eiffel Tower, Notre Dame Cathedral, and the elaborate Victorian courthouse in Waxahachie, Texas, designed by James Riley Gordon. He's even been hired to make special commissions, including a church in England and the Bexar County Courthouse. Laura Bush asked for one of his birdhouses to include with the work of other folk artists in a Christmas display at the Governor's Mansion. His intention is not to make money but to pay for the material to keep making more birdhouses.

Visiting with the Mirelezes in the back yard, sitting under the rambling expanses of woven aluminum canopies, surrounded by hundreds of birdhouses, listening to the gurgling of the fountains, the sounds of the birds, and the sharp barks of their tiny dogs Carmelita and Esmeralda, you almost feel like you are inside one of the birdhouses yourself, so complete is the setting. Tile pathways wander among an endless variety of things to look at. Birds dart in and out. The yard doesn't seem connected to the street or much of anything else. It's a separate world. The accumulation and arrangement of Sam and Lupe's work has turned the bland uniformity of the fifties housing development in-

side out. In this space, variety, change, and living things surround you, compete for your attention, and at the same time provide a tranquil shady sanctuary. The arrangement isn't static; Sam and Lupe are continuously rearranging, sorting, and organizing their work, both to maintain their own sense of order and to catalog the collection. ("All the Chrysler buildings are over here now," Sam reports.) As we have seen in other gardens, the process of organizing and reorganizing the display are as important as the display itself.

*When me and her are alone there, we like to see different plants, different flowers. We see the blue jays come and drink the water out of the birdbath. In the afternoon, that's when they come. We used to spend a lot of time outdoors with others before, but now everything is high-tech, moving fast. People admire my work, but they don't have time to sit down and talk like the good old days. I like to call it my Garden of Eden.*

Welcome to Sam's Eden.

The back yard feels like being inside one of Sam's birdhouses.

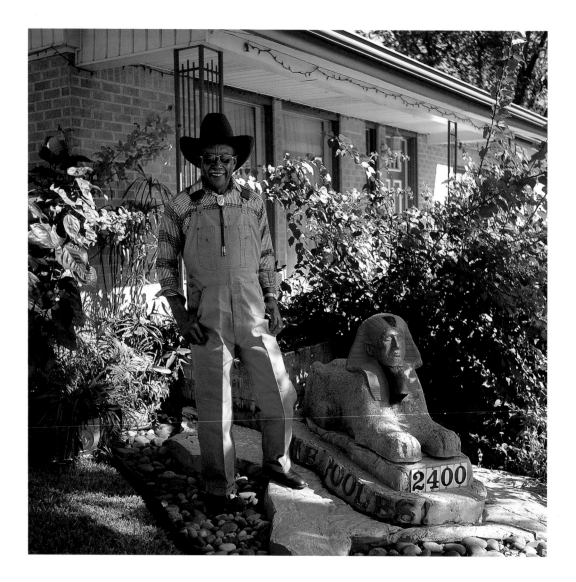

Mr. Ira Poole, educator, invites
passers-by to learn from history.

# A Lesson in Landmarks

Towns and cities are often organized and divided by arrangements, both codified and implicit, that continue to influence where people choose to live and conduct their business long after the political and cultural circumstances that mandated those original boundaries have passed into history. Sometimes the lines separating one part of town from another are initially determined by topographical features; other times the reasons are not so benign. Though priding itself on its progressive politics and tolerant attitudes, Austin, the capital of Texas, is no exception to this pattern. In many ways the city still struggles with its legacy of cultural divides.

Thanks to the federal government's massive highway building program in the 1950s, the line of demarcation between white residents and people of color in Austin was literally set in concrete by the construction of Interstate Highway 35, which cuts right through the center of town. This boundary was actually established much earlier through zoning laws passed in the 1920s that were meant to keep most African Americans and Latinos segregated from the Anglo part of town, and also to direct the dirtier industrial developments and fuel depots away from upper-class neighborhoods. So despite stunning views of the State Capitol and a convenient location, neighborhoods east of IH 35 remained undervalued and inhabited mostly by minorities with lower incomes.

Today the old patterns are beginning to change, as all central-city property rapidly rises in value. One of the major east-west arteries off the interstate is Martin Luther King Jr. Boulevard, which until recently was the main road to the airport (now relocated to the outskirts of town). As in many other towns and cities, an older street name (in this case Nineteenth Street) was changed to honor Dr. King and to affirm pride and solidarity in the African American community. Although an important thoroughfare in the residential life of the African American community, for many Austinites, driving down MLK Boulevard on the way to the airport was the only exposure they had to these neighborhoods and the people who lived there.

## TO BEAUTIFY AND INSTRUCT

In the early sixties, Ira Poole designed and built a custom home in a new subdivision developed especially for the growing African American middle class in Austin. Mr. Poole positioned his home toward the rear of his long, horizontal lot, exchanging backyard space for an ample front yard. Almost everyone with any history in Austin is familiar with Ira Poole's corner, even if only by a quick glance from the road. His front yard is known for its display of monumental sculptures representing patriotic and historical themes. The arrangement of sculpture and landscaping is set out in a careful and uncrowded manner, deliberately enticing the passing motorist with a declarative feeling more often found in public places. Through the display of classic iconography, such as the Statue of Liberty and the Egyptian

The Poole Statue of Liberty is a well-known roadside landmark in Austin.

*I just remember my grandmother making quilts, and when I went out there [to the rock supply yard], and the guy showed me all the different rocks, then I just got the idea of using those different rocks in a different pattern.*

Other flowerbeds outlined in undulating brick are filled with colorful hibiscus plants, bougainvillea, and annuals. Ira added more sculptural elements by shearing two large juniper shrubs along the walkway into elaborate Oriental-style shapes.

At the opposite end of the yard, the Statue of Liberty stands ten feet tall from the hem of her flowing robes to the tip of her outstretched flaming torch, soberly hailing all passersby with her beacon of liberty. To raise it higher, Mr. Poole built a special concrete pedestal covered with patriotic stars. Beneath her, lush canna lilies frame a concrete map of the Continental United States. This map, like the one of Texas, was made from molds designed and built by Ira himself. The map is surrounded by a rock garden containing a depiction of Mexico and the Pacific and Atlantic oceans. Adding even more detail to the tableau, miniature figures engaged in an array of activities are sprinkled on the map to represent aspects of the American and Mexican worker. Behind the statue, an American Eagle perches on a tall painted flagpole. A handful of pecan trees with white and red painted trunks match the statue and combine with the house's blue trim to complete the patriotic theme of red, white, and blue. To enhance the dramatic presentation, each night the statue is lit from below by large floodlights.

Sphinx, Ira strives to communicate a personal interpretation of human history.

Like an eternal sentinel, the low-lying cement sculpture of the Sphinx is positioned near the front porch entry. It's mounted on a concrete map of Texas that has been tilted slightly to face the oncoming eastbound traffic. Ira explains why he decided to set the Sphinx on an elevated part of this map.

*When I got the idea to make a larger map of Texas to set the Sphinx on, I decided one part would be coming up out of the other to show how the explorers came here to Texas out of nowhere; they just popped up on the Gulf Coast.*

This is one way Ira communicates the complex theory of how ancient history echoes through the ages into present time. "The Sphinx is history rising right out of the modern world," he explains.

Nearby, a planting bed is elaborately laid out in geometric shapes, each one filled with a different color of gravel, forming what he calls a quilt pattern.

## IRA AS EDUCATOR

Ira Poole came to Austin to attend Huston-Tillotson College, the historic African American college founded on the city's eastside. After obtaining his degree, he

taught in various Austin elementary schools for several decades before retiring. Mr. Poole's distinctive flair, both in personal style and home decoration, compliments his status as a church deacon and respected member of the community. For him, decoration and display, though important, are not their own end. As an educator (a term he prefers to "teacher"), Ira tells us how he often used innovative approaches to get the daily lessons across to his students.

*In the elementary classroom, I started using different media to introduce the units of study. I started with bulletin board decoration, decorating it like the outside of a movie theater to give you a preview of what was in the units—just to welcome you to the classroom.*

So it is no surprise that several pieces in his yard originated as classroom projects and bear witness to his creative style of instruction and his commitment as an educator. All of the objects represent in one way or another what Ira believes people should know about themselves and their world. For example, the Sphinx emphasizes what Ira feels is an important and often overlooked idea, that Western civilization began in Africa on the banks of the Nile. His fifth grade students made the original model in the early seventies as part of a class activity. "I decided that one of the art pieces that we were going to do was sculpture," explains Ira.

*We were sculpting different things, but I had seen the Sphinx in a book, and I decided we would sculpture that Sphinx. And we did [out of plaster of paris]. But over the summer it wasn't serving any purpose, and after it had set in the classroom one summer, I decided, well, I would just get a rubber-coat paint and set it out in my yard.*

(*below left*) Familiar icons have special meaning for Mr. Poole.

The history lesson is illuminated at night.

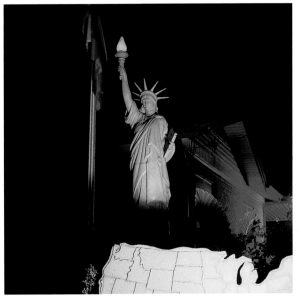

Unfortunately, someone tried to steal the Sphinx and destroyed it in the process. That did not deter Ira. Determined to display that ancient icon, Ira decided to have a mold cast of the Sphinx, despite the hassle and expense.

*There was a guy who was making molds, and he said to bring it to him and he would see what he could do. So he did it. We made a mold of it. I still have the mold . . . he charged me six hundred dollars.*

Constructed of concrete and steel rebar, the weight of the Sphinx provided its own theft protection and allowed Ira to display it confidently again in the yard.

*When I painted it, I was fascinated myself. I put it in the yard, and it got a lot of attention. And I know when the vandals came over to lift it, they couldn't.*

Ira pays careful attention to arranging the objects he has gathered or created, rather than simply setting them out as individual pieces in a collection. Just as he found creative ways to use bulletin board and classroom decorations to entice his students to become more interested in their lessons, Ira intentionally used his yard with its prominent street location to motivate motorists and pedestrians alike to become curious about complex historical themes.

In 1976, Poole was inspired by the upcoming Bicentennial celebration to propose the creation of a Statue of Liberty as a schoolwide project, which he hoped to place somewhere on the campus of his elementary school.

*One of the units I was teaching was the Constitution. I got the idea that maybe I ought to, this time, instead of putting it on the bulletin board, to take it outside the classroom. So I got the idea, let's put a Statue of Liberty out there and a map of the USA. I said that ought to make a real nice display to stand in front of the school. When I started to ask their permission to do that, they thought I had some kind of political ambition. And of course all I had wanted to do was to take what I was studying inside the classroom outside the classroom.*

Again, differences of opinion did not discourage Ira once he set his mind on something. He resolved to place a Statue of Liberty in his own front yard instead.

*I had to find a statue. I didn't know they even made them. When I started looking and asking, I had a student I had taught and she had a boyfriend from up in Dallas, and so we were talking and I was telling him about my idea and he said, "I can tell you where the Statue of Liberty is. On Highway 25 is a whole row of antique dealers, and one of those dealers might have that Statue of Liberty." So I went over there and I bought it.*

Ira readily volunteers information on the financial investment he has made in his yard displays that communicate his ideas. He's not boasting; he's underlining his commitment to educating others and the value he places on his worldview.

*I cashed in one of my insurance policies for a thousand dollars. Oh, my wife, she blew her top! "That's just a waste of money." But you see, every year she went on a big trip. But I didn't; I didn't take trips. I told her, "You go and come back and all you got is a dream, a memory, and pictures to show. Now, I'll spend this*

*thousand dollars and I'll have this thousand dollars to last me the rest of my life." Then I poured my platform, and I also made the continental USA. That was the mold I made for that.*

## STAYING OPEN TO GOD'S LESSONS

Ira's investment in the careful decoration of his front yard is more than just a static display of patriotism. Standing there with him as he points out the details, you get the sense that Poole strongly believes he is both observer and participant in history. When he describes what motivates his choices and his attention to certain themes in his yard, he does not hesitate to say,

*When I put it [the statues] out in my yard, I did it to beautify God, so to speak. Of course I also wanted to beautify my home surroundings, too. I love God. I like the country that God has made for me. I like the state that I live in, and I like the laws—most of the laws— which I have to live under. I am very appreciative.*

Although the basic symbolism represented by these statues is familiar to the casual observer, for Ira they also come with a deep philosophical and spiritual component, revealing his lifelong study of the mysteries of life and nature. To help us understand, he explains,

*When I graduated from high school, I was interested in history. And then when I entered college, then I wanted to be a lawyer. . . . So a lot of the things you see in the yard, I'm influenced by what I've studied down through the years. I know what the Egyptians did . . . and how they started civilizations. And their civilization influenced the whole world, the known world at that time. After all my studying, I don't know yet what new lessons God wants me to learn, but I'll just stay open.*

## A PLACE FOR HISTORY

Seen from a moving car, Ira's yard first impresses one as a vibrant collection of familiar large statuary dotting an otherwise groomed lawn. Yet, if one parks the car and walks inside Ira's corner lot, the experience is almost the opposite. From the sidewalk or standing in the yard, the effect is structured and coherent overall. Patriotic themes and colors are immediately recognizable, as are the miniature tributes to human enterprise and history. It's almost as if Ira Poole's yard is his own memorial park, with a homey stateliness reminiscent of the aesthetics associated with classic public monuments.

The location of Ira's home on a prominent east-west thoroughfare had a lot to do with how his yard came to be regarded as a local landmark. Ira has been featured in a number of publications and Internet sites like *Roadside Attractions* and *Keep Austin Weird*. He's even been featured on the HGTV program *Extreme Homes*. Ira's landmark is less complex and outlandish than many others in this genre, but its underlying meaning is not obvious or easily comprehended by the casual visitor. It is a direct product of Ira Poole's own personal experience, philosophy, and imagination. Ira invites us all to participate in history as an ongoing experience of the human race and has used his yard as an outdoor classroom. As he tells us,

*I'm trying the very best I can to fulfill the purpose in which God made me or made any man. I'm trying to live out my purpose for being on Earth. Does it mean to help others? Yes. To be a comfort to others? Yes. I'm not trying to overshadow anybody, or anything like that. No. My purpose is to live and let live. And in living and let live, I'm hoping that there will be knowledge.*

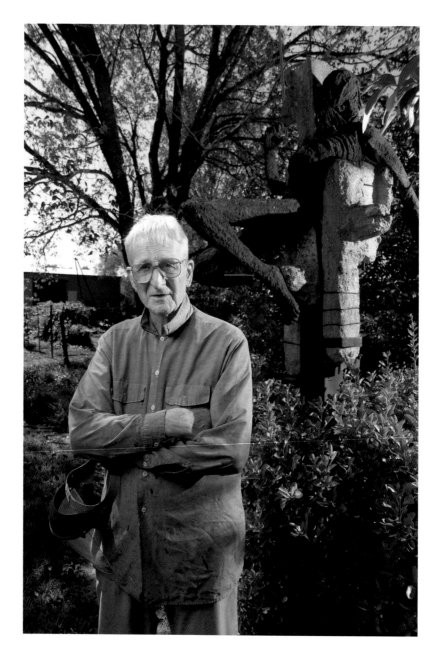

Dr. Joe Smith stands in front of his masterpiece "Crucifixion." (Photo Griff Smith)

# This Is How You Stay Alive

The little town of Caldwell in east central Texas lies at the intersection of state highways 21 and 36, amid the gravelly hills of the Post Oak Savannah region that gradually drop down eastward into the broad alluvial valley formed by the Brazos River. Besides being a center of agricultural and oilfield services for the area and also the county seat of Burleson County, Caldwell proudly identifies itself as the kolache capital of the world.

With a rich and varied history and superlative kolaches, Caldwell remains a sleepy little ranch and oilfield town, far from major highways or big cities. The main highway running through town bypasses the historic courthouse square without giving the traveler any real sense of Caldwell's character and flavor, apart from the same old scenery of roadside gas stations and fast-food franchises seen everywhere.

Coming into town from the west, you pass under a railroad trestle, and if you're not going too fast to glance to the left, you may catch an unexpected display of monumental abstract steel sculptures arranged on a large manicured lawn in front of a classic mid-century modernist brick home. The sculptures are carefully positioned among other pieces, including a large figure of a reclining woman clad in brightly painted fiberglass, and smaller sculptures carved from wood, concrete, and stone. On a far corner of the yard is a big metal shed workshop with other sculptures in various stages of assembly or disassembly crowding the area in front. A

large lot behind the house is filled with still more steel sculptures, set apart in neat rows. This is the public exhibition area of the very private art world of the town's doctor, Joe Smith.

### THE ONLY DOCTOR IN TOWN

It seems preposterous to us now to think about identifying one single person as the town doctor, even if Caldwell's population in 1955 was considerably smaller than the 3,600 it is today. For nearly half of his career, though, Dr. Smith *was* the town's only physician. Mornings would be filled with surgeries and baby deliveries, followed by clinic hours in the afternoon, when he might see thirty to forty patients. Many nights would be interrupted by phone calls with a frightened voice on the other end of the line, or the sheriff asking Dr. Smith to meet him at the hospital because there had been an accident out on the highway. Although small towns organized under regional hospital districts are able to offer generous incentives these days, many still have a hard time attracting doctors. It's difficult to imagine a young doctor in our times accepting the terms under which Dr. Smith worked his whole life.

Joe Smith grew up in rural Tennessee, the son of a devout hard-shell Baptist preacher and farmer. Joe's plans to attend college in 1940 were interrupted by World War II, and as a soldier he was wounded in the Okinawa campaign. Later he was sent to China, where he assisted in repatriating Japanese civilians who had

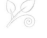

Abstract metal sculptures begin to fill the yard. (Photo Griff Smith)

*If you build me a hospital where I don't sacrifice the knowledge I have, then I'll come. And they did. We raised a little over a hundred thousand dollars and built a little sixteen-bed hospital. Then it was time for me to keep my end of the bargain.*

Joe brought his family to Caldwell, and they settled there for good. "And I was by myself fully fifteen years of the thirty that I practiced. Near killed me," explains Joe. "We would get a doctor that would come in now and then and they would stay a little while, but they just couldn't stand the claustrophobic atmosphere. Just crazy is how I stood it!" Once, he didn't have a vacation for five years. Eventually other doctors were hired to pinch-hit for him so he could take off from midday Saturday until Sunday at dinnertime. But that was all. Many times the family would load up in the car for one of these short weekend trips and would just make it to the city limits before an emergency call would come through on the radio phone and they would have to turn back.

### SOMEBODY RELEASING CREATIVE ENERGY

The study of art and the practice of creating original works through photography, painting, jewelry, and sculpture became essential mechanisms for coping with the impossible demands of his medical practice.

*Being on duty twenty-four/seven put me more or less in a cubicle, and every day the walls of that cubicle got higher and higher. Art provided for me an escape route and allowed me to fly over the top of that cubicle. I chose that route, and I enjoy it to this day.*

In the early seventies, a patient who was a metal fabricator showed him how to weld pieces of metal to-

been living in the north part of the country. Although Japan had been the enemy, Joe grew quite fond of the Japanese in his charge, and they of him. When he left, they gave him the gift of a small Japanese camera, and thus began Joe's lifelong interest in the creative arts, including photography, painting, jewelry design, and, finally, sculpture.

Dr. Smith was able to return to college on the G.I. Bill, but he had decided early on to enter a profession that guaranteed economic security, and that ruled out fine art. By the time he entered the Baylor School of Medicine, he was married to Mollie, and they had the first of four children.

When it was time to graduate, a friend told him about a community that badly needed a doctor. Joe and Mollie visited Caldwell, and Joe made a deal with them.

gether. "He showed me the basics, then he just walked off and left me with this pile of junk metal. Well, I just had a ball pasting it together," remembers Joe. From his first experimental attempts to create something out of scrap steel saved from a demolished railroad trestle and a wealth of other found metal objects, metal sculpture has been his principal form of expression. He found the production of sculptural pieces easier to control compared to photography, which was sometimes ruined when the inevitable emergency call came during the processing and printing phases.

The abstract expressionist era of art from the 1940s to the 1970s is a source of special inspiration for Joe Smith, particularly the metal sculpture of David Smith, Julio Gonzalez, and Mark Di Suvero. Henry Moore may have also influenced his first big sculpture, "Mother Earth," built in the driveway before he had his own shop. Patients in the hospital across the street watched the sparks fly from his welding torch as he attached the heavy wire frame, covered it with sheet metal pieces from auto parts, and then coated it with bondo and sealed it. Other metal sculptures reveal an understanding of what the abstract artists were discovering with line, weight, and arrangement in space. Yet Joe does not regard himself as an artist.

*I don't classify myself as an artist. I really don't. I just classify myself as somebody releasing creative energy. Then maybe that's all that an artist does, but to me an artist is an originator, a really good one. I'm not original. I don't copy, but I do observe. Art produces the kind of emotional outlet I need.*

As his technical skills in welding and assembly improved, his pieces became more complex, many expressing humanistic or philosophical messages. An early piece, "Impossible Dream," began as a Mother Goose float for his youngest daughter to ride in a Caldwell parade. It was made from chicken wire, with napkins for feathers, and had a goose head. His daughter rode on top. Joe remembers,

*When I got it back, it was in my way, so I decided to get old torn up metal from a car and cover it, and in doing that I made a single supportive element in the foot. And you will notice that the wings are far apart. It cannot fly. It cannot walk. It can hop a little bit, but when you look at the face on it with its gimme cap, it's got a very self-satisfied look like, "I got it made!" Well, of course, no human being has got anything made except a six-foot hole. So there you have it.*

The piece of which he is most proud is called "Crucifixion." In this large concrete and steel sculpture, a

The doctor's first monumental sculpture, "Mother Earth," waits by the driveway. (Photo Griff Smith)

Smith transformed a parade float into a statue with a satirical message. (Photo Griff Smith)

Dr. Smith retired in the late eighties. Now that he was able to devote more time to his art, his work increased in scale and complexity. Like many people heading east through Caldwell to College Station, certain art and medical school faculty from Texas A&M University had noticed the large sculptural pieces gradually filling more and more of the big corner lot. Eventually the attention they gave to his work led to the commissioning of several monumental pieces for the entrance to the campus, the courtyard at Texas A&M's University College of Medicine, the public experimental display gardens for the horticulture program, as well as more than fifteen other pieces, all fabricated from models built by Joe. Caldwell also began to see Smith's pieces migrating into the public landscape; the library (formerly Smith's clinic, which he donated to the city) has one, and so does the Chamber of Commerce, which organizes tours of Smith's collection. "I don't necessarily like [giving tours], but it's my civic duty. I just do it. Now, I like to talk to people, particularly if you are interested in art, but if you're just curious, I don't," remarks Joe.

Dr. Smith's wife, Mollie, plays a big role in the display of his sculptures. She is the one who decides where they will go and who maintains high standards of grooming for the huge lush grass lawn, trees, and flowerbeds. Tuesdays were always set aside as mowing days, and until recently, she did most of the work herself.

beam pierces the entire body of Christ like a single large nail. Joe explains his work:

*The nail goes through the body, and the body can't be taken down; it's nailed to concrete. We've trapped the dynamic element [the body of Christ] in religion and churches, and then we worship this trapped image, and it becomes more or less like an idol.*

### LANDMARK AND LEGACY

The history of Joe Smith's life, his experiences overseas, the impressive intelligence characteristic of a lifelong learner, and his commitment to pursue artistic expression despite the relentless demands of his practice are all reasons to be interested in what we find in his yard in Caldwell. Yet, had he had all these qualities but confined himself to a private connoisseurship, by ac-

quiring or creating objects for his personal enjoyment only, the result would have been so different. Can we describe the effect his work had on a conservative rural town and the salt-of-the-earth people who live there, or the way the public reaction in turn affected him? The sculptures themselves changed the configuration of the space outside his home, inviting the attention that eventually led to commissions for sculpture for public places. We can only wonder what it was like for someone like Joe Smith to stay in Caldwell all these years when he could just as easily have been successful in larger cities, places with art museums, foundries, galleries, and art-loving peers. According to his son Griff, the only time Joe seriously considered moving was when an oil company offered him a job in Borneo. "Other than that, I think he's smart enough to know that wherever you go, there you are," explains his son.

The public exhibition of his work provided an interaction that was just about all a small town could offer, and maybe that was enough for an overworked but highly motivated autodidact like Dr. Smith. "I needed something that was personal, something I could leave as a footprint." His is an extraordinary life whose legacy includes assisting others at those great thresholds of life—birth and death. Through the display of his art in an unlikely place, Joe also memorialized noble ideas and aspirations, as well as the human follies that occur in between.

Joe Smith's creative pastime eventually became a sculpture park for a small town. (Photo Griff Smith)

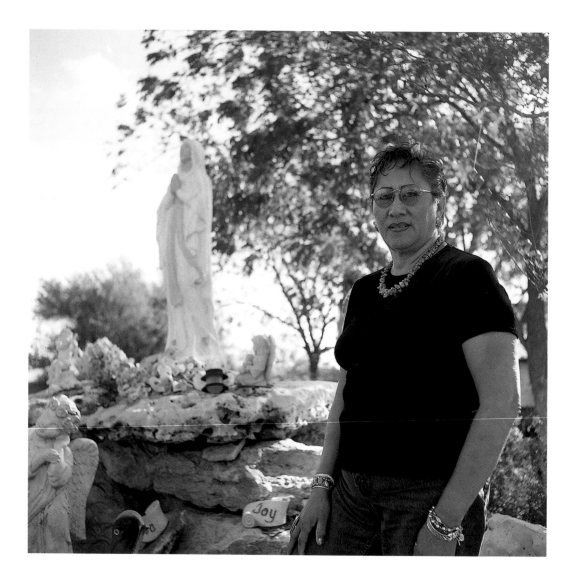

Marian Reyes watches over a
tableau of Our Lady of Lourdes.

# Desires of the Heart

U.S. Highway 183 splits off the road to the Austin airport, then heads out of town through the southeast part of Travis County. It's on this side of town that fingers of the blackland prairie roll down to meet the frayed edges of a different vegetation zone, the South Texas Plains. In contrast to the appealing Texas Hill Country just to the west, this part of the county has little to recommend it in terms of scenic beauty. Intensive corn and cotton farming, begun in the early twentieth century, played out within a couple of generations, and now the abandoned fields yield mostly invasive mesquite trees, poverty weed, and Johnson grass. Even the area's most prominent geological feature, Pilot Knob, believed to be the remains of an eighty-million-year-old submarine volcano, looks more like just another landfill mound than the remains of a Cretaceous volcano.

Highway 183, once more of a farm-to-market link to small towns in south-central Texas, has now become a hectic commuting route to outlying communities that are more affordable, unincorporated mobile home neighborhoods, and light industrial development. In this sort of leftover landscape the motorist can expect to find the highway frontage dominated by auto salvage yards, miniwarehouses, gentlemen's clubs, and second-class stock car racing tracks. What you don't expect to find is a sanctuary garden.

**THE LORD IS MY SHEPHERD**

At a certain place along this forlorn and overcrowded highway, a large mechanic's garage is attached to a rambling fence that hides the remains of uncounted wrecked cars and trucks. Painted on the side of the garage are fluffy white clouds floating on a pale blue sky bordered on one side by a Texas State Highway Inspection sign and on the other a wrecking truck with a custom paint job parked on the gravel drive. Under the single gable of the roof is a sign proclaiming, "The Lord Is My Shepherd." To complete the tableau, several large plywood sheep graze among big tractor tires painted lime green with red stripes. From each tire planter sprouts a bright turquoise flower made from radiator fan blades. A wide gravel driveway bordered by rows of telephone poles, also brightly painted with stripes, guides the visitor to the garage on the right and the house on the left. Large rubble stone borders sweep around the beds behind the poles, enclosing a small mound decorated with special handpicked and interesting rocks, shells, and other decorative items. This mound is one of several shrines to the Sacred Heart of Jesus, Saint Francis, and the Blessed Mother that divide the garden into devotional areas. Jesus extends his arms in blessing to an assortment of adoring concrete angels, children, and animals arranged at his feet. Behind one statue of Christ are other purely decorative groupings

**CHAPTER 24**

151

An answered prayer
inspires a roadside shrine.

(*right*) The sheep await the Good
Shepherd.

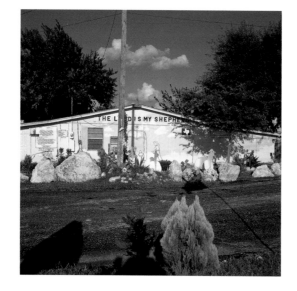

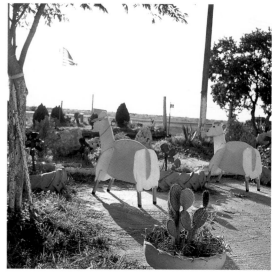

or collections, such as a metal hoop festooned with large red bows and Mardi Gras beads, painted pots, bathtubs, and tire planters filled with plastic flowers in winter and colorful annuals in the growing season. Between the garden and the house is one of those portable carports, filled with iron patio furniture painted in bright candy colors. Shells of all sorts are piled up on a red table. The trunk of each tree in the yard is carefully painted white halfway up the trunk, matching the fence and other borders. A handmade purple and red bench by the front fence provides a place for the children to wait for the school bus.

You have to concentrate to hear the story of Marian and Richard's garden over the constant roar of the highway. Richard and his son operate Reyes Towing, open twenty-four hours a day. Usually Richard is the one answering the knock on the door or the police radio in the middle of the night after a car wreck has occurred somewhere. Often he must deal with traumatized

people coming to collect what's left of a family member's vehicle. Sometimes deputies on the graveyard shift who come to inspect the cars for the accident reports tell Richard what this garden means to them. "It's like a sanctuary here," they say, while pausing for a quiet moment under the carport pavilion. They sense the love and effort that has been spent on this strip of land so close to the highway, and know that this simple resting place has been set aside for them.

### EARLY DAYS ON THE FARM

An aunt sponsored Marian's dad so that he could emigrate from Mexico to Texas with his wife and nine children. Many years of hard work as a farmer in the Creedmore area finally provided him with the opportunity to buy a little piece of land and build his own home in 1959. Early photos show a simple house isolated on the blank prairie, with only a single mesquite tree in the front yard providing skimpy shade. In 1978, Marian and

Richard bought the old homeplace, and within a few years they moved there to set up a towing and auto salvage business with their son. From the early days of her marriage, Marian had shown an interest in and flair for decorating and landscaping her yard. Back in 1964, at their first house in east Austin, she won a beautification award for Most Improved yard, sponsored by the Austin Garden Club Council. Money was tight back then, so instead of going to a nursery, she gathered plants and interesting rocks from the countryside and arranged them in an attractive display. Later, when they moved out to the old homeplace on the highway, a larger space and a series of experiences inspired her to expand her vision of what a garden could be.

## A SIGN FROM GOD INSPIRES A GARDEN

Marian explains what motivated her to begin such an ambitious project of landscaping and shrine-making on her property:

> *The theme here is spiritual, because that's part of who I am, my expression of my faith, which is that the Lord keeps us together. And especially I decided to put that phrase up there, "The Lord Is My Shepherd," because of something I have always believed, and that is He has always been the shepherd of our family in a lot of different instances.*

Although she had begun to paint landscapes on a small scale after watching the how-to shows by Bob Ross in 1987, the large scenery painting on the side of the garage was inspired by special circumstances.

> *We have a foster son [Larry] that we started to raise when he was two years old. He's our son now actually. I don't say "foster" anymore. But we had a real hard*

*time in between his growing years because his mother wanted him back and then she didn't—that kind of deal. Once she took him to North Carolina and wouldn't let us know where he was. I used to ask the intercession of the Lord to watch over him. He was about five at that time when she had taken him.*

The Reyeses worried because they hadn't heard from him. About the same time, an older son had rented a car to visit an aunt living in Florida. On the day he was going to return the car, he said to Marian, "Mom, did ya'll go shopping today? You left some boxes in the trunk, and you need to take them out before I return the car." Marian was puzzled because she hadn't used the car at all.

> *So anyway, I went in there to check in the trunk, because I thought, "That's strange." I looked in the box, and in it was a picture of Jesus as the Good Shepherd. And all this time I had been asking the Lord to give me a sign because I was worried about my son and I wanted to make sure he was okay, and there it was, inside the box in that rental car.*

A busy highway seems an unlikely location for a sanctuary garden.

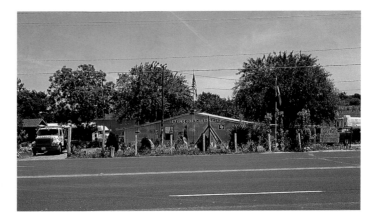

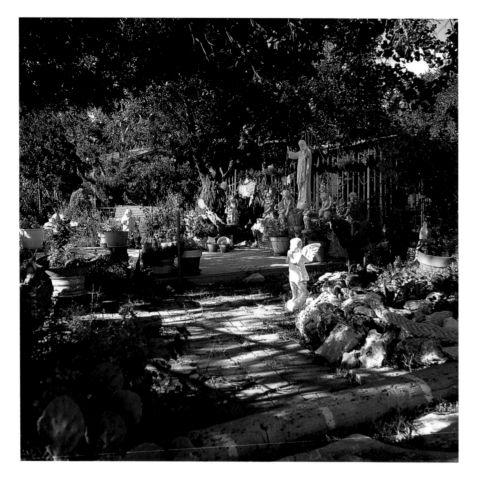

Boulders, shells, and found treasures decorate a shrine to the Sacred Heart.

*really enjoy it. It just kind of flows. At first, I was just going to put the sign [The Good Shepherd] on the garage, but I wanted to bring some life into it. I didn't want to plant anything there because the soil wasn't all that good. So one day I was just sitting there looking at all that stuff and I thought, We talk so much about recycling, and it just hit me one day to use them [the radiator fan blades as flowers], so I just started painting them.*

Part of the charm of this garden, aside from the color and the abundance of materials, is Marian's inventiveness in the use of recycled objects and materials that are at hand. For example, much of the structure and organization of the spaces come from the use of interesting karst boulders, caramel and white in color, riddled with holes that give it a coral-like form. "One day this man came by, they were doing excavating somewhere, and he came to ask if we would accept some clean fill," begins Marian. It turns out the man had thirty truckloads of boulders. "I don't say no to anything, but my husband was very upset about it, and I said, Just let him be, you don't know the price of things. There's a *treasure* in that." Marian sold off some of the decorative boulders to landscapers and continues to sort through the remaining pile of honeycomb rocks for new garden projects.

Shells are also found throughout the property, some forming beaches, some strewn as borders, others displayed on little mounds, in baskets, broken *cazuelas*, and on brightly painted tables. Marian's house is full of shells. "I started collecting shells a long time ago," remembers Marian.

*A friend back in the sixties brought me back a little cluster of shells. I had never gone to the beach, but I loved shells. From then on, I was able to start going to*

Soon afterward, Larry called from a convenience store in North Carolina, and the family rushed out there to bring him home.

Marian has a confident sense of her own creative abilities, and the large size of her property offers lots of space for expansion.

*Once I start a project, my sons and my husband help by utilizing the equipment we have around here. But I really,*

*the coast, picking up driftwood. I had even made it a goal of mine to go to Florida because I heard it was the shell-picking capital of the world. I guess I set goals for myself, or desires of the heart, if you want to call it that, and so much so that I have no doubt that within us is the power to fulfill the dreams that we have, if we just work at it.*

**OUR LADY BLESSES HIGHWAY MOTORISTS**

Across the private drive on the other side of the house is the most recent project of the garden, a pond inspired by a pilgrimage to Lourdes. That special trip represented another example of Marian's "desires of the heart." Marian longed to make the trip; though it was expensive, she was determined to go. "I put everything that I had in my house for sale to go there with my sister, and we accomplished it in two weeks." When she got home, she once again went to her stockpile of honeycomb boulders to make the hillside shrine for the statue of our Lady. A large metal stock tank was buried to create a pond, which she surrounded with plantings and smaller concrete statuary. At night, colored lights shine on this scene so all can see it. Marian explains the motivation for expanding her garden:

*It's just a sharing. It's not to broadcast anything, but to share the beauty that God has created for us. There have been people who stopped by. I used to have the Blessed Mother's statue in another location. I had her in front with all these angels, and people would stop by and take pictures. Sometimes I'd be sitting here and I'd watch people go by [on the highway], and they'd make the sign of the cross. And I thought, How beautiful. It's touching them. And it's not like I'm out here pushing religion on anybody, but it touches them. I like the whole idea that it's there, you can take it or leave it.*

What began as more or less a home improvement project, sprucing up the old family homestead, has evolved over the decades to become a deliberate composition of a sacred place offered freely to a wounded and battered world. Whether it's the exhausted deputy taking a break in the predawn hours beneath the hackberry tree surrounded by religious statuary, or Marian's pen pal Anna from Croatia, whom she met at Lourdes and later brought over for a visit and a Mexican fiesta in the garden, or the anonymous commuter speeding to work giving a glance and a quick genuflection, the garden is there for everyone.

Marian surveys her garden, still very much a work in progress.

*For myself, even though the traffic is so heavy and loud out there, it becomes more and more of a sanctuary. Because even though the noise is there, I find time to get out there and be quiet and just to sit, and then I can regroup and come back into my every-day situation. Even in our community here, I know a lot of people and I know what they go through. We're all just part of suffering humanity, and we need a moment of something good. I want to share what I have, and it makes me happy that I'm inspiring other people or giving them a moment of peace.*

Her quiet determination and hard work have proven once again that the realm of the sacred is not confined to grand cathedrals, but can have special power when found in the overlooked, ordinary, and unexpected places as well.

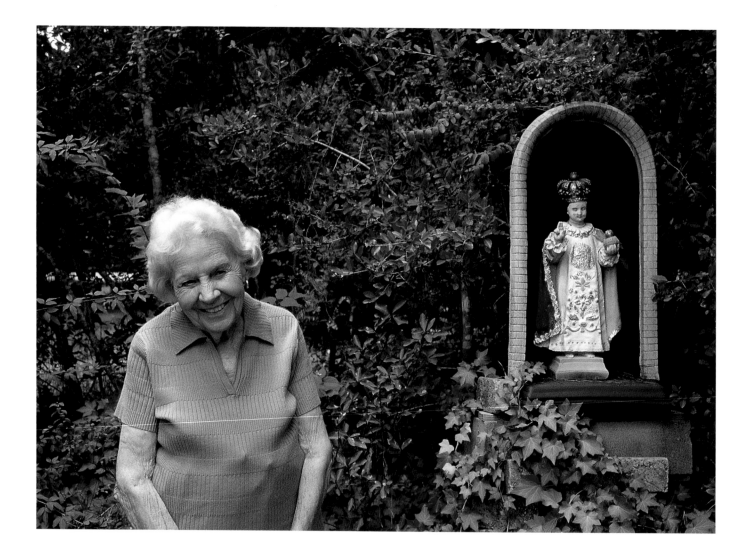

Evelyn Blazek is the faithful
keeper of the Sacred Gardens.

# More Than Four Seasons

The state map puts New Waverly near the tip of a peninsula surrounded by Sam Houston National Forest. Houston is sixty miles south down Interstate Highway 45, just a little too far for most of the commuters who have recently colonized so much of the southern edge of the Piney Woods. The relentless traffic on IH 45 is soon forgotten once the motorist turns onto State Highway 150 and heads a few miles east. Except for the loud rumble of the occasional lumber truck, and the particular long-distance whine of heavy tires on three-quarter-ton diesel pickups, the landscape is quiet. Standing still a moment, you become aware only of the wind breathing through pine trees and the sporadic cawing of crows. From the curving road you can see woodlands and pastures, the occasional pump jack well, horses, and a few cattle. Also, from the road two miles east of town, you can see a seventeen-foot-tall statue of Jesus Christ.

It's surprising to see Him standing there, arms outstretched, against the dark backdrop of pine trees and a split-rail fence. His robes of plastered concrete swirl around Him, white as unbaked meringue. His expression is abstracted, and His gaze is directed to some far-off place we cannot see. Inscribed on His imposing pedestal is:

*Christ of East Texas*
*May All Who Pass This Statue*
*Be Reminded of Our Lord*
A Dream Come True
Evelyn Blazek 2002

A few feet away, a large handmade sign informs readers that they have arrived at Sacred Gardens, where tours, weddings, parking, and a gift shop await them. A winding gravel drive leads past the small cottage gift shop at

The Christ of East Texas watches over Highway 150.

the gate into three and a half acres of holy shrines, with the Blazeks' modest brick home and patio resting at the center.

## THE GARDENS MEAN EVERYTHING TO US

Evelyn Blazek has been creating, tending, and loving these Sacred Gardens for more than thirty-three years. Greeting her latest visitor, her bright blue eyes, energetic demeanor, and engaging personality belie her eighty-six years. Except for a little help on the weekends with mowing the grass, Evelyn does all the work herself, including the daunting job of spreading eight yards of iron ore gravel on her driveway.

Like some of the other garden makers we have visited, Evelyn is a practiced tour guide who never tires of telling the story of how the gardens came to be. She shares her narrative in the form of recounted conversations that give them a fresh sense of immediacy, as if memorable events of several decades ago occurred just last week. She begins this way:

*I get so much pleasure thinking about how this happened and how that happened and how I would pray about something and people would try to discourage me, and I say, "Well, you know, I just believe it's God's will that it will work out."*

The seed of inspiration for the garden was planted in 1950 when her husband, Gene, built their first shrine to Saint Jude, patron saint of hopeless causes, in gratitude for the miraculous recovery of their twelve-year-old son, Gene Junior, who had been seriously ill with a congenital heart abnormality. Later, they brought the statue with them in 1968 when Gene Senior retired and they moved to New Waverly to escape Houston's worsening traffic and congestion. The idea of creating a sa-

cred garden appeared soon after they were settled. Evelyn remembers:

*That's what seems so strange about this garden. When we moved, we had just had a lot [in Houston], about one hundred by one hundred twenty-five feet, I think, but then we had bought these seven acres. It seemed like a lot of land for people who were used to living on a small lot. One morning we were having coffee on the terrace, and I said, "Honey, do you think we deserve to have such a pretty home?" And he said, "Honey, you know I have something I want to tell you. I've thought about it for such a long time, but I've never told you." I said, "What's that?" He said, "Something inside of me is saying we should do something besides just going to church and trying to serve God." I said, "Honey, that's a strange thing, because I feel the same way." Gene said, "Why don't we do something special with our beautiful property?" And I said, "Make a garden?" And he said, "Yeah." And I said, "It could be a sacred garden." "That's a good idea," he answered. And I said, "We could have it blessed. Do you think we could get the bishop?" And he said, "We could sure try." And my hope on that day came through a million times more. In 1972 Bishop Morkovsky came to dedicate the garden. At that time we had seven shrines. We now have seventy-four shrines.*

## WHAT EVELYN AND SAINT HELEN HAVE IN COMMON

Shortly before deciding to begin their epic project, Evelyn and Gene had visited Bellingrath Gardens in Alabama and were enchanted by the design and layout. They realized they could never afford something as elegant, but their lifelong practice of frugality and making do with what was at hand gave them confidence that

they could make their own version of a homespun public garden. Steadily, the Blazeks began to populate three and a half acres with small concrete statues of various saints, the Blessed Mother, and scenes from the Bible, like the Sermon on the Mount, the Ten Commandments, and Christ's journey to Calvary. Each figure is surrounded by its own shrubbery alcove or backdrop, many enhanced by an energetic use of recycled materials, such as old road culverts, concrete test cores, oil-field drill stem pipes, discarded plumbing fixtures, rusty lawn mowers, and washing machines. No material was too humble or shabby for consideration. Red carpet salvaged from a church covers many of the pathways and is meticulously swept clean of pine needles. Evelyn describes the way she has recycled each of these materials for holy use the same way someone might show enthusiasm for a challenging game or treasure hunt. Once, on a trip to Mexico, she retrieved a concrete cross from a garbage dump. "It took my husband, my cousin, and another man to put it in the car. It is that heavy," recalls Evelyn.

Italian cypresses frame a tableau of the Sermon on the Mount.

*So we brought it home, and I was so excited I put it there and made it a shrine to the Holy Cross. I had a tour come through the garden, and I was telling them about it and a lady said, "Did you know that Saint Helen found the original Old Rugged Cross in a pile of trash years and years after Christ was crucified?" I said, "No, I didn't know that." She said, "Well, that's true." Well, that made this old cross nearer and dearer for me.*

One of the earliest installations came about this way:

*My beauty operator's husband made flowers out of old hot-water heaters. I went to the beauty shop one day and she had one out in front of her shop, and I said, "Oh, Geneva, your flower is so gorgeous!" And she said, "I think it's tacky, but please tell Bubba something nice because I hurt his feelings." Bubba was a real tall man, and he came in and I said, "Oh, Bubba, I love your flowers!" He said, "Evelyn, you're the only one that appreciates them. Would you like me to make you one?" I said, "Would you make me two?" In the end, he made me four.*

Throughout the history of the Sacred Garden, it seems few people have been able to resist the sweet talk

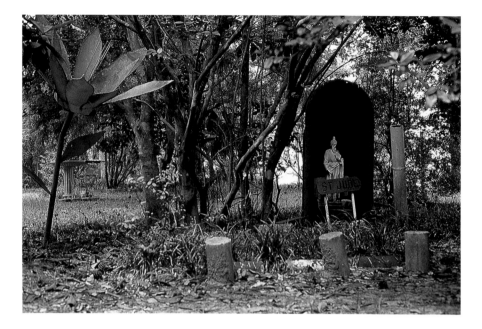

Old water heaters are transformed into permanent flowers.

Most of the shrines are enclosed by trimmed box-woods or yaupon hollies that Evelyn has grown from cuttings. Liriope, or monkey grass, divided and spread by plugs, lines many walkways. Urns made from buck-ets and concrete pipes hold billowing asparagus fern, kolanchoe, or begonias, all grown in Evelyn's green-house, where a radio tuned to a Christian station keeps them company. Many of the shrines have been carefully positioned in foliage alcoves off the main circulation path, with entries designated by an archway or gate made of PVC pipe or iron wire. Evelyn's three favorite built forms are bridges, columns, and gates. These threshold markers are deliberately used to suggest that the time we have here is short and our passage to eter-nity is close at hand. At some shrines, the archway and a long path allow the visitor ample time to consider this reality as they approach the statue.

## ALL WHO VISIT HERE

of this diminutive dynamo. Close to the entrance to the garden is a rosary chain made of boulders begged from the engineers building the dam at nearby Lake Conroe. Highway department employees have donated their cranes for shifting 800-pound sections of discarded concrete culverts into position as columns or pedestals for a statue. Another friend hauled more than a hundred used tires as underpinnings for a shrine commemorat-ing the Sermon on the Mount and the Blessed Mother.

The Blazeks' two sons, Gene Junior and Truman, regularly spent part of their vacation time helping with the heavy work on the grounds and in the greenhouse. Visitors and friends sometimes commissioned shrines in honor of loved ones or certain events. A special altar made of stone from Mount Rushmore was built in re-membrance of the justice of the peace who performed more than seventy weddings in the garden.

The veneration of saints and the iconography of stat-ues are typically associated with traditional Roman Catholics. It's true that Evelyn and Gene were devout Catholics, but wandering through the parklike setting of the various shrines, the visitor feels that Catholi-cism is emphasized less as a specific faith and more as representing something universal, involving all, and of interest to all. Among the modest statues of less familiar saints, like Saint Fiacre, Saint Roche, and Saint Aloysius Gonzaga, are sites commemorating the victims of the Holocaust, a setting honoring a member of the African American congregation of South Union Missionary Baptist Church in Houston, the Wailing Wall (also a memorial to her son Gene), a garden with a Chinese theme, and a plot representing the sentimental favorite poem "Footprints in the Sand." Evelyn's plans for her next garden continue

this theme of inclusion. "Well you know, I want to make another garden, but I'm having trouble finding rocks. Rocks about this big around," Evelyn says, indicating the size of a golf ball.

*Just a small garden, and I want to put a sign in there that says, "Let ye without sin cast the first stone." I have friends who think that if you don't believe in a certain way, you just don't have a chance in heaven, and I just don't believe that everyone has to believe in the same way. Everyone has the right to believe the way they want to believe, as long as you believe in God.*

## IT'S GOING TO BE UP TO GOD

From the late seventies to the end of the nineties, the Sacred Gardens were at their peak. Rising early each morning, Evelyn would put her house in order and then pack a lunch in a small cooler before heading out to spend most of the day in the garden. It was a full-time job for both her and Gene to keep the grounds raked, the mildew bleached from the statues, the various pillars and pedestals freshly painted, and the greenhouse tidy. Two or three times a month, busloads of church pilgrims or senior citizen groups would arrive to tour the gardens. Gene and Evelyn built an extensive patio outside their home with lively umbrellas, birdbaths, and flowers just so the visitors could rest and have refreshments there. Countless weddings, both religious and secular, were performed in the garden. Charging a small fee, Evelyn lavishly decorated the altar with silk flowers, ribbons, and garlands and opened up her own home, which she also elaborately decorated with religious statuary, flower arrangements, and her special cut-glass collection.

As we have seen in other gardens (Chapter 8), at Evelyn's, the domestic arts are highly esteemed and are expressed with equal enthusiasm inside and outside the home.

At Christmas, the Blazeks undertook the extra job of setting 2,000 lights and 1,500 candelarias to decorate the garden. Children from a local church group performed a live nativity. Fifty-two Knights of Columbus dressed in their finest uniforms, formed a ring inside the boulder rosary, and held up their swords in salute to the special night celebrating the Nativity. On those nights the house would be filled with crowds of people singing carols, eating cookies, and drinking coffee.

## SEASONS IN THE GARDEN

There are more than four seasons in a garden. In the

A monumental rosary chain is made from Lake Conroe dam boulders.

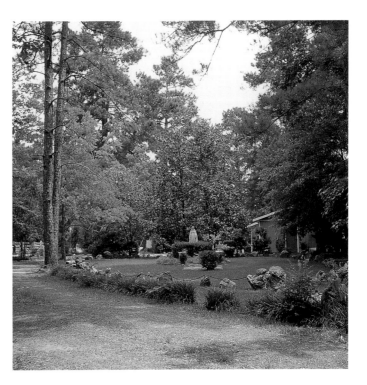

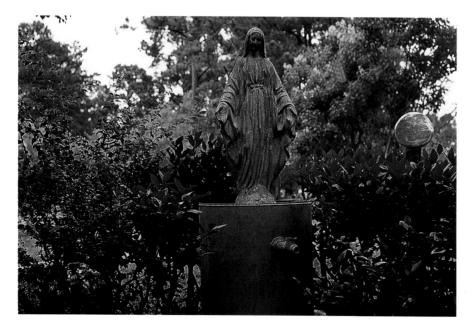

The Blessed Mother on a water-heater pedestal welcomes visitors to the Sacred Gardens.

*die! I had never seen anything so gorgeous, so beautiful. I thought about it all the way home. So one night I was lying in bed thinking about it, and I said, You know, God, I don't understand why I can't get a statue built of you, and they can build one of Sam Houston [on IH 45]. He's not important, to the average person. God is more important than Sam Houston, you know.*

Evelyn's quest to have a monumental statue of Christ on Highway 150 that would outshine the statue of the Texas hero became a long, drawn-out saga of naïveté, unexpected support, bitter disappointment, and, finally, a disputed ending. The delivery of the statue was repeatedly delayed and involved much more money than was originally proposed. To make things worse, the Texas Department of Transportation contended that the statue is on state property and threatened to fine Evelyn (the matter was eventually dropped). Never one to emphasize the negative, Evelyn simply remarks, "God had a funny way of letting me have that statue." Still, the list of donors on the dedication plaque notes a variety of supporters, including the youth group of a small-town Methodist church. That's where Evelyn's victory lies, with those countless visitors who experienced something holy while in her garden. "I just hope that God's pleased. That's all I care about."

Someone once remarked that gardening and dance are the most ephemeral of art forms. The more extravagant the gesture, whether it be materials or devotion, the more fragile the space becomes. Who can quantify passion? Sacred Gardens is the embodiment of the joyful aspects of religion, and that is something that cannot be measured or easily replaced. Today's visitor to Sacred Gardens might not be impressed by the arrangement, or the design, or the fading amusement provided

early nineties, Gene Senior died after suffering from Alzheimer's for eight years. Evelyn cared for him herself. Then in 2001, Gene Junior, who had been spared from death as a child, died at age sixty-five. The bus tours gradually stopped coming. Formerly helpful Knights of Columbus began feeling the limits of their age. The Christmas pageant was eventually cancelled, as the cost of putting up the lights grew beyond Evelyn's modest budget.

Despite the signs that the garden was perhaps entering its inevitable twilight phase, Evelyn conceived of one more extravagant project that would really put Sacred Gardens on the map.

*I had gone to Eureka Springs, Arkansas, with a group from my church, and I saw this statue in the mountains of Jesus [Christ of the Ozarks], and I thought I would*

by everyday objects employed as classical elements like pillars or columns. But the love and faithful devotion of the Blazeks, who believed they were co-creating this space with God, is still evident. As Marilyn Robinson wrote in her book *Gilead*, "[It] doesn't enhance sacredness, but it acknowledges it. And there is power in that." Today the beauty of Sacred Gardens shares the same melancholy appeal found in an old country cemetery, the slightly overgrown kind with homemade grave markers, heirloom roses and bulbs, and simple rock borders. The humble materials may be less visually impressive, but in their own way more moving because of the spirit of generosity and loving attention that still lingers there.

Throughout the grounds, you can see signs that trumpet creeper, poison ivy, privet, and Chinese tallow tree are all waiting to take over. Has it been worth it? Evelyn has no doubts.

*There'll be people who come visit, and I'll say, "Oh, hello, welcome to Sacred Gardens." And they'll say, "Can we tour the gardens?" And I'll say, "Sure, would you like me to go along with you?" And they say, "No, we'd like to do it ourselves." Then they'll be acting like, "Huh? What's all this about?" You know, not very impressed. But before they're through they'll say, "You know, you really feel the nearness of God, don't you?" This is a lot of work, but think if it saves one soul!*

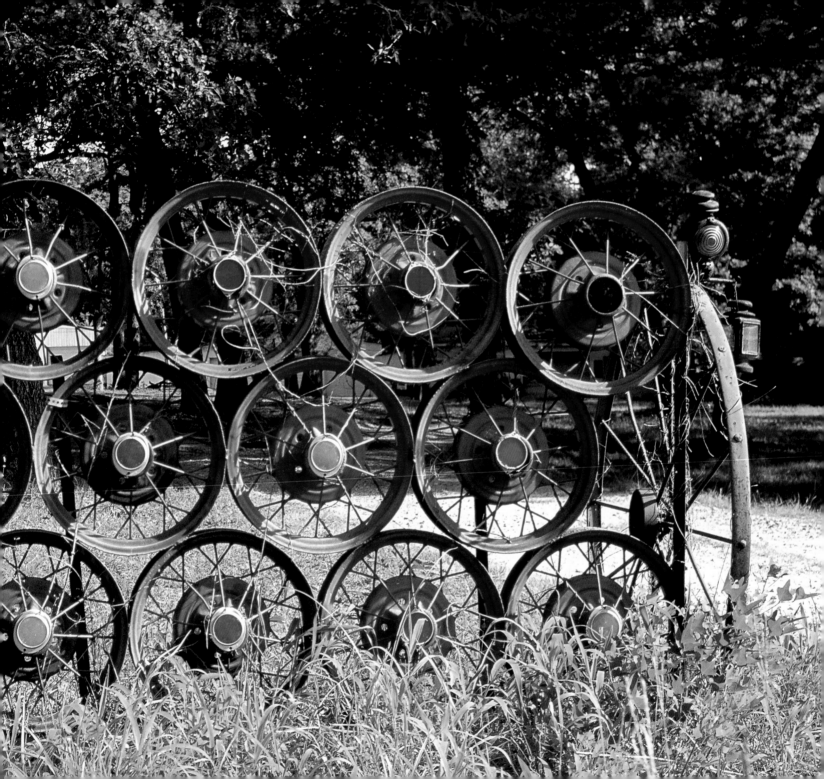

## CHAPTER 1

1. Richard Westmacott, foreword to *African-American Gardens and Yards in the Rural South* (Knoxville: University of Tennessee Press, 1992), p. x.

2. Robin W. Doughty, *At Home in Texas: Early Views of the Land.* (College Station: Texas A&M University Press, 1987), 4.

3. Neal Peirce, "Privatized Neighborhoods: The Future We Want?" *Liberal Opinion Week,* 27 July (2005), 31.

4. For an in-depth discussion of the phenomenon of private neighborhood associations, see *Behind the Gates: Life, Security, and the Pursuit of Happiness in Fortress America,* by Setha Low (New York: Routledge Press, 2003).

5. Colleen Josephine Sheehy, *The Flamingo in the Garden: American Yard Art and the Vernacular Landscape* (Ann Arbor: University of Michigan Press, 1991), 60.

6. Timothy Beatly, *Native to Nowhere: Sustaining Home and Community in a Global Age* (Washington, D.C.: Island Press, 2004), 31.

7. Jan Wampler, *All Their Own: People and the Places They Build* (Cambridge: Schenkman Publishing, 1977), 7.

8. Elizabeth Barlow Rogers, *Landscape Design: A Cultural and Architectural History* (New York: Harry N. Abrams, 2001), 20.

9. Doughty, *At Home in Texas,* 7.

10. Rita Dove, ed., *The Best American Poetry 2000* (New York: Scribner Publishing, 2000), 19.

11. Doughty, *At Home in Texas,* 7.

12. For an interesting discussion on the value of looking at ordinary places, see *Outside Lies Magic: Regaining History and Awareness in Everyday Places,* by John R. Stilgoe (New York: Walker & Co., 1998).

13. Michael Pollan, *Second Nature: A Gardener's Education* (New York: Atlantic Monthly Press, 1991), 194.

14. Westmacott, *African-American Gardens,* 1.

15. Steve Bender and Felder Rushing, *Passalong Plants* (Chapel Hill: University of North Carolina Press, 1993).

16. J. B. Jackson, *A Sense of Place, a Sense of Time* (New Haven: Yale University Press, 1994), 158.

## CHAPTER 2

1. Scott Ogden, personal communication.

2. Eric Ramos, "Mexican-American Yard Art in Kingsville" in *Hecho en Tejas: Texas-Mexican Folk Arts and Crafts,* Publications of the Texas Folklore Society, ed. Joe S. Graham (Denton: University of North Texas Press, 1991), 252.

3. Pat Jasper and Kay Turner, in *Hecho en Tejas: Texas-Mexican Folk Arts and Crafts,* Publications of the Texas Folklore Society, ed. Joe S. Graham (Denton: University of North Texas Press, 1991), 56.

4. John Beardsley, *Gardens of Revelation: Environments by Visionary Artists* (New York: Abbeville Press, 1995), 7.

5. Ibid., 11.

6. Thad Sitton and Lincoln King, eds., *The Loblolly Book* (Austin: Texas Monthly Press, 1986), 119.

7. Cynthia L. Vidaurri, "Texas-Mexican Religious Folk Art in Robstown, Texas" in *Hecho en Tejas: Texas-Mexican Folk Arts and Crafts,* Publications of the Texas Folklore Society, ed. Joe S. Graham (Denton: University of North Texas Press, 1991), 228.

8. Sheehy, *Flamingo in the Garden,* 135.

9. Beardsley, *Gardens of Revelation,* 190.

## CHAPTER 7

1. Virgilio Elizondo, *La Morenita: Evangelizer of the Americas* (San Antonio: Mexican American Cultural Center, 1980), 15.

## CHAPTER 16

1. Beardsley, *Gardens of Revelation*, 19.
2. María Cortés González, "Honoring the Virgin of Guadalupe," *El Paso Times*, 12 December 2002.

## CHAPTER 17

1. Donald Worster, *Dust Bowl: The Southern Plains in the 1930s* (New York: Oxford University Press, 1979), 220.